DATE DUE

MASTERPIECES OF EIGHTEENTH-CENTURY FRENCH IRONWORK

WITH OVER 300 ILLUSTRATIONS

EDITED BY
F. CONTET

DOVER PUBLICATIONS, INC.
Mineola, New York

Bibliographical Note

This Dover edition, first published in 2004, is a new compilation of all 166 plates from *Documents de ferronnerie ancienne de la seconde moitié du XVIIIᵉ siècle: Fin Louis XV & Louis XVI*, published by F. Contet, Paris, in 1908, and from the three volumes of *Documents de ferronnerie ancienne: Epoques Louis XV et Louis XVI*, also published by F. Contet: *2ᵉ série* in 1909; *Troisième série* in 1911; and *Quatrième série* in 1912. Captions have been newly translated from the French for this edition.

DOVER *Pictorial Archive* SERIES

Library of Congress Cataloging-in-Publication Data

Documents de ferronnerie ancienne de la seconde moitié du XVIIIe siècle. English.
 Masterpieces of eighteenth-century French ironwork : with over 300 illustrations / edited by F. Contet.
 p. cm.
 "This Dover edition . . . is a new compilation of all 166 plates from Documents de ferronnerie ancienne de la seconde moitié du XVIIIe siècle : fin Louis XV & XVI, published by F. Contet, Paris, in 1908, and from the three volumes of Documents de ferronnerie ancienne : époques Louis XV et Louis XVI, also published by F. Contet [1909-1912] Captions have been newly translated from the French"—
 ISBN 0-486-43404-4 (pbk.)
 1. Ironwork—France—History—18th century—Catalogs. 2. Decoration and ornament—France—History—18th century—Catalogs. I. Title: French ironwork. II. Contet, F. (Frédéric), b. 1873. III. Documents de ferronnerie ancienne. English. IV. Title

NK8249.D63 2004
739.4'0944'09033—dc22

 2004043826

Manufactured in the United States of America
Dover Publications, Inc., 31 East 2nd Street, Mineola, N.Y. 11501

CONTENTS

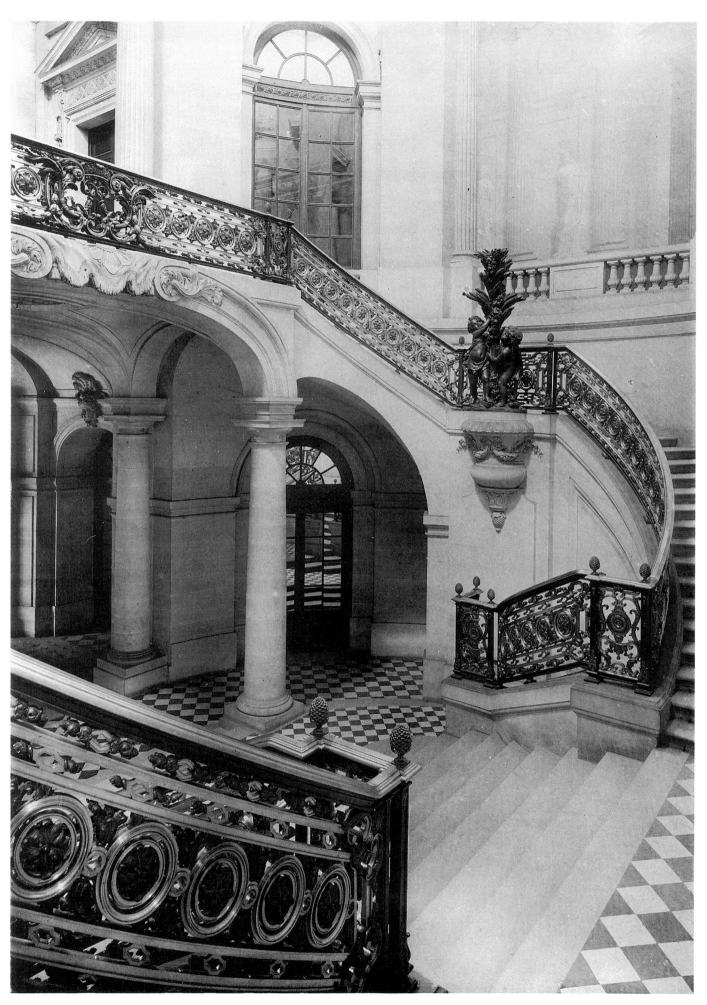

Paris. Perspective view of the grand staircase of the Royal Palace,
built in 1763 by Contant d'Ivry.

Plate 1

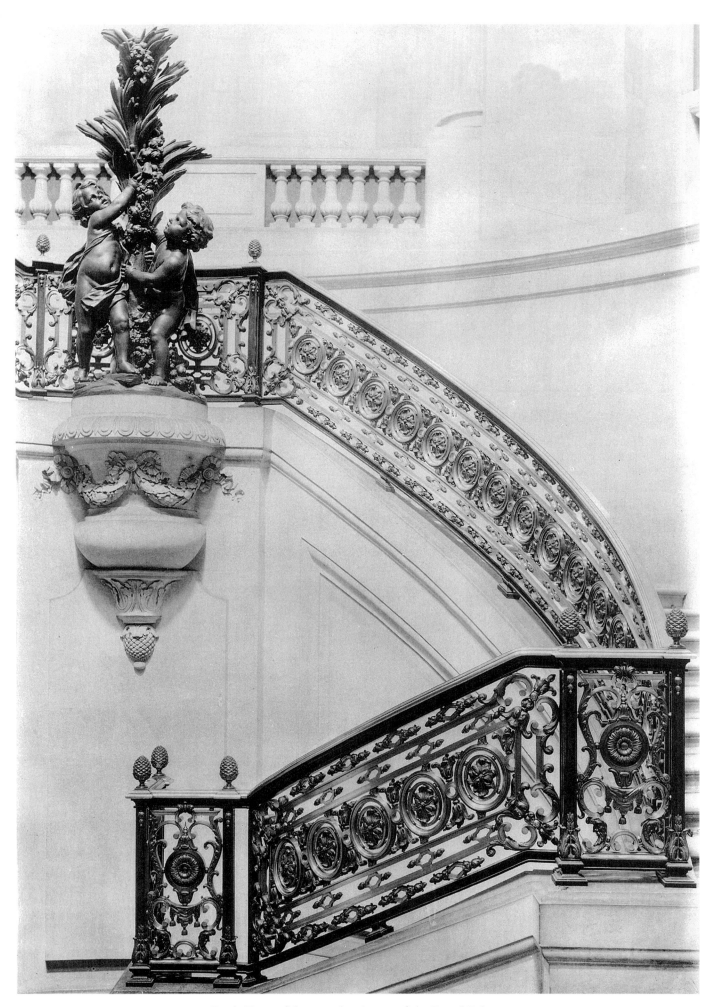

Paris. Foot of the grand staircase of the Royal Palace.

Plate 2

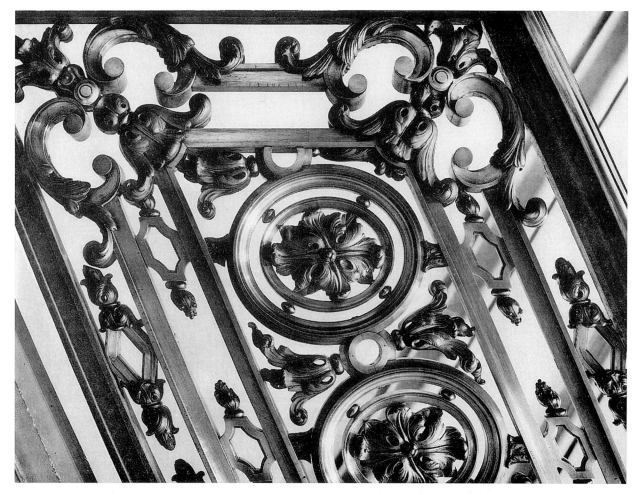

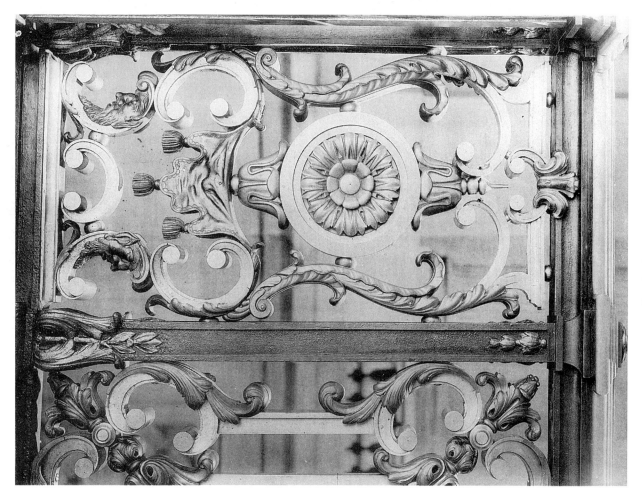

Paris. Grand staircase of the Royal Palace. Details of a small horizontal panel and of a large inclined panel.

Plate 3

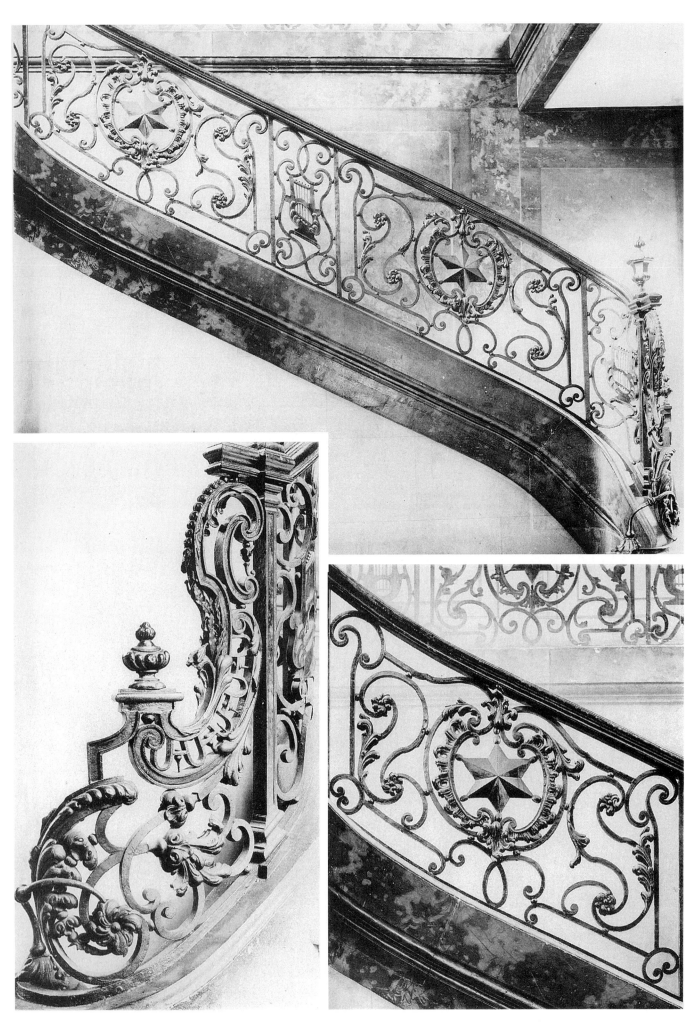

Paris. Brancas townhouse. Banister, foot of stairs, and detail of a panel.

Plate 4

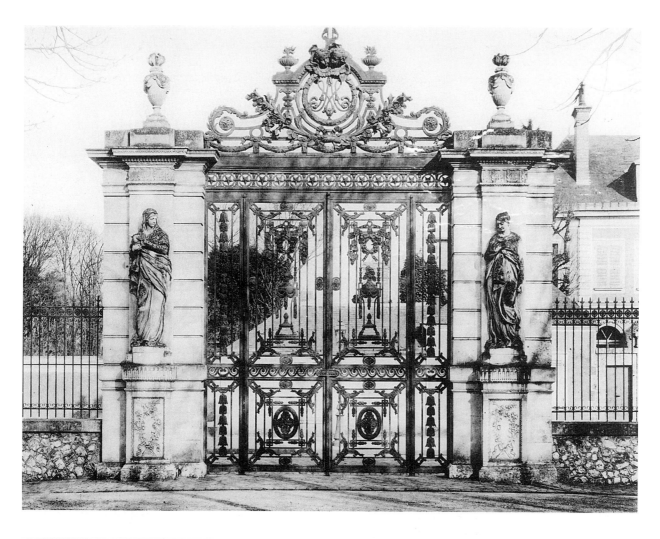

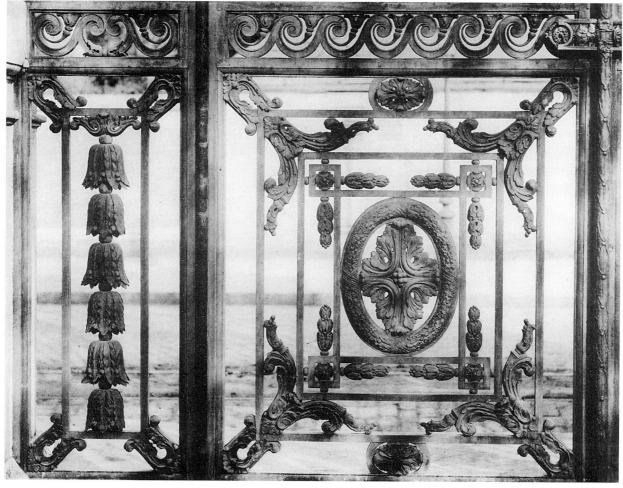

Chartres. Gate of Hôtel-Dieu—overall view and detail.

Plate 5

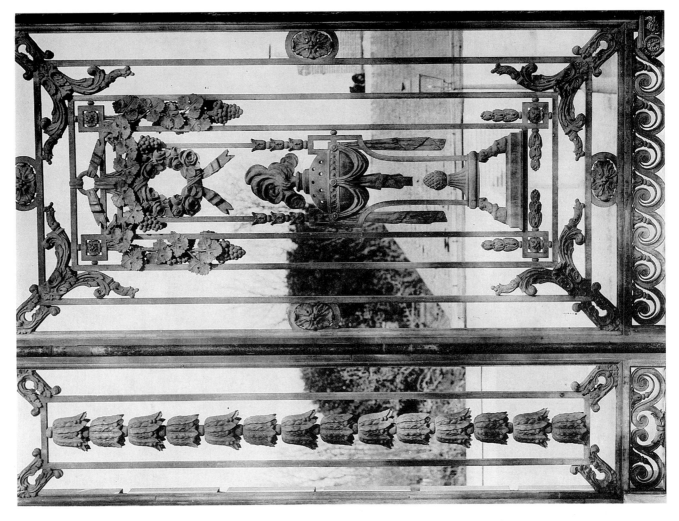

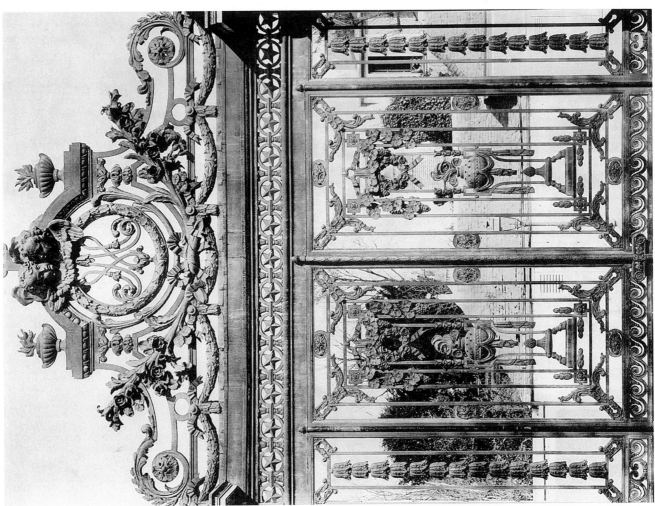

Chartres. Gate of Hôtel-Dieu, details.

Plate 6

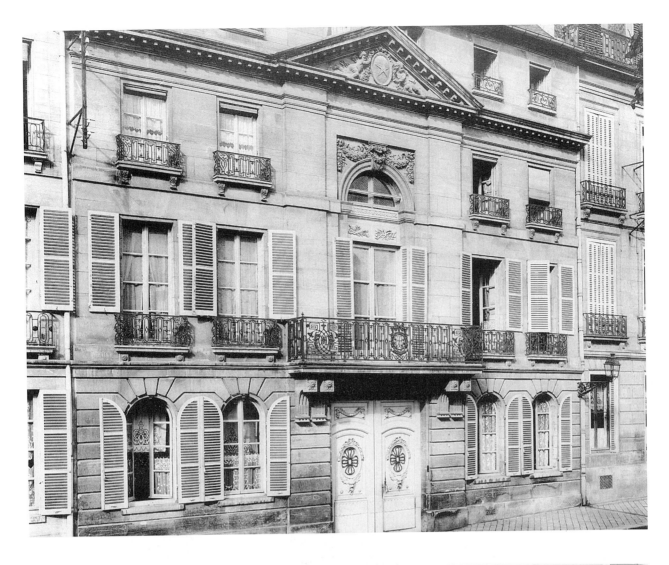

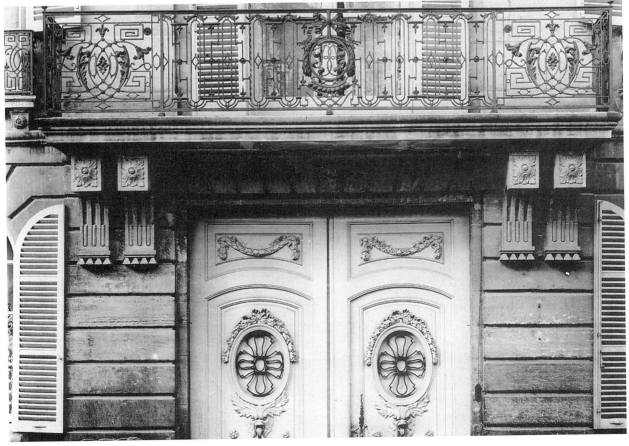

Versailles. Townhouse at 83 Avenue de Saint-Cloud.

Plate 7

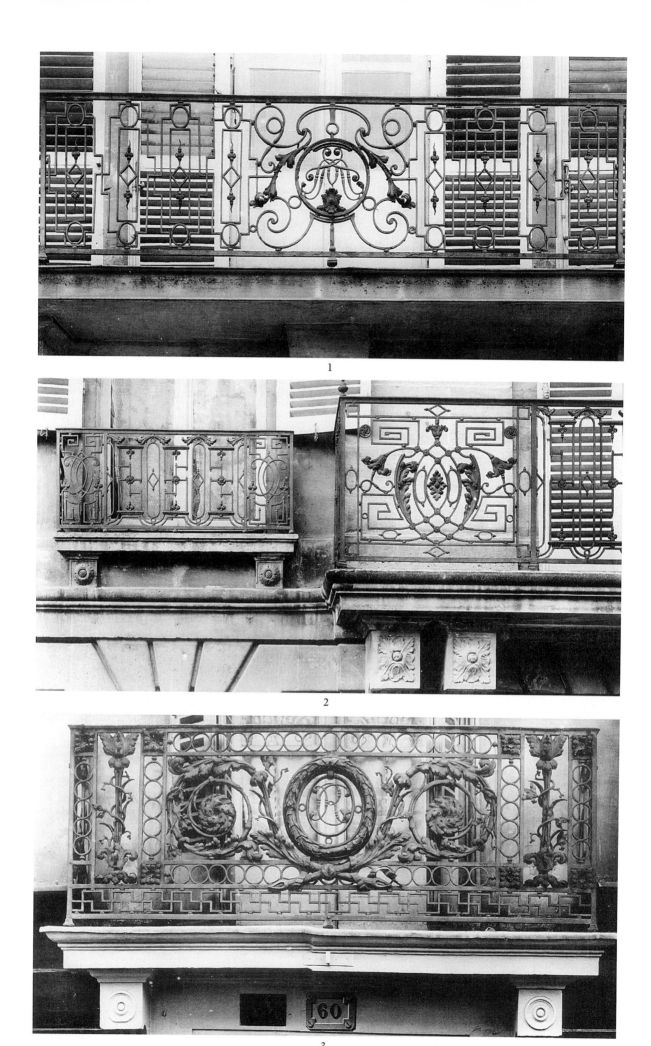

Versailles. **1.** Balcony at 5 Place Hoche. **2.** Balconies at 83 Avenue de Saint-Cloud.
3. Balcony at 60 Rue Royale.

Plate 8

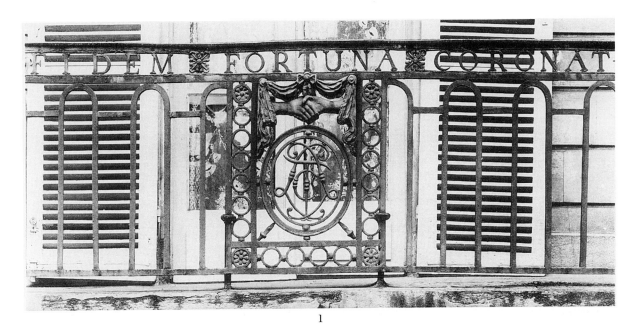

1

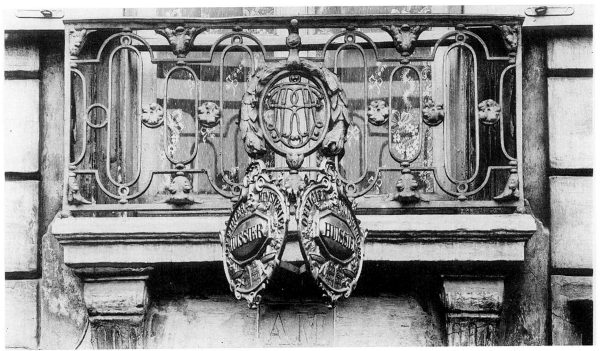

2

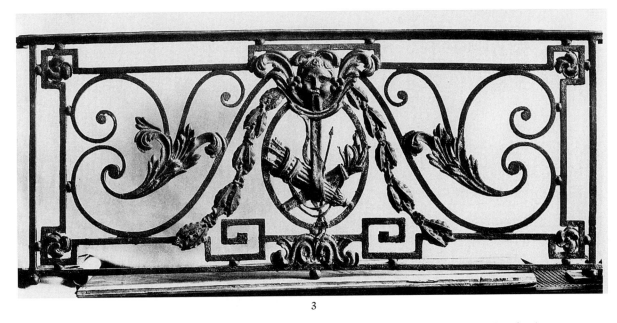

3

Versailles. **1.** Balcony at 65 Avenue de Saint-Cloud. **2.** Balcony at 41 Rue Duplessis.
Museum of Decorative Arts. **3.** Balcony (collection Le Secq des Tournelles).

Plate 9

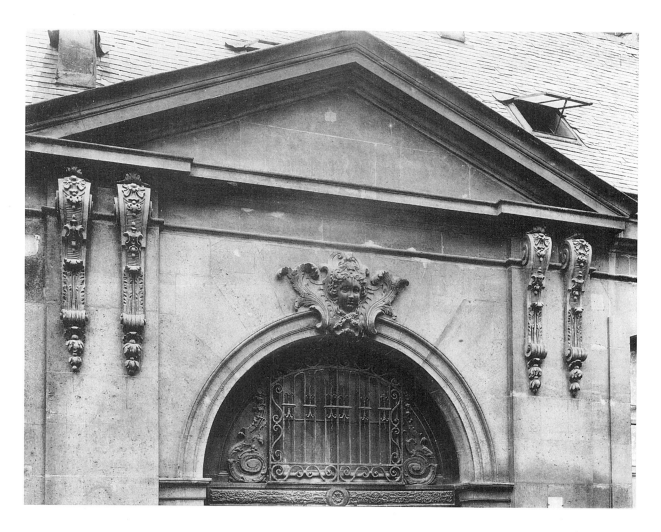

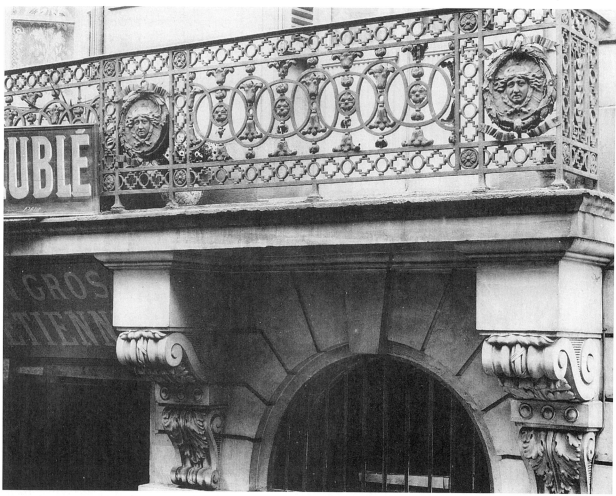

Paris. Door crest of the Beaune townhouse, 7 Rue du Regard.
Rouen. Balcony at 21 Rue aux Ours.

Plate 10

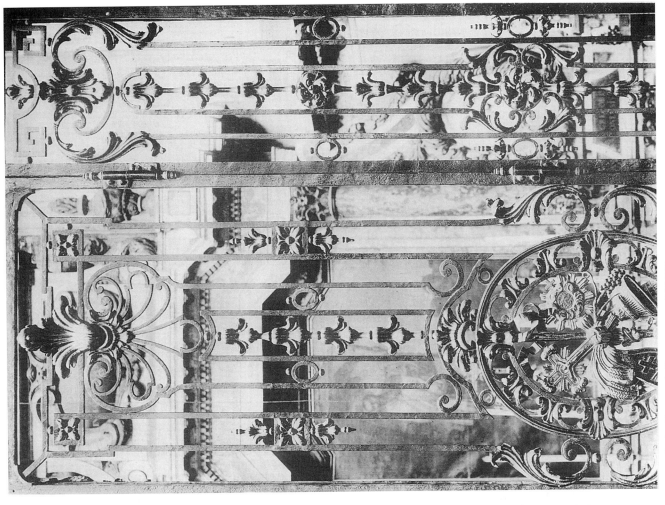

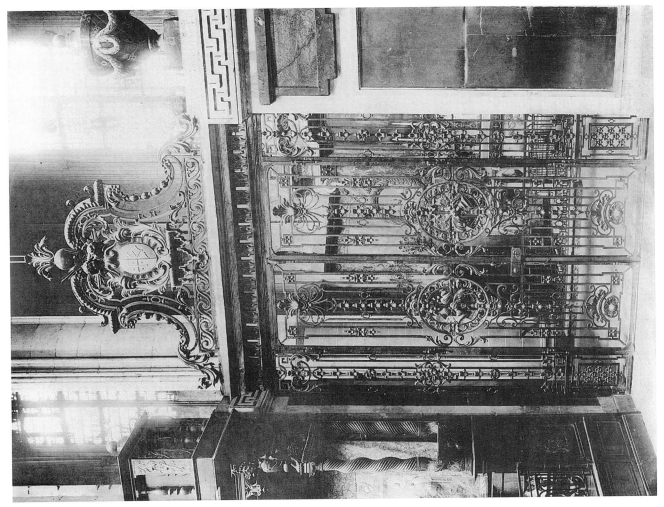

Toulouse. Choir gate at Saint-Etienne Cathedral, made by Bernard Ortet around 1767.

Plate 11

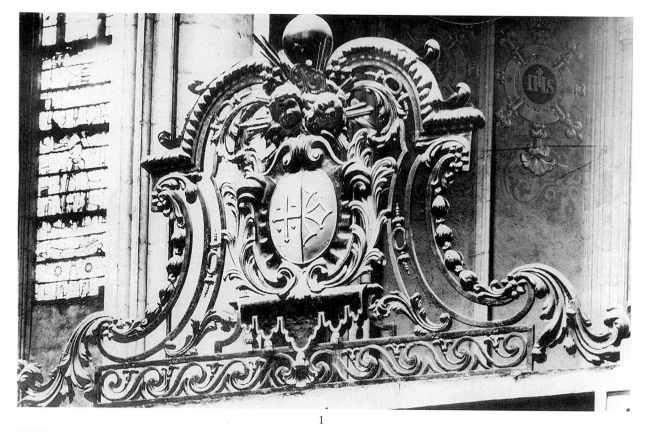

1

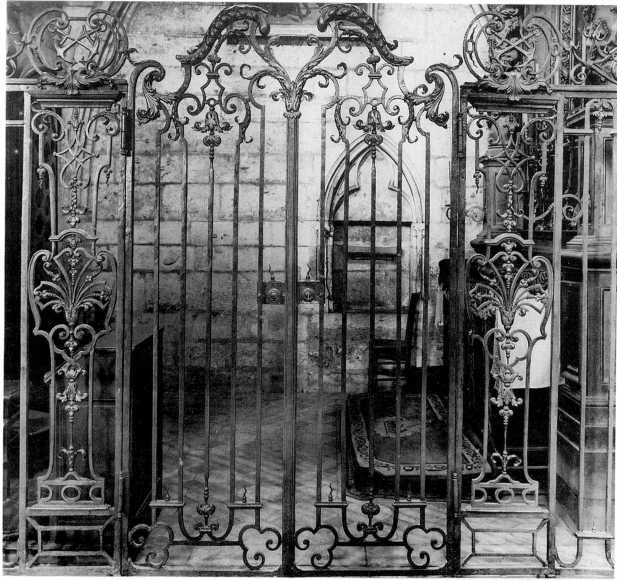

2

Toulouse. **1.** Detail of the pediment of Saint-Etienne Cathedral's choir gate.
Rouen. **2.** Chapel gate at Notre-Dame Cathedral.

Plate 12

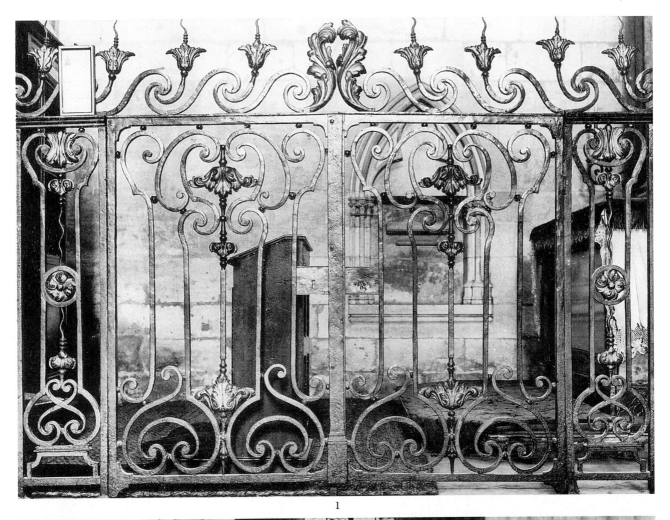

1

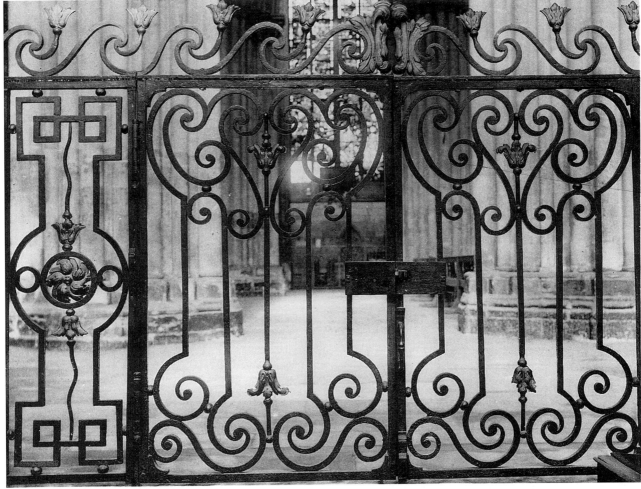

2

Rouen. **1** and **2.** Chapel gates at Notre-Dame Cathedral.

Plate 13

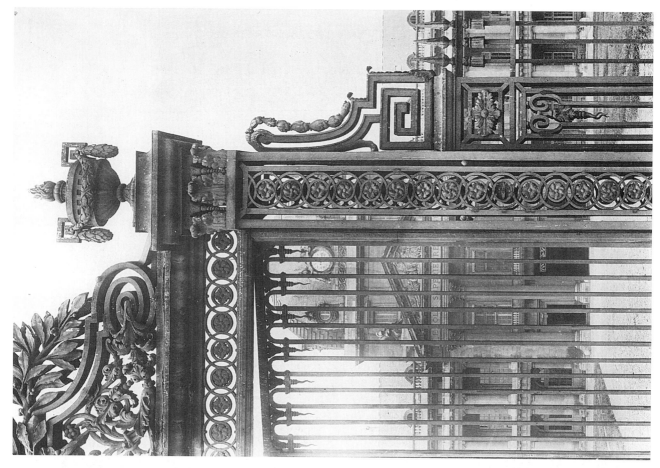

Paris. Detail of the main gate of the Ecole Militaire.

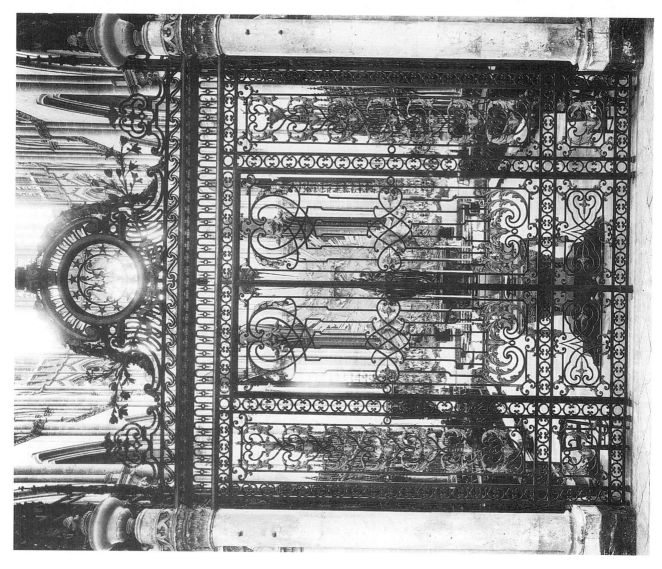

Amiens. Choir gate of the cathedral.

Plate 14

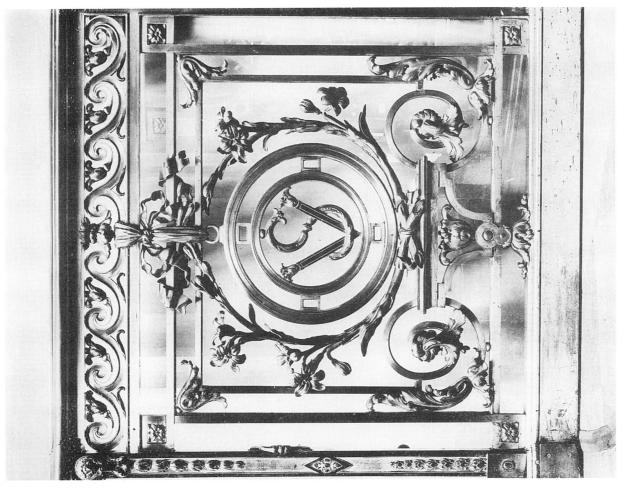

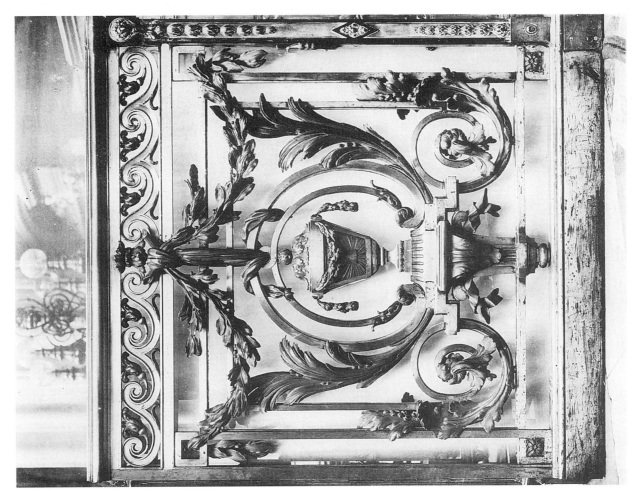

Paris. Church of St-Germain l'Auxerrois. Chest-high gates, made of polished iron and gilded bronze, surrounding the choir.

Plate 15

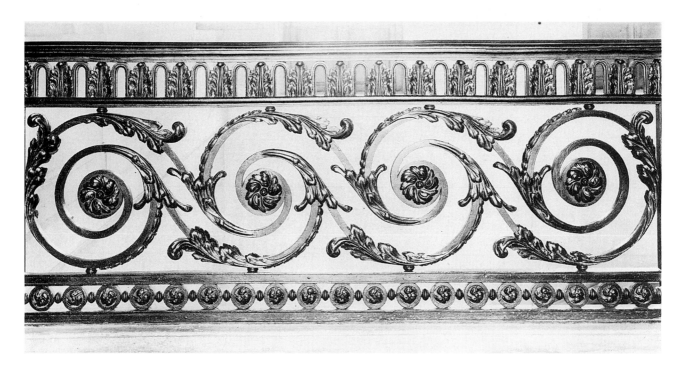

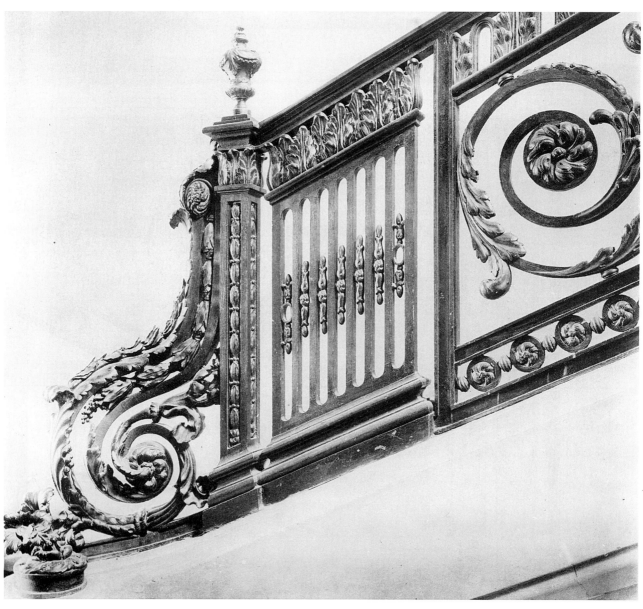

Paris. Main staircase of the Ecole Militaire. A horizontal panel
and the beginning of the stairs.

Plate 16

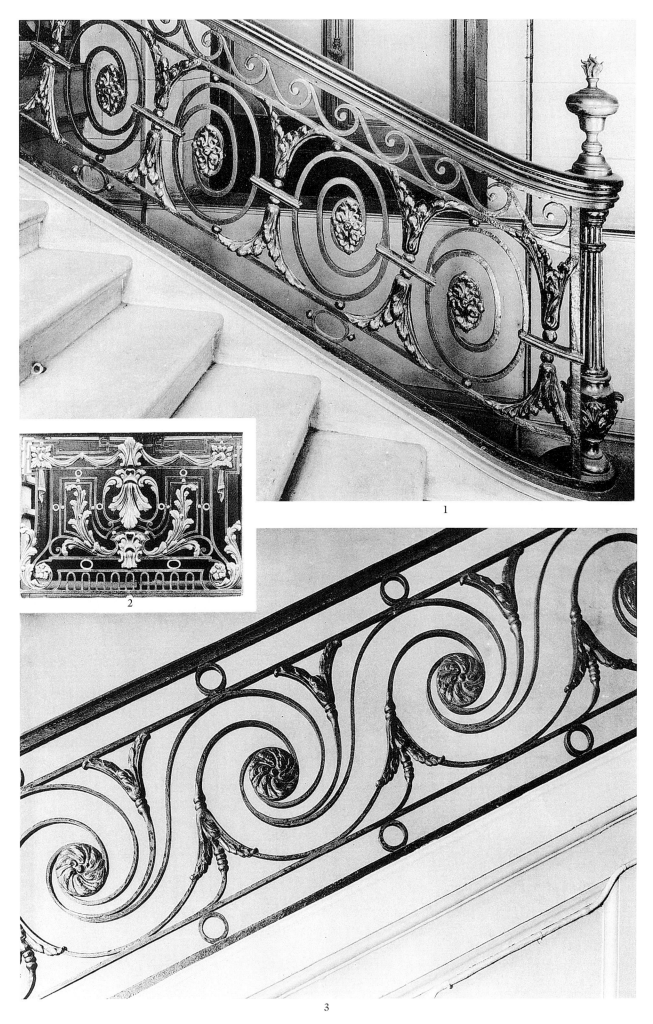

Bordeaux. **1.** Piganeau townhouse, beginning of banister.
Toulouse. **2.** Balcony executed by Ortet. *Paris.* **3.** Grammont townhouse, banister.

Plate 17

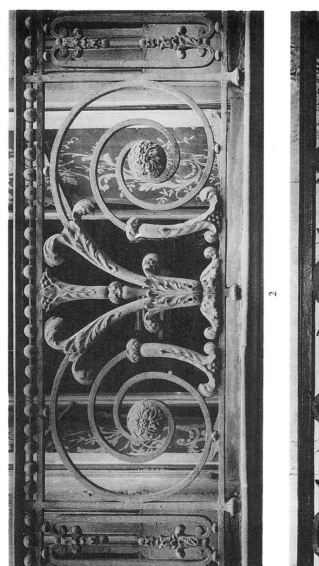

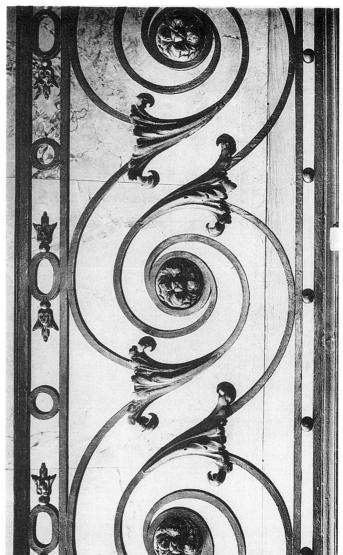

2

3

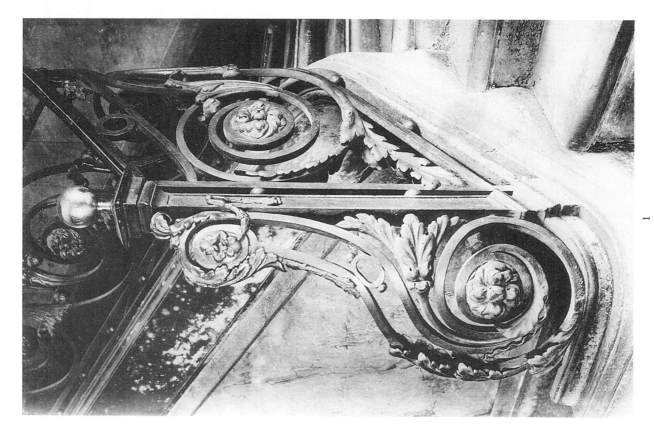

1

Paris. Sully-Charost townhouse: **1**. Foot of stairs. **2**. Balcony. **3**. Banister detail.

Plate 18

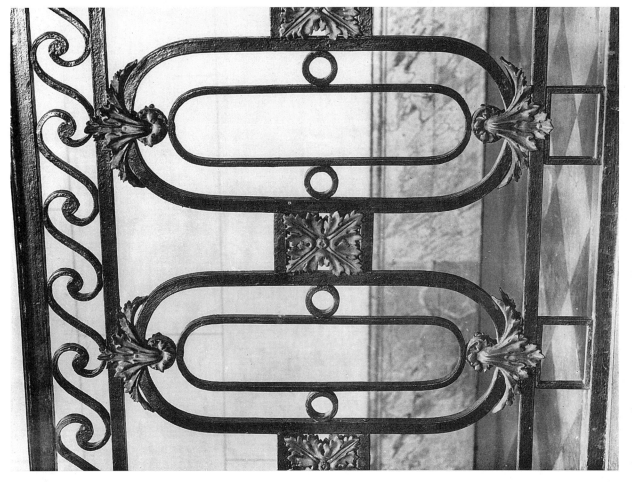

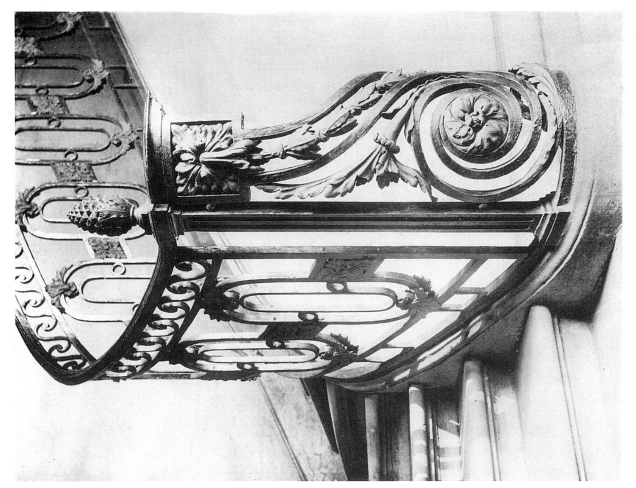

Paris. Foot of stairs and banister detail from an eighteenth-century townhouse at 58 Rue du Faubourg Poissonniére.

Plate 19

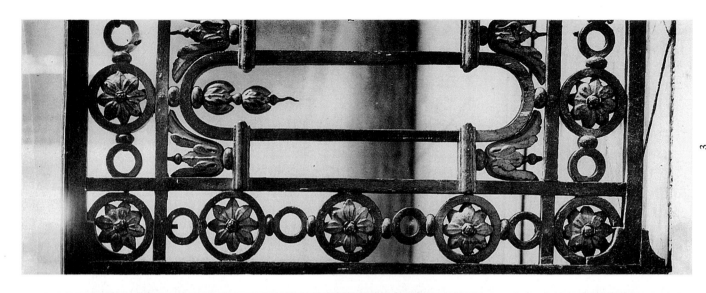

3

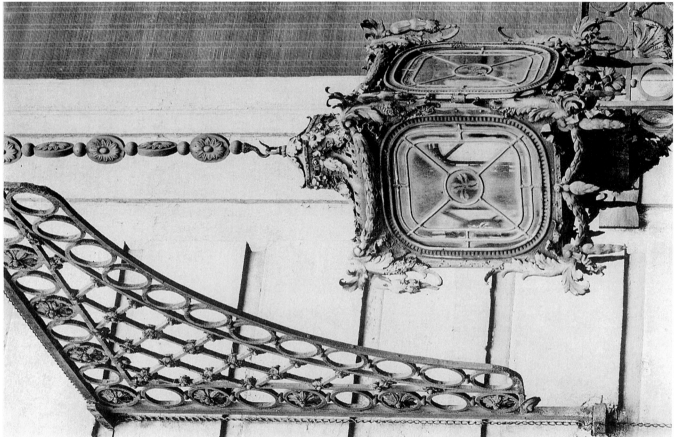

Rouen. **1** and **3.** Details of the chest-high gate at the choir entry, Notre Dame Cathedral.
2. Lantern in the courtyard of an old townhouse.

2

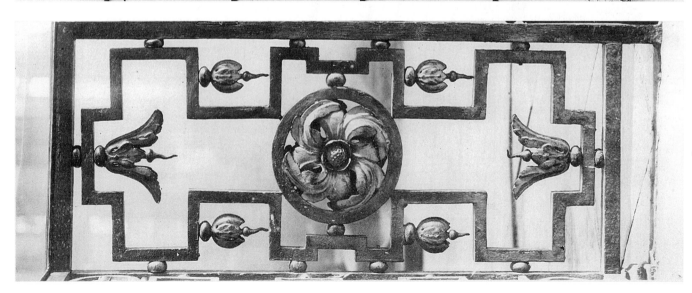

1

Plate 20

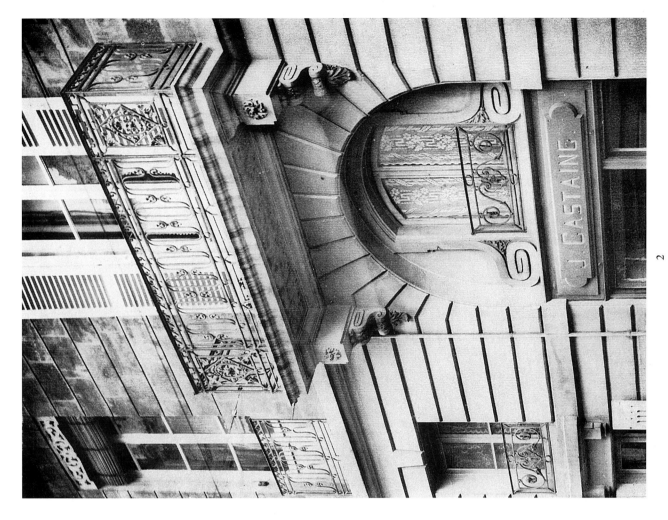

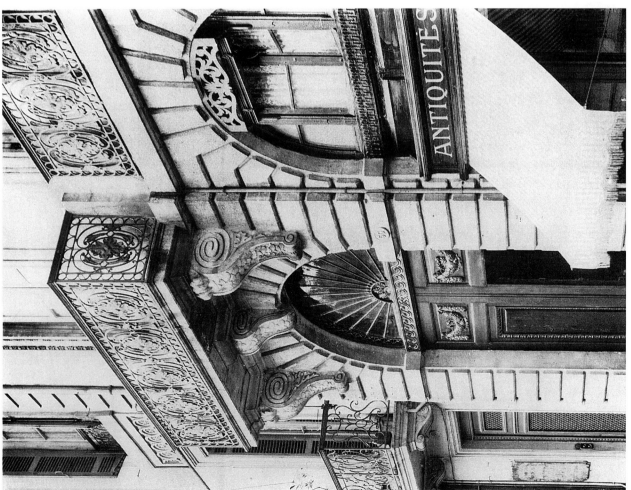

Bordeaux. 1. Balcony of the Maison de Brivazac, 55 Cours Tourny. 2. Balcony in the Rue Rolland.

Plate 21

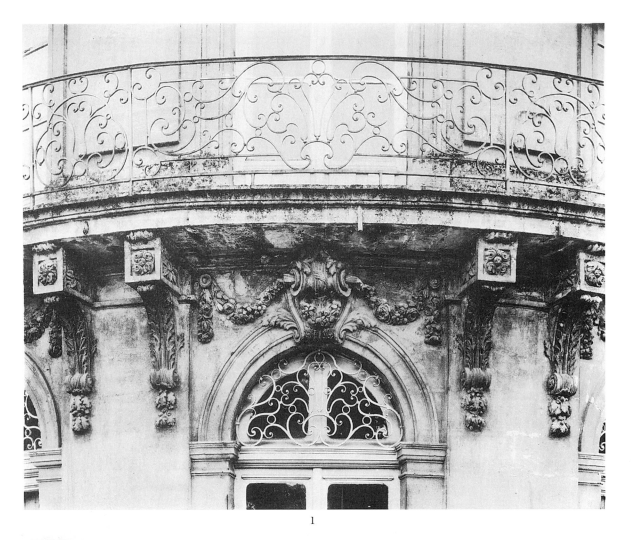

1

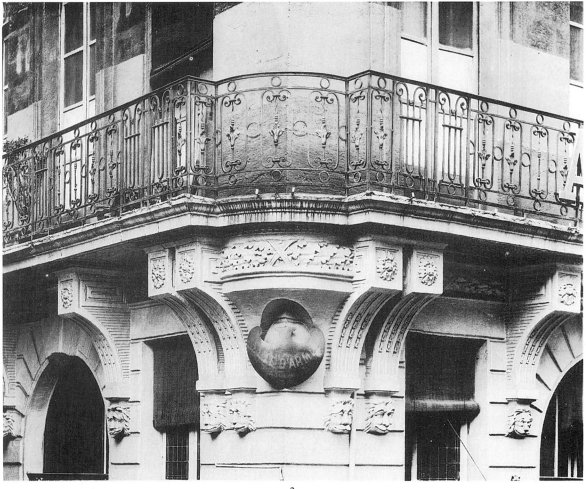

2

Bordeaux. **1.** Balcony of the Labottière brothers' former country house,
built by Laclotte between 1775 and 1780. **2.** Balcony at 48 Cours du Chapeau-Rouge.

Plate 22

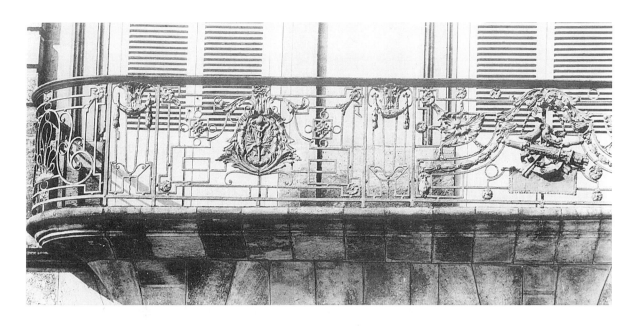

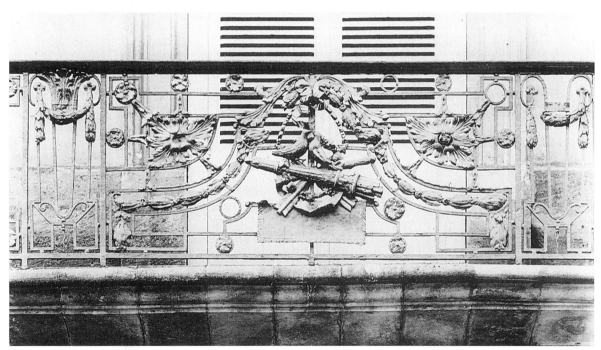

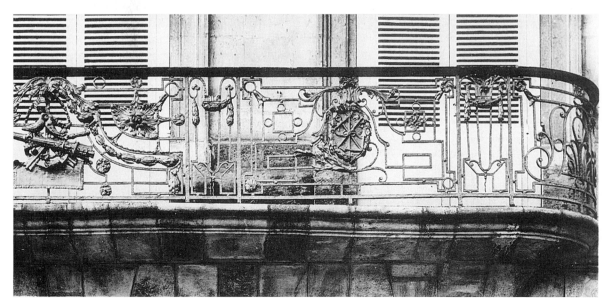

Bordeaux. Different motifs on a balcony at 45 Cours du Pavé des Chartrons.

Plate 23

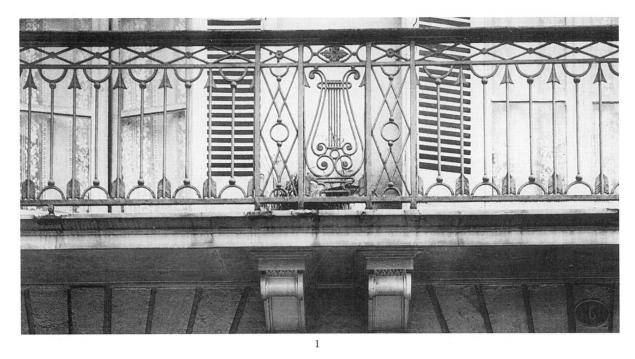

1

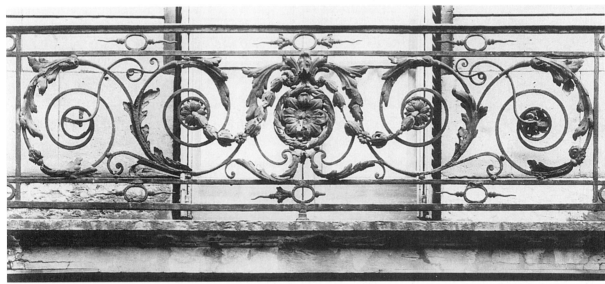

2

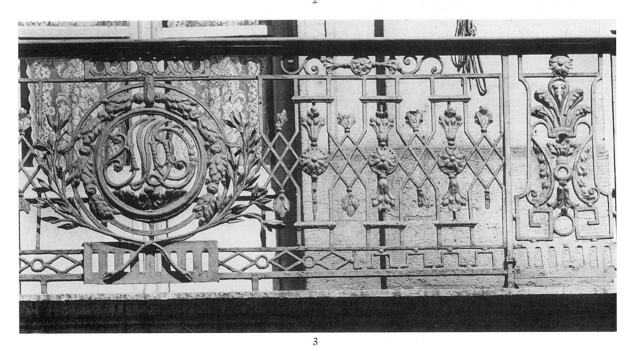

3

Bordeaux. **1.** Balcony in the Cours Tourney. **3.** Balcony in the Rue des Ayres.
Rouen. **2.** Balcony at 26 Rue de Crosne.

Plate 24

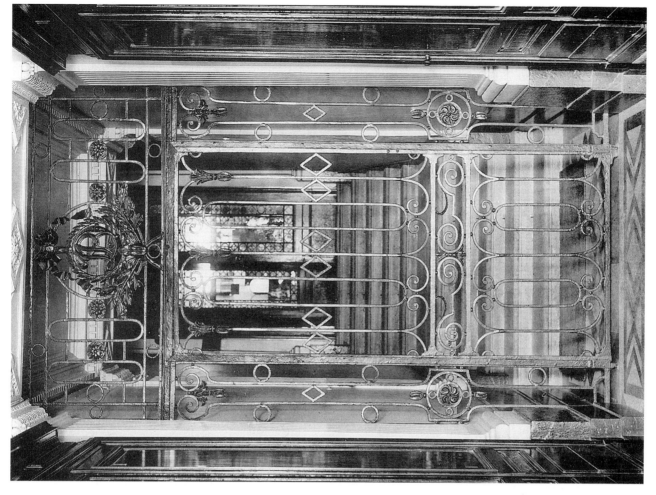

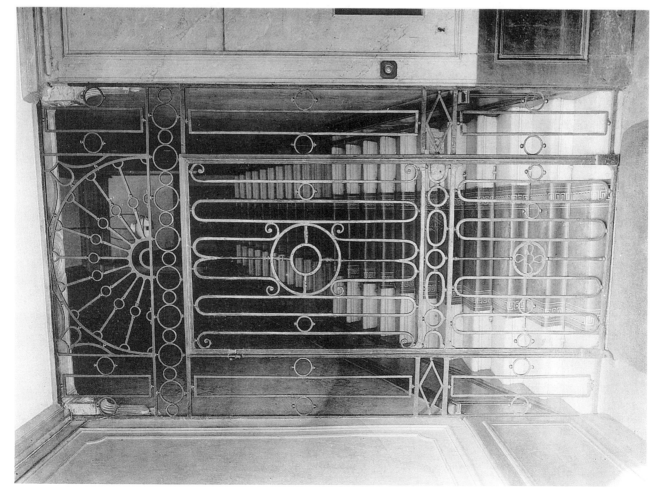

Bordeaux. Vestibule gates at 3 and 22 Cours du Chapeau-Rouge.

Plate 25

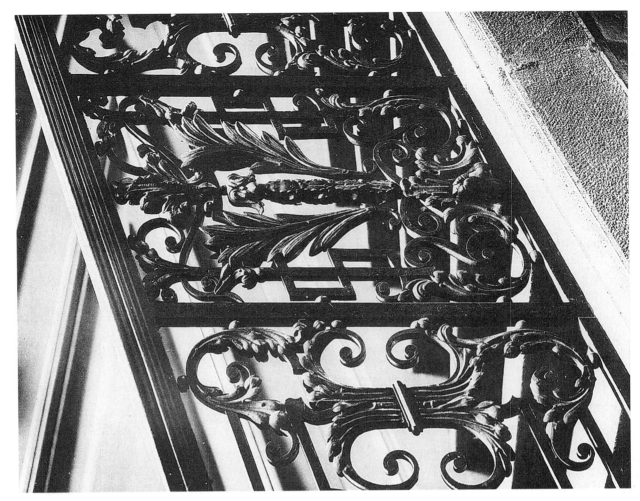

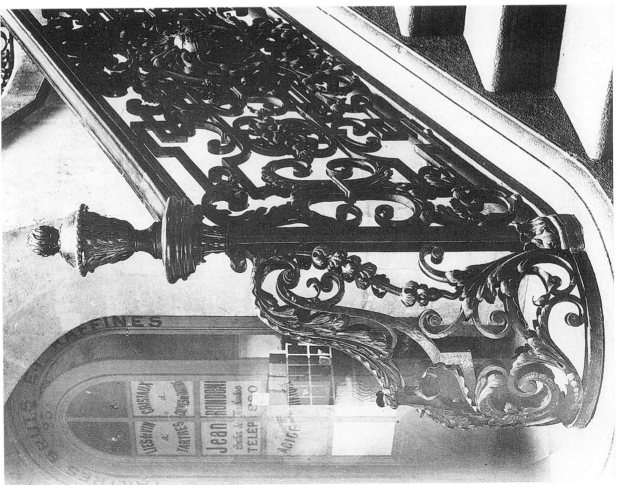

Bordeaux. Bourse townhouse: foot of staircase and detail of banister.

Plate 26

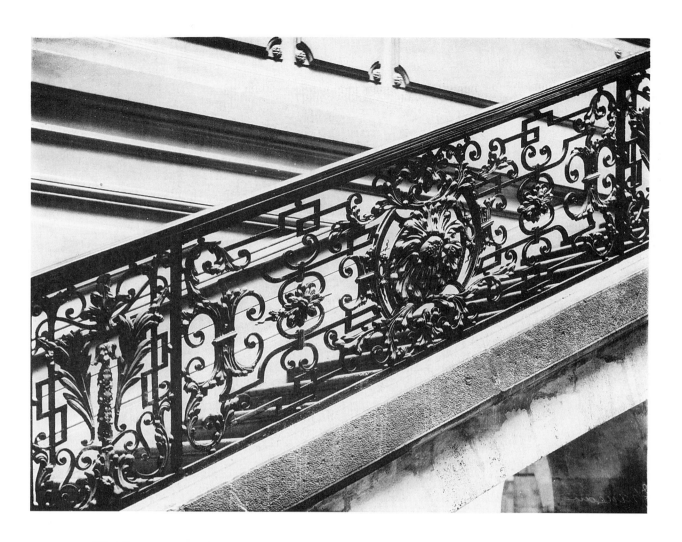

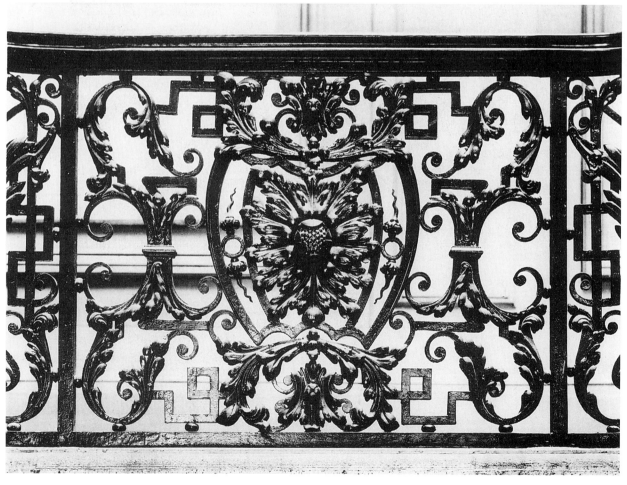

Bordeaux. Bourse townhouse: details of a large inclined panel and a small horizontal panel.

Plate 27

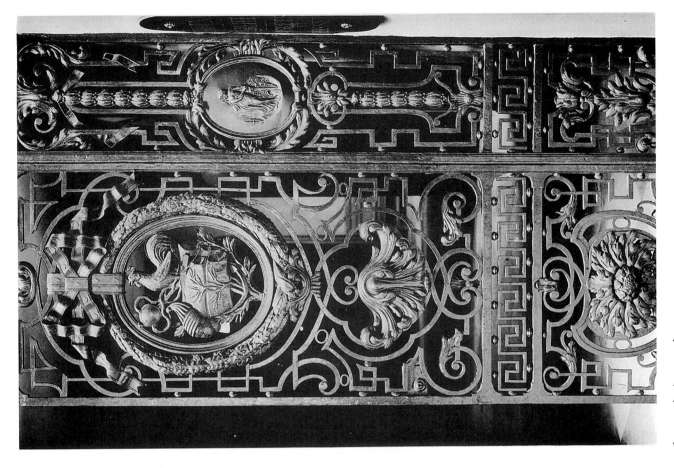

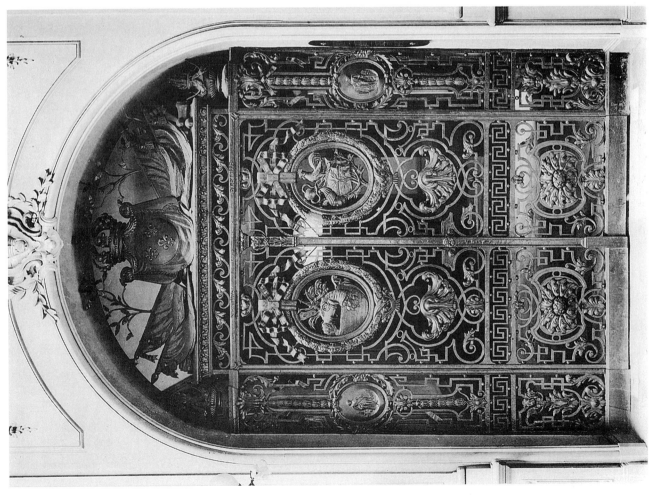

Bordeaux. Bourse townhouse: inside door of wrought iron and spun copper, signed by Dumaine in 1773, restored by Faget in 1855.

Plate 28

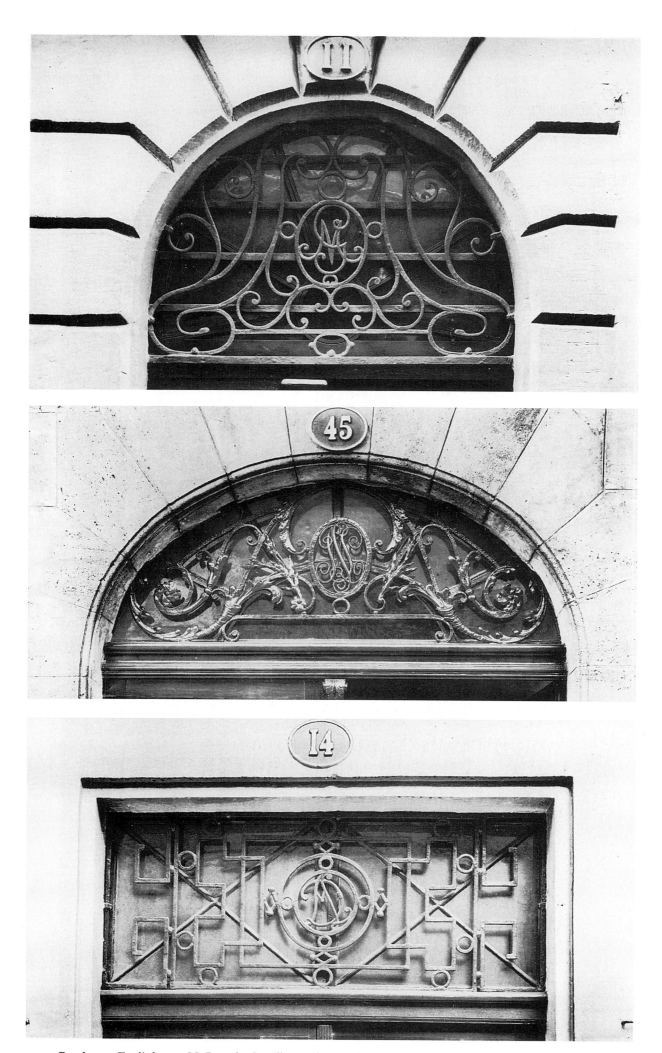

Bordeaux. Fanlights at 11 Rue de Castillon, 45 Pavé des Chartrons, and 14 Rue du Palais-Gallien.

Plate 29

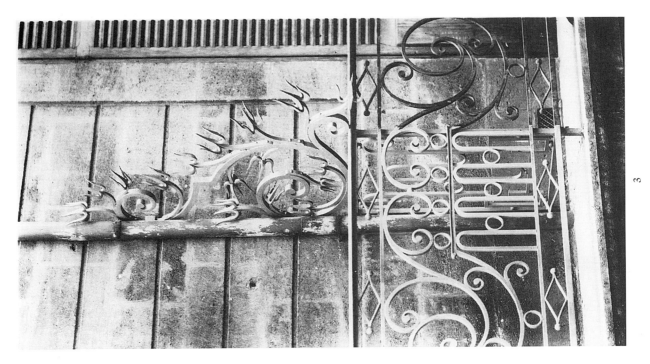

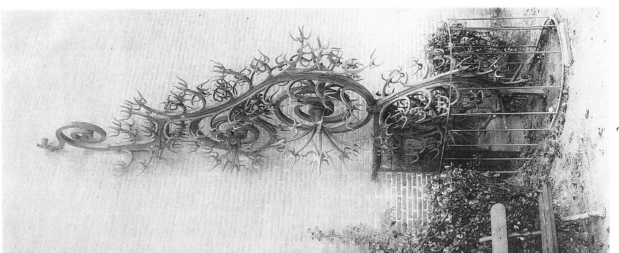

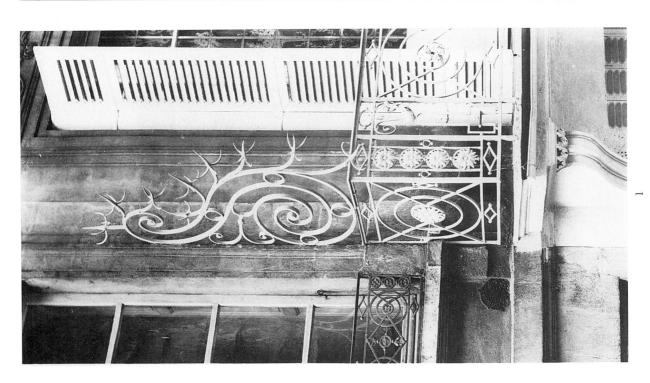

Bordeaux. **1.** Balcony and spike clusters, 15 Rue Castillon. **3.** Balcony and spike clusters, 53 Rue Hugerie. *Toulouse.* **2.** Spike clusters executed by Joseph Bosc—from the Cours Dillon, but now in the garden of the St-Raymond collegiate church.

Plate 30

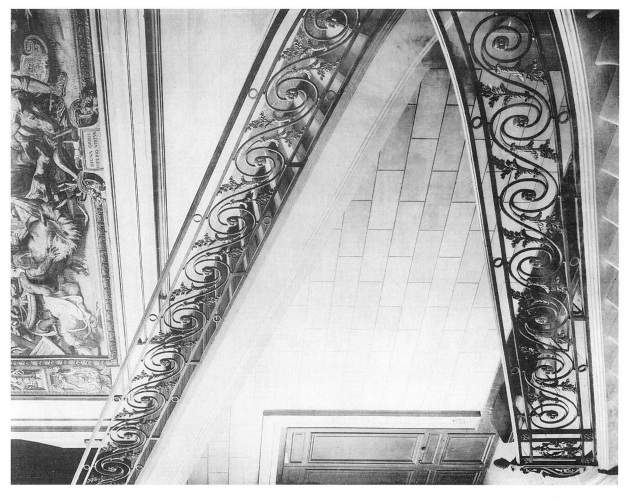

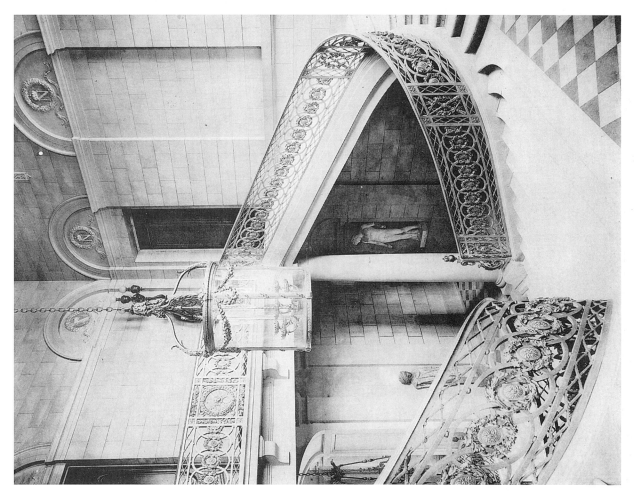

Compiègne Palace. Overall views of the grand staircase and the Apollo staircase.

Plate 31

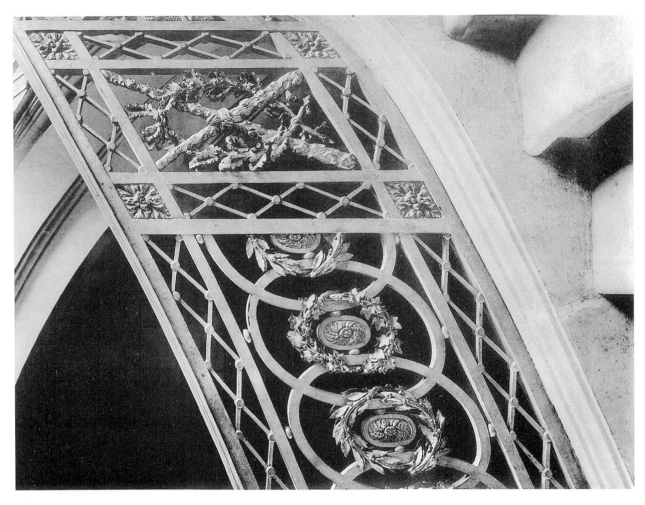

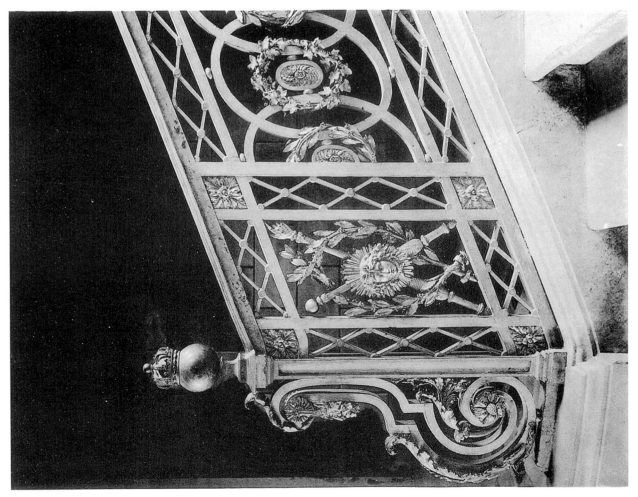

Compiègne Palace. Grand staircase: foot of the stairs and detail.

Plate 32

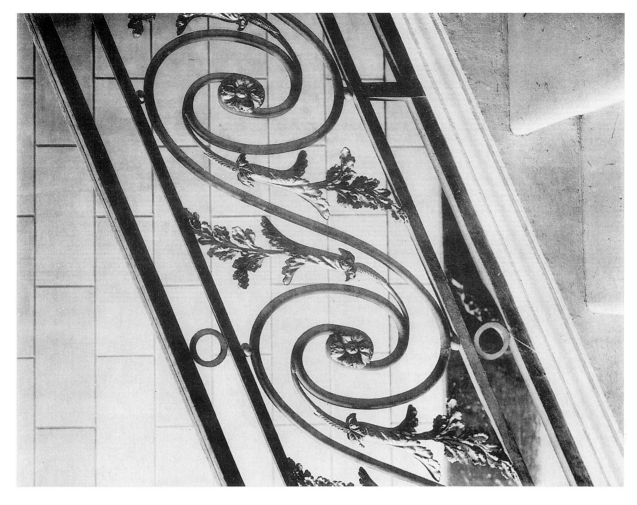

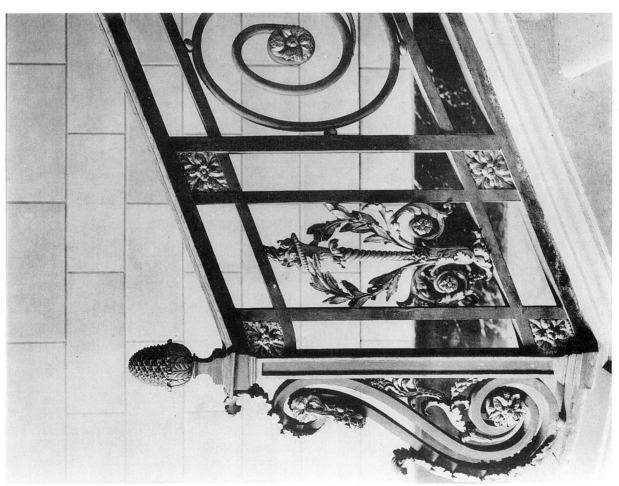

Compiègne Palace. Apollo staircase: foot of the stairs and detail.

Plate 33

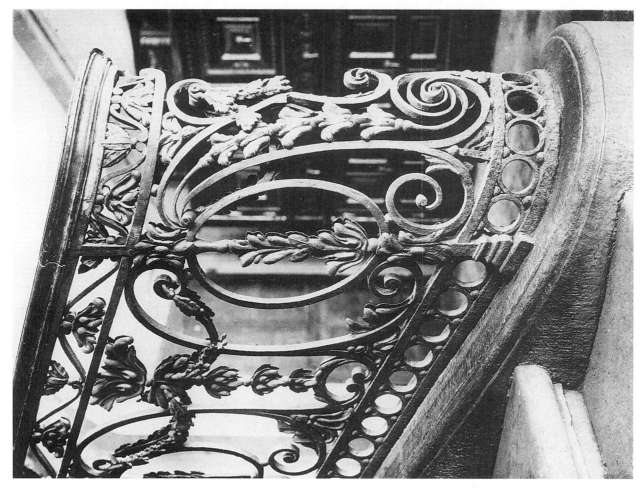

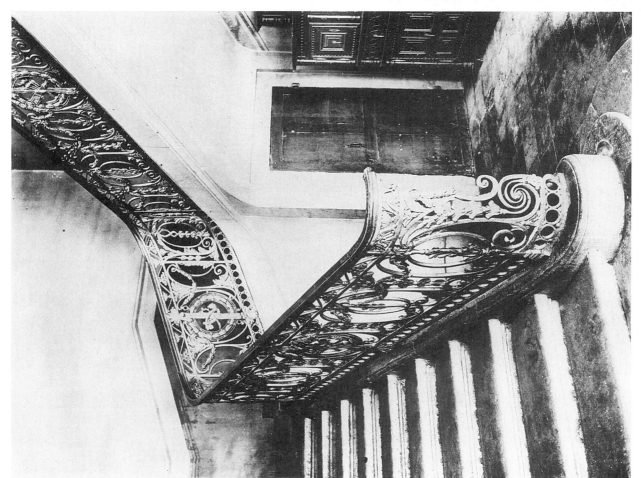

Toulouse. Dassier townhouse: banister executed by Joseph Bosc, ironsmith, around 1780.

Plate 34

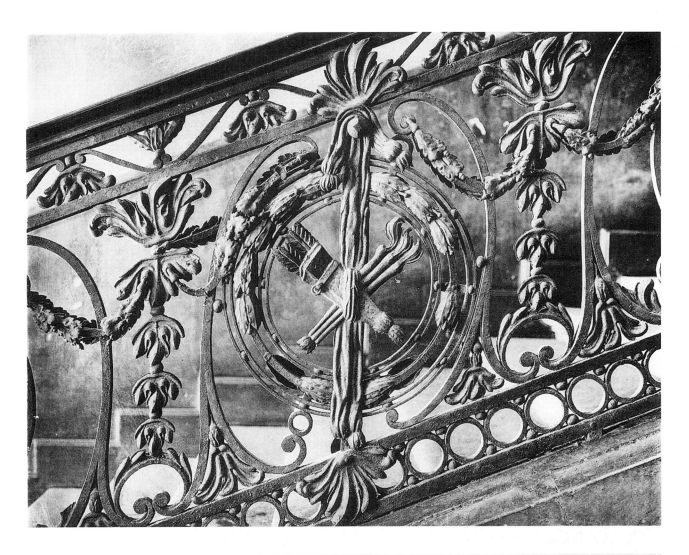

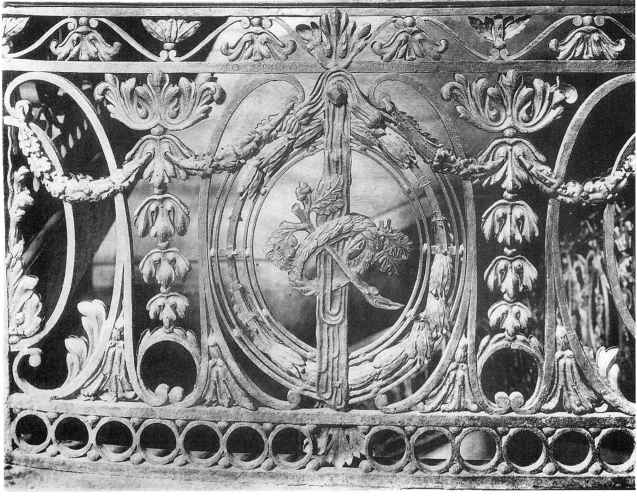

Toulouse. Dassier townhouse: banister motifs bearing the mark: JOSEPH·BOSC·FECIT.

Plate 35

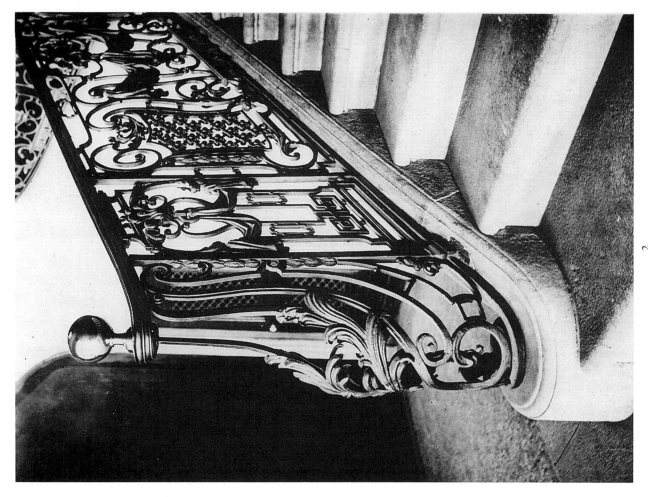

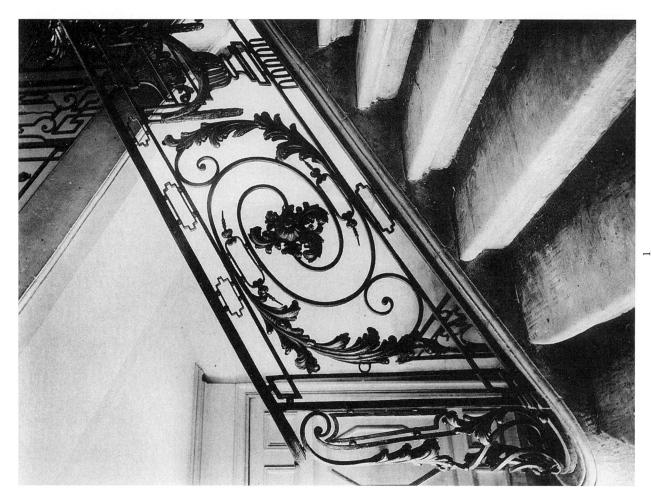

Toulouse. 1. Banister executed by Bosc on the Place Ste-Scarbes. 2. Banister at 10 Rue Croix-Baragnon, executed by Ortet.

1

2

Plate 36

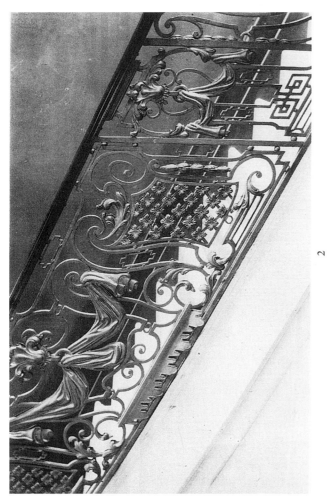

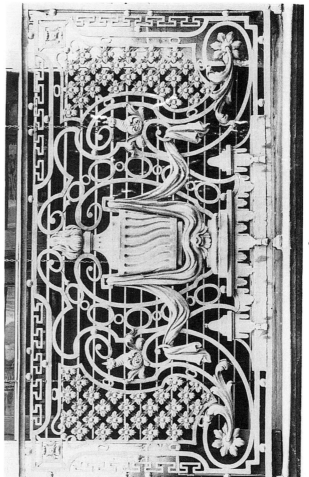

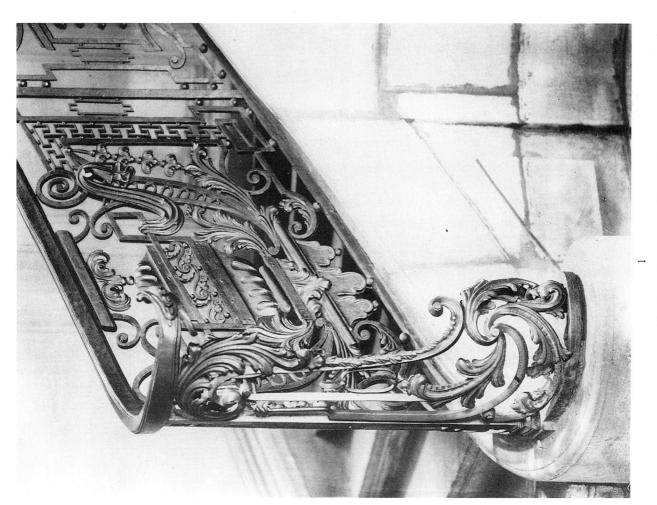

2

3

1

Toulouse. 1. Puymaurin townhouse, 27 Rue du Vieux-Raisin: foot of banister executed by Joseph Bosc around 1770. 2 and 3. Campaigno townhouse, 10 Rue Croix-Baragnon: banister and balcony executed by Ortet.

Plate 37

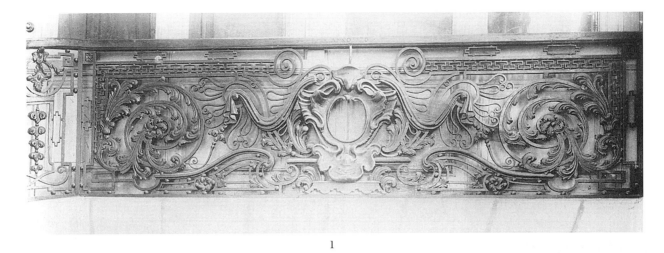

1

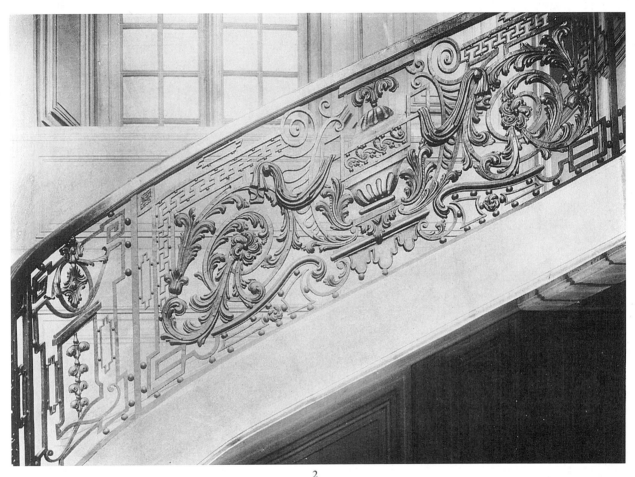

2

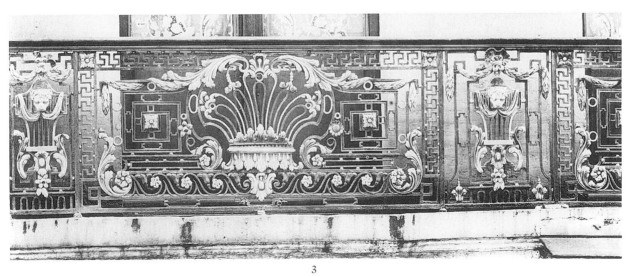

3

Toulouse. **1** and **2.** Puymaurin townhouse: balcony and banister executed by Joseph Bosc, ironsmith, around 1770.
3. Puivert townhouse: balcony with thrice-repeated design, executed by Bernard Ortet around 1771.

Plate 38

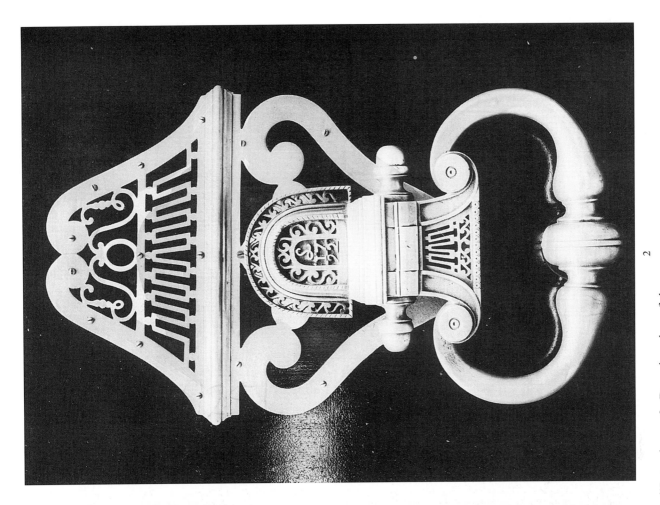

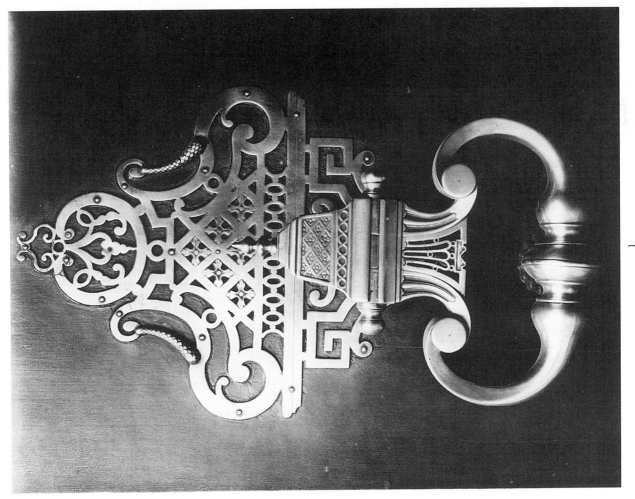

Bordeaux. **1.** Door knocker on Cours de l'Intendance. **2.** Door knocker of the Pinchon-Longueville townhouse on Rue Poquelin-Molière.

Plate 39

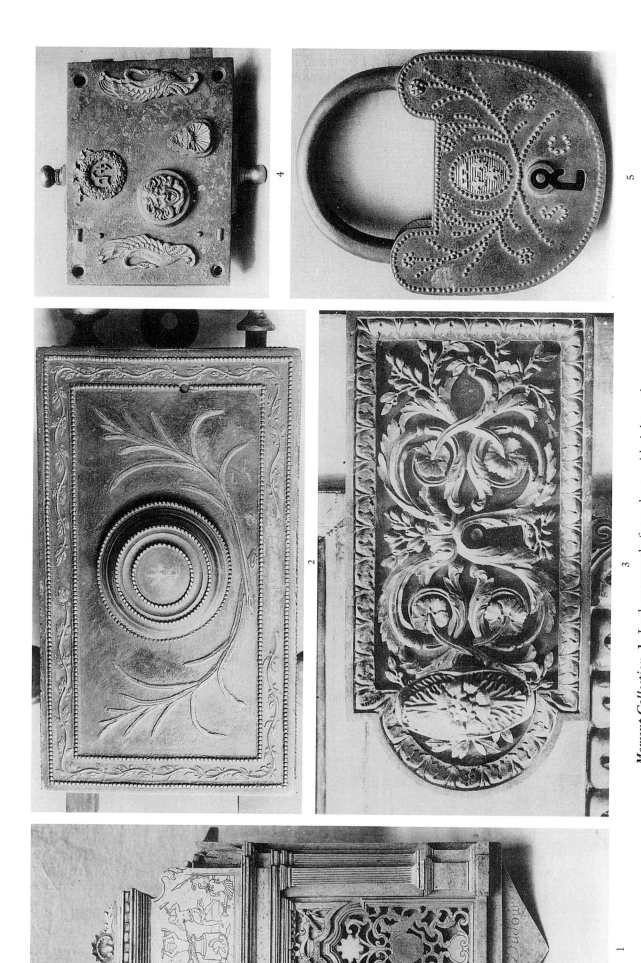

Morsent Collection. **1.** Lock apparently for a chest, mid-eighteenth century.
2 and **3.** Locks from the time of Louis XVI. **4.** Safety lock made for Napoleon's room at Saint-Cloud.
5. Large padlock from the gate of the Castle of Saint-Cloud (eighteenth century).

Plate 40

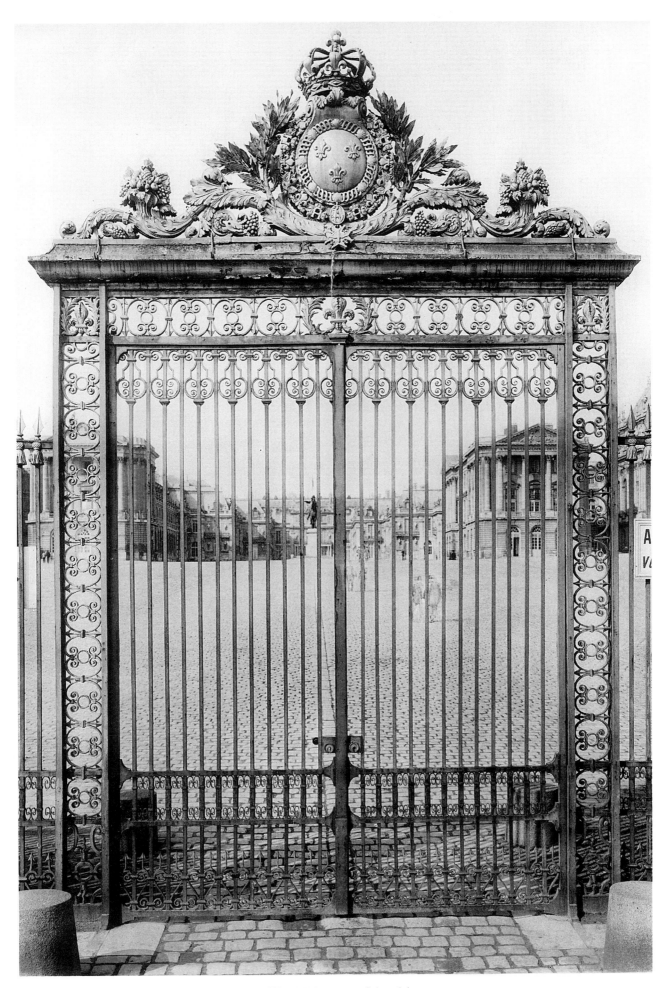

Versailles. Main gate of the château.

Plate 41

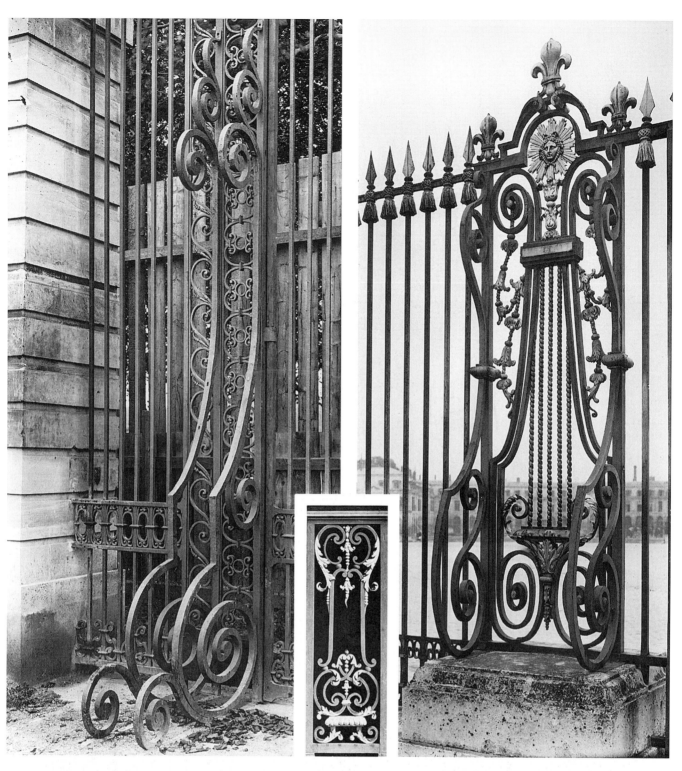

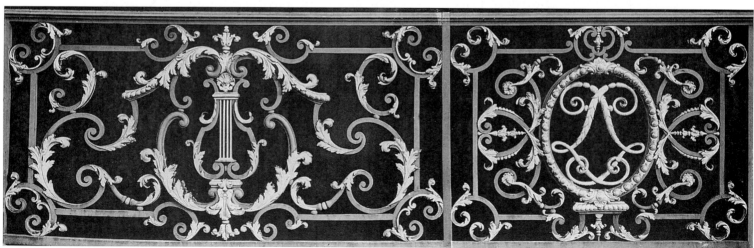

Versailles. Top left: buttresses for the gate to the king's kitchen garden. Top right: pier and buttresses for the main gate. Middle and bottom: balcony of the dauphin's office (1747).

Plate 42

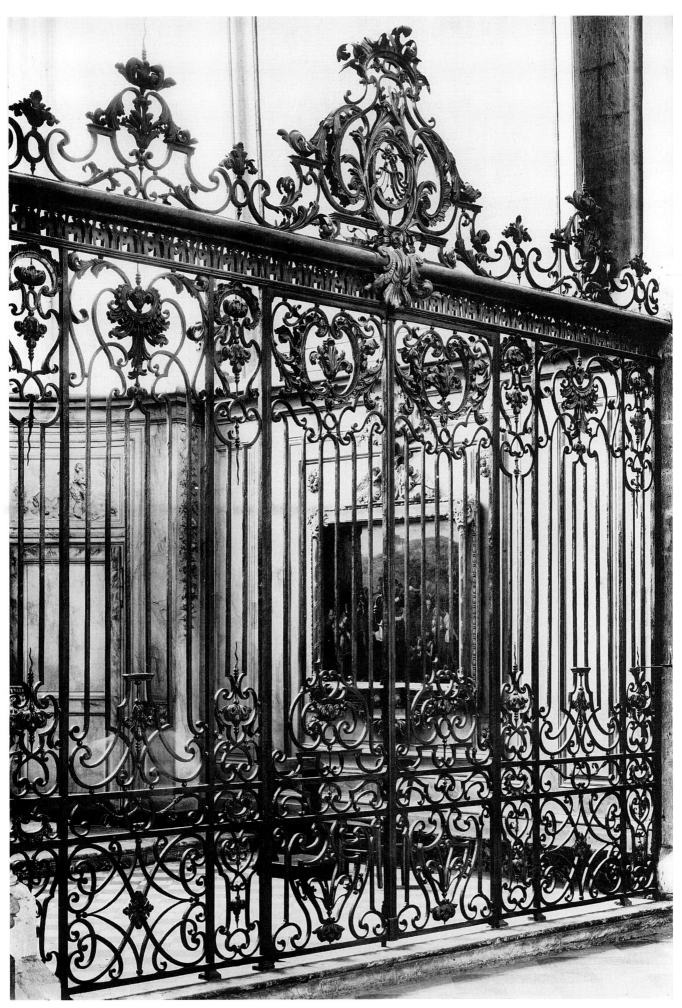

Amiens. Notre-Dame Cathedral. Grillwork of the chapel dedicated to
Saint Firmin (side aisle to the left of the nave).

Plate 61

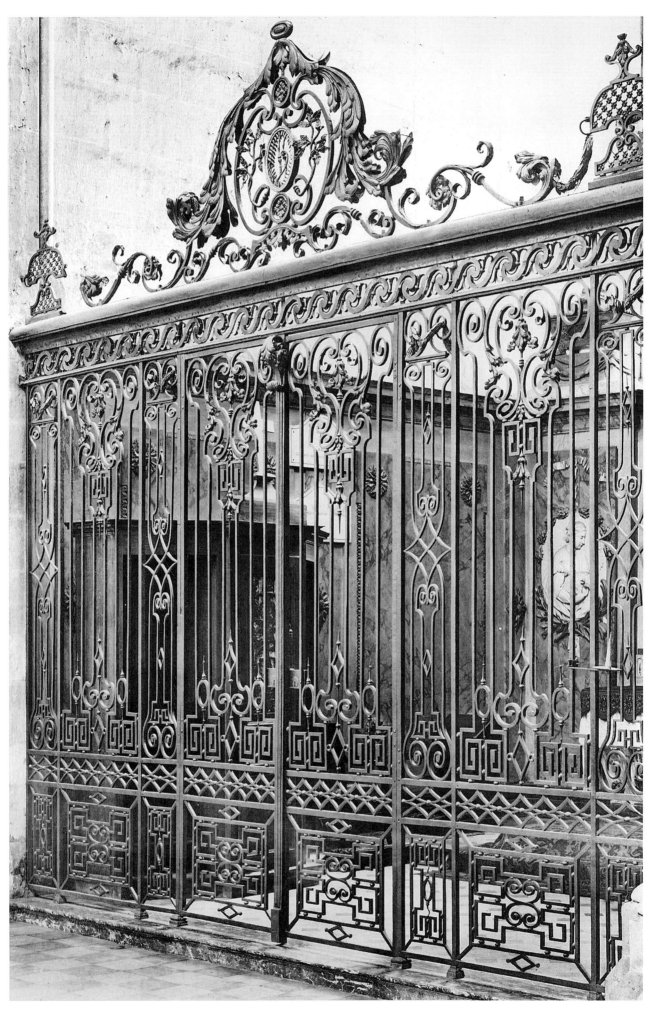

Amiens. Notre-Dame Cathedral. Grillwork of the chapel dedicated to
Our Lady of Good Help, executed around 1769 (side aisle to the left of the nave).

Plate 62

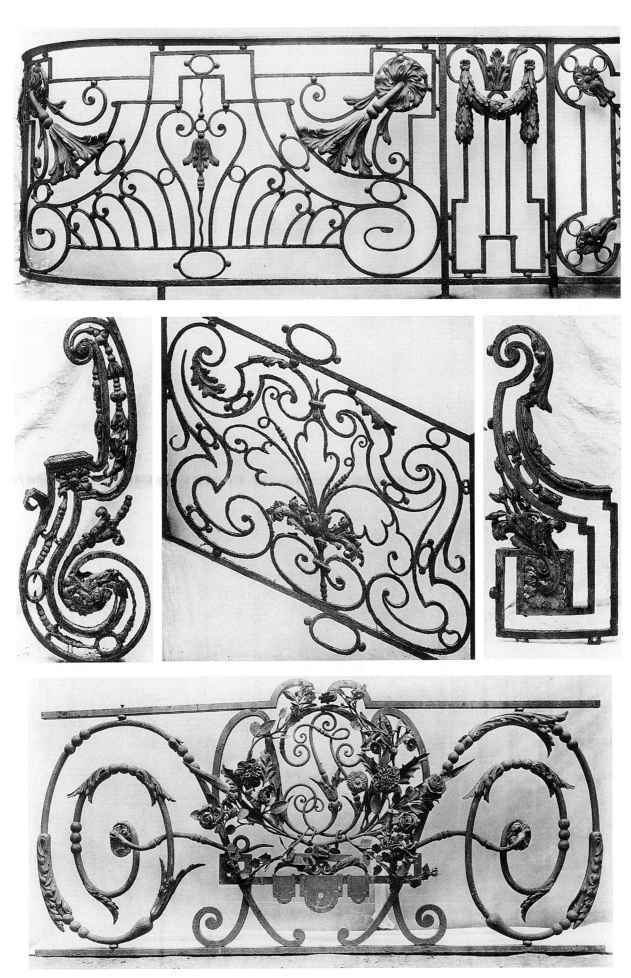

Collection of M. Lemeune, Parisian art metalworker. Balcony, banisters,
and newel posts, styles of Louis XV and Louis XVI.

Plate 63

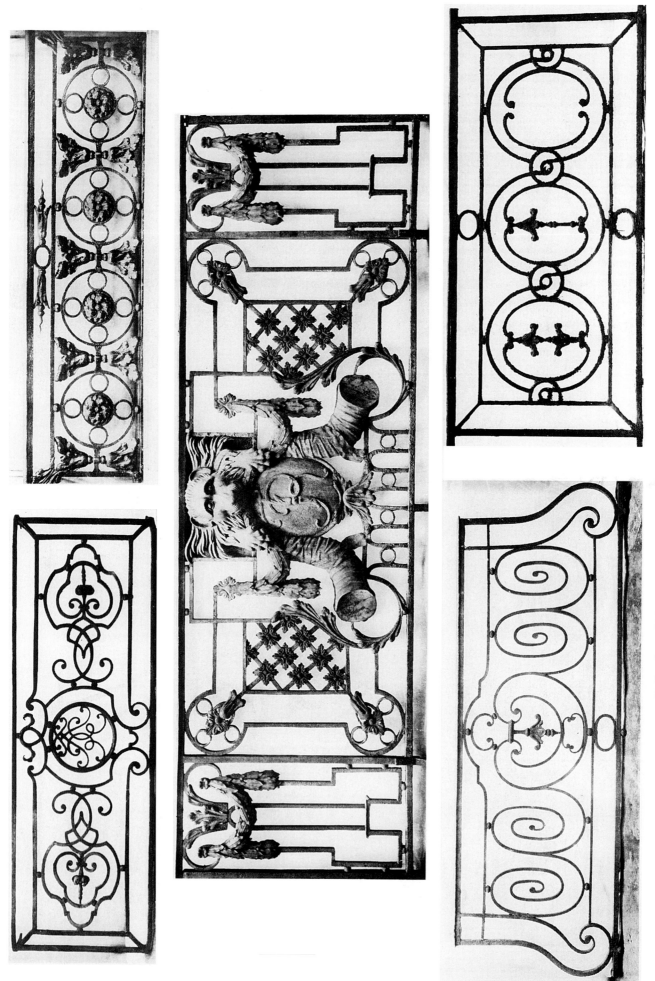

Collection of M. Lemeune, Parisian art metalworker: Window rails and balconies, styles of Louis XIV and Louis XVI.

Plate 64

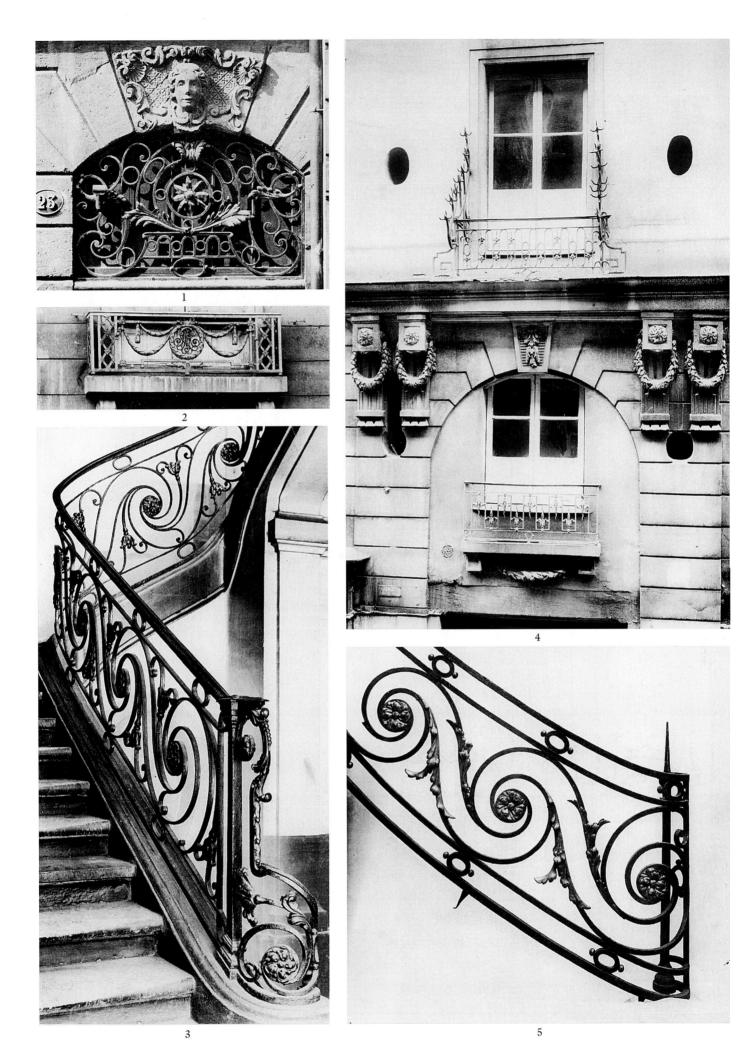

Bordeaux. **1.** Fanlight, 23 Cours Pasteur. *Paris.* **2.** Window rail, 4 Rue de Tournon. **3.** Banister,
19 Rue Michel-le-Comte. **4.** Detail of façade, 4 Rue Chérubini. **5.** Banister, style of Louis XVI (collection of M. Lemeune).

Plate 65

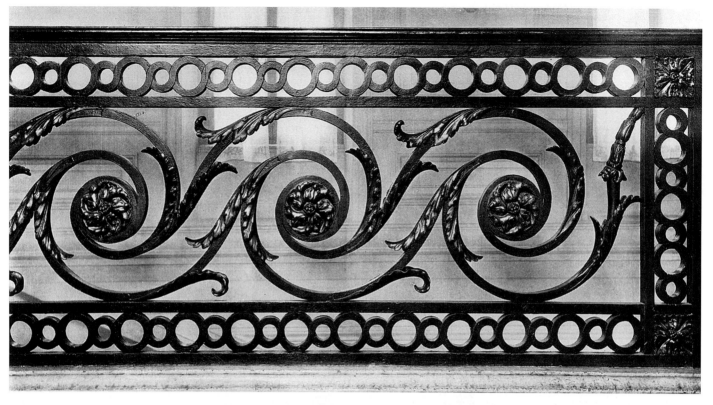

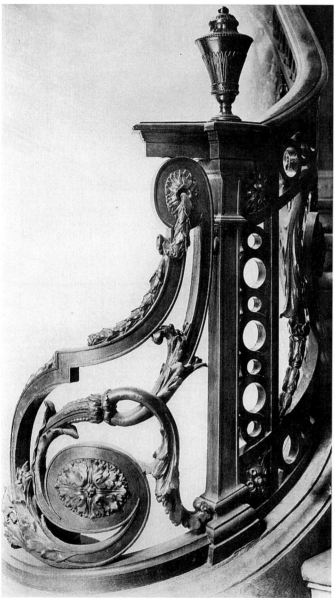

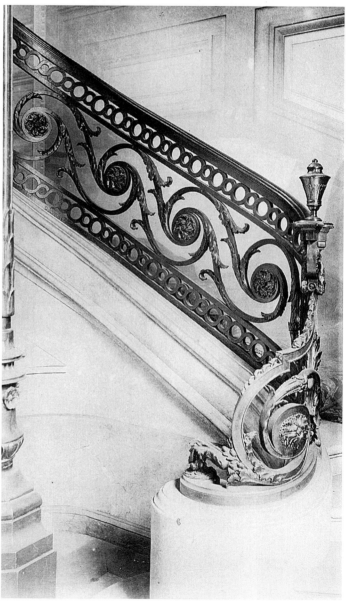

Paris. Marine Ministry. Banister details of the grand staircase.

Plate 66

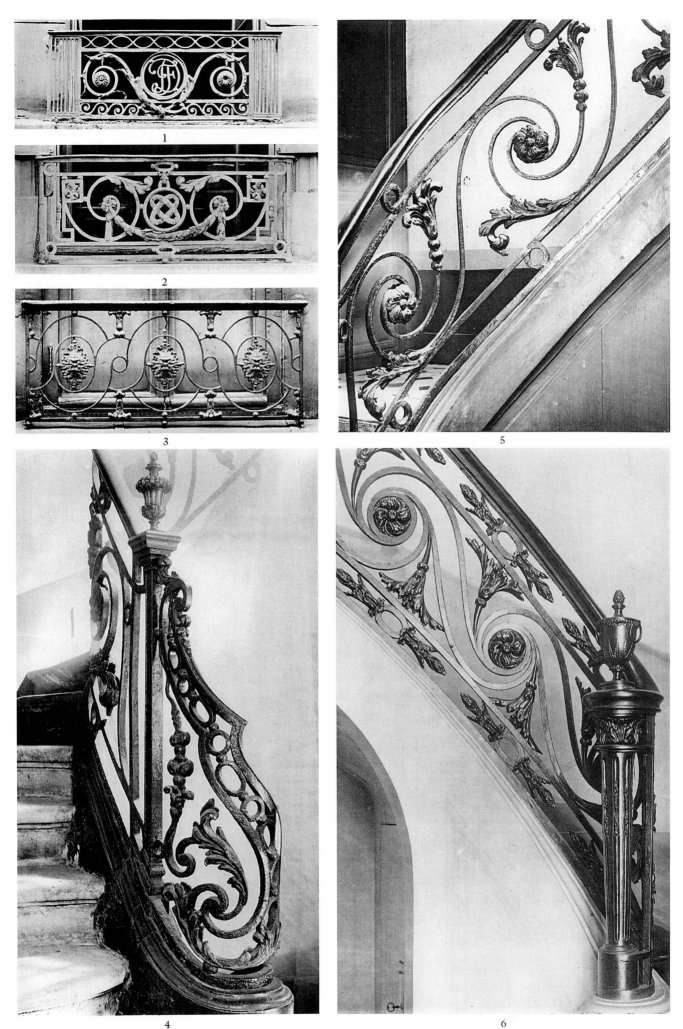

Paris. **1.** Window rail, 3 Rue St-Sauveur. **2.** Window rail, 26 Rue des Francs-Bourgeois.
3. Window rail, 7 Rue Chabanais. **4** and **5.** Newel post and banister, 17 Rue Radziwill.
6. Banister of the Rochechouart townhouse, 40 Rue de Grenelle.

Plate 67

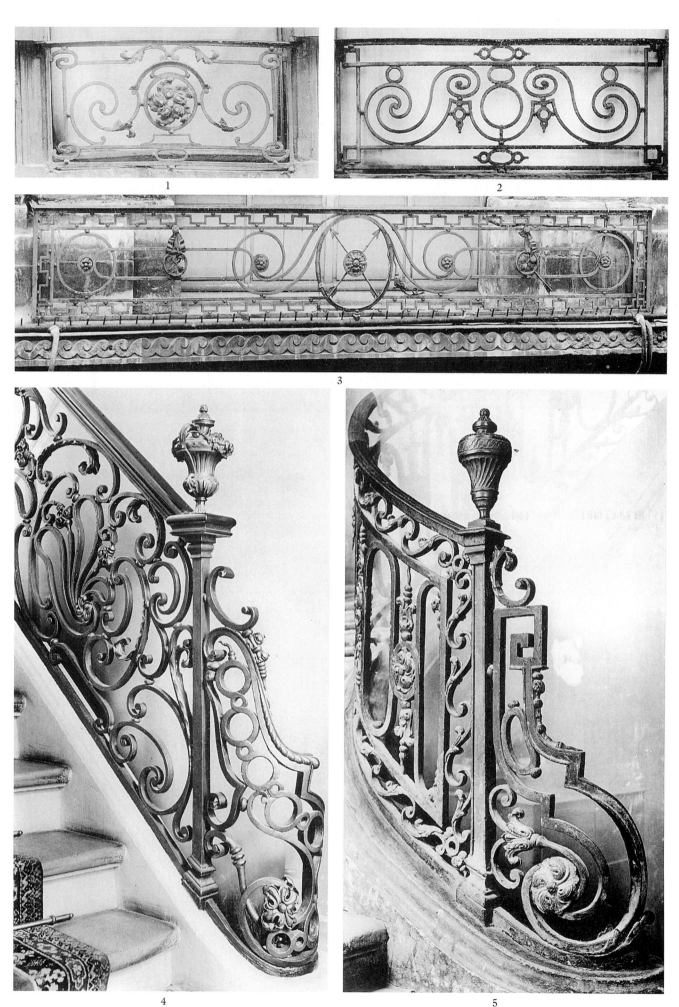

Paris. **1.** Window rail, 14 Rue Française. **2.** Window rail, 24 Rue des Petits-Carreaux. *Amiens.* **3.** Balcony of the Theater.
Paris. **4.** Foot of banister, Barmond townhouse, 102 Rue Vieille du Temple. **5.** Foot of banister,
Le Mayrat de St-Cyr townhouse, 26 Rue des Francs-Bourgeois.

Plate 68

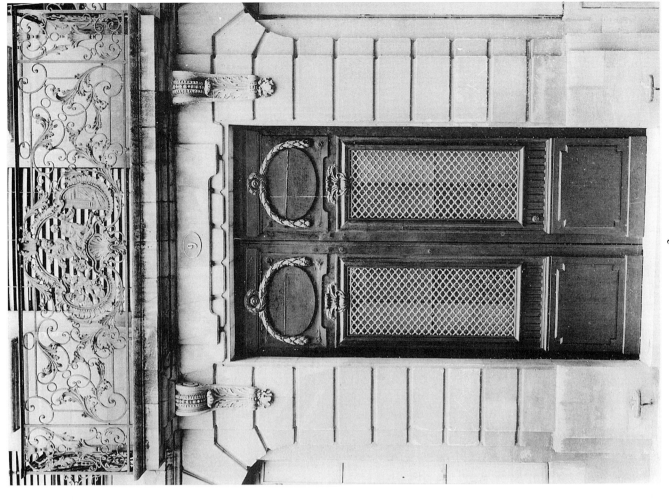

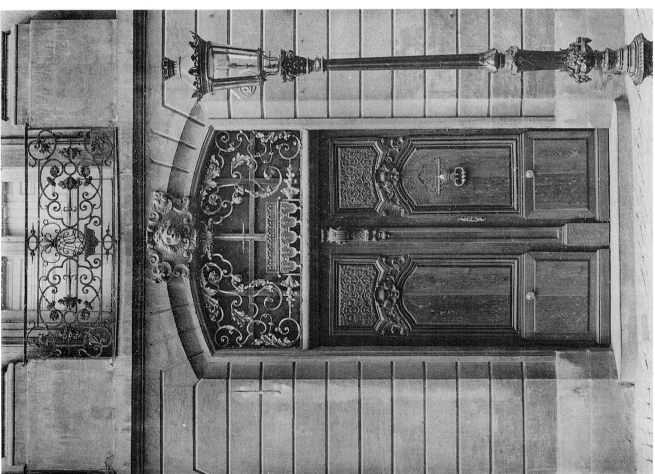

Bordeaux. **1.** Door and balcony, 20 Cour Pasteur. **2.** Door and balcony, 9 Cours du Jardin Plante.

1

2

Plate 69

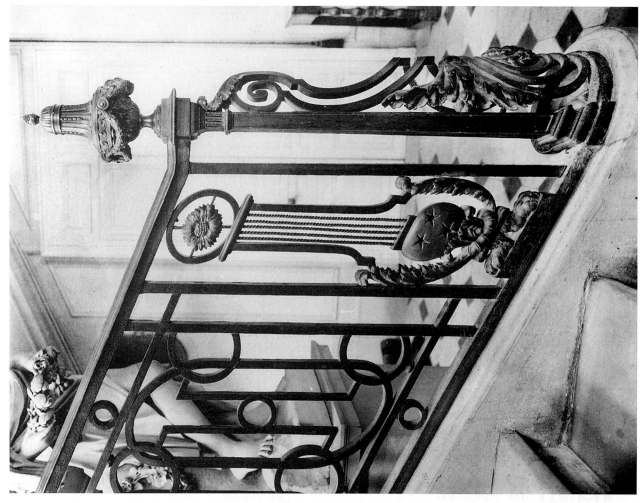

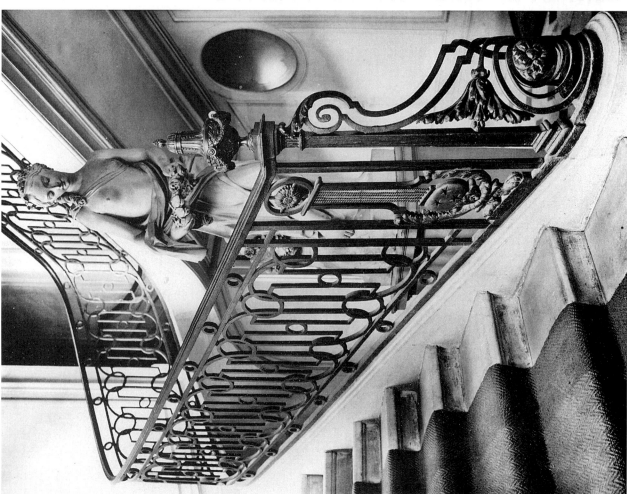

Versailles. Hôtel des Réservoirs, 9 Rue des Réservoirs—the former townhouse of the Marquise de Pompadour, built in 1752. Staircase and foot of stairs.

Plate 70

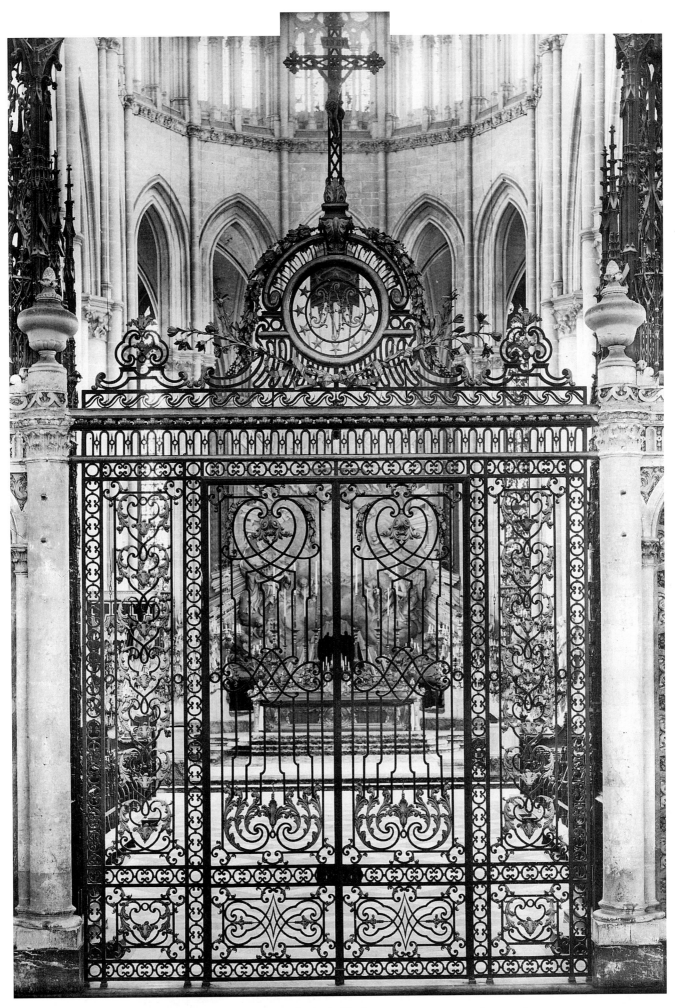

Amiens. Notre-Dame Cathedral. Choir entry gate, executed around
1761 following the designs of Michel-Ange Slodtz, the king's architect.

Plate 71

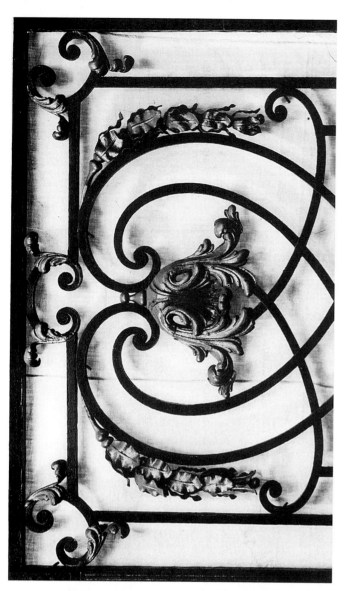

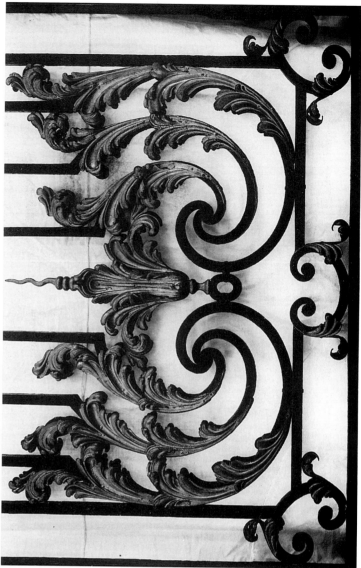

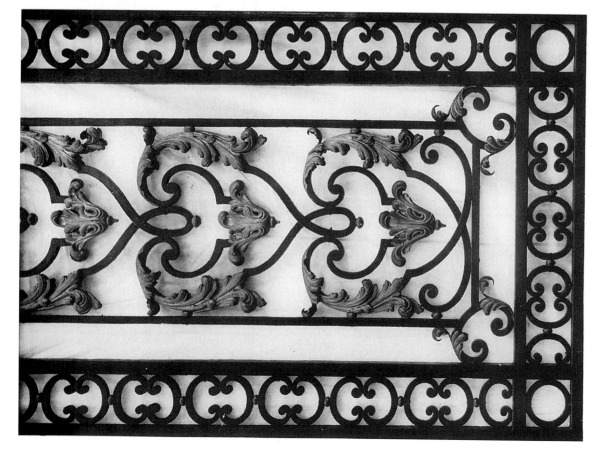

Amiens. Notre-Dame Cathedral. Large-scale details of the choir entry gate.

Plate 72

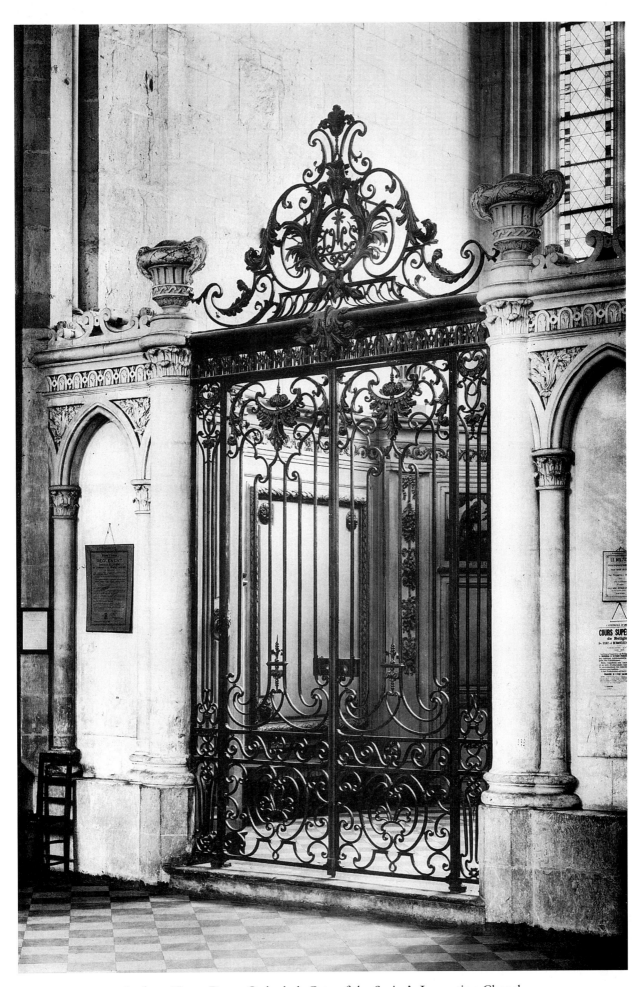

Amiens. Notre-Dame Cathedral. Gate of the Savior's Invocation Chapel.

Plate 73

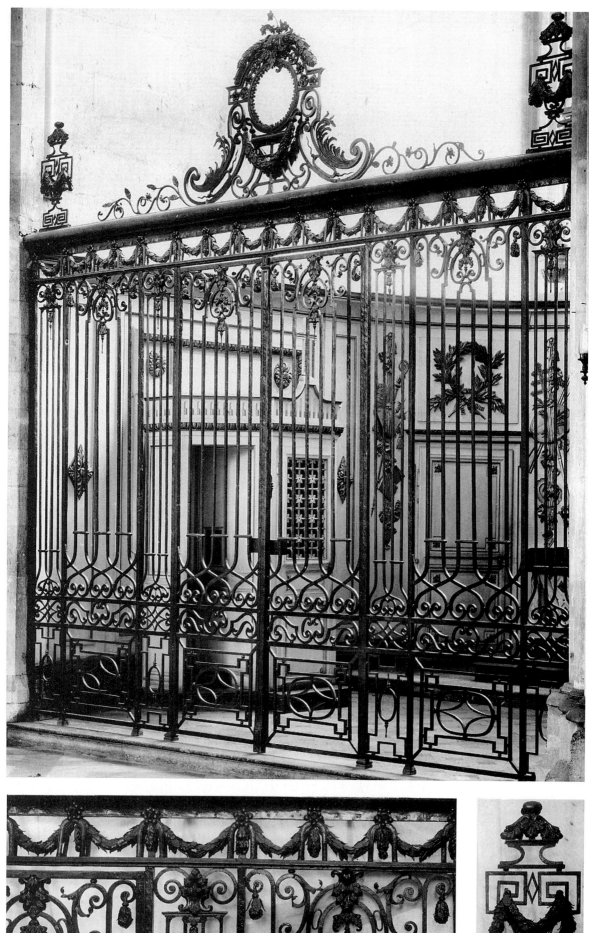

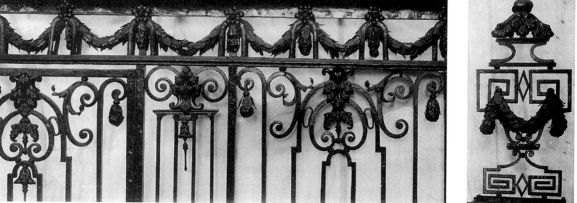

Amiens. Notre-Dame Cathedral. Gate of the chapel dedicated to Saint-Honoré.

Plate 74

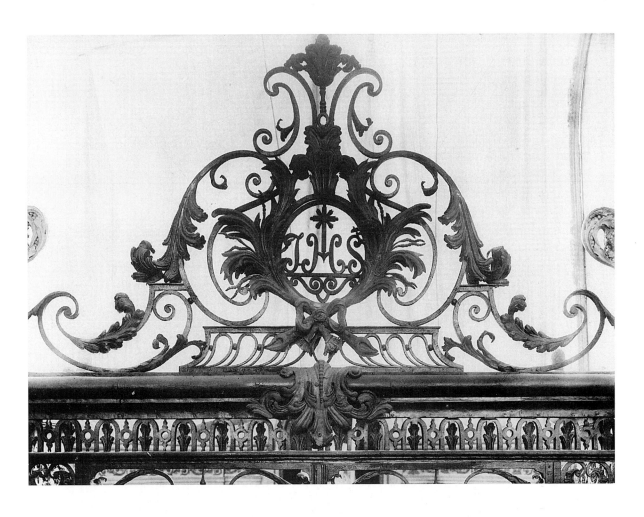

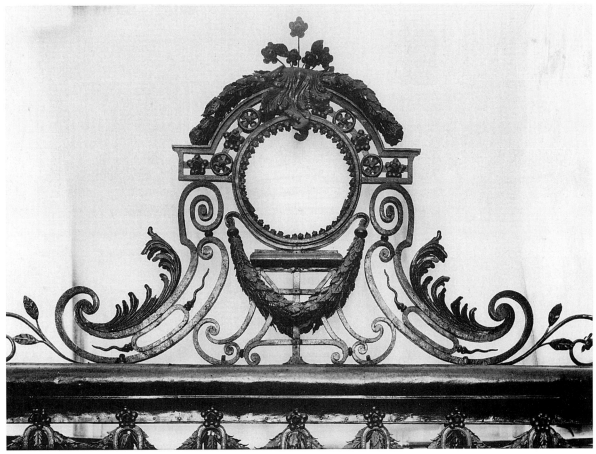

Amiens. Notre-Dame Cathedral. Crests of chapel gates.

Plate 75

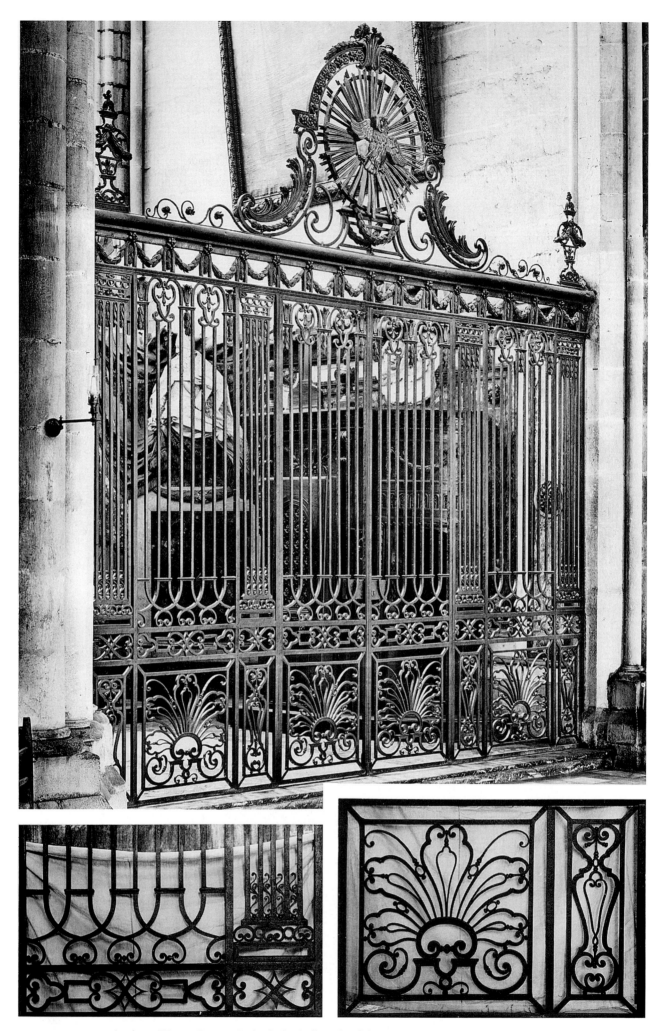

Amiens. Notre-Dame Cathedral. Grillwork of the chapel dedicated to St-Etienne.
The grill enclosing this chapel was executed in 1768, paid for by M. Caron, canon of the cathedral.

Plate 76

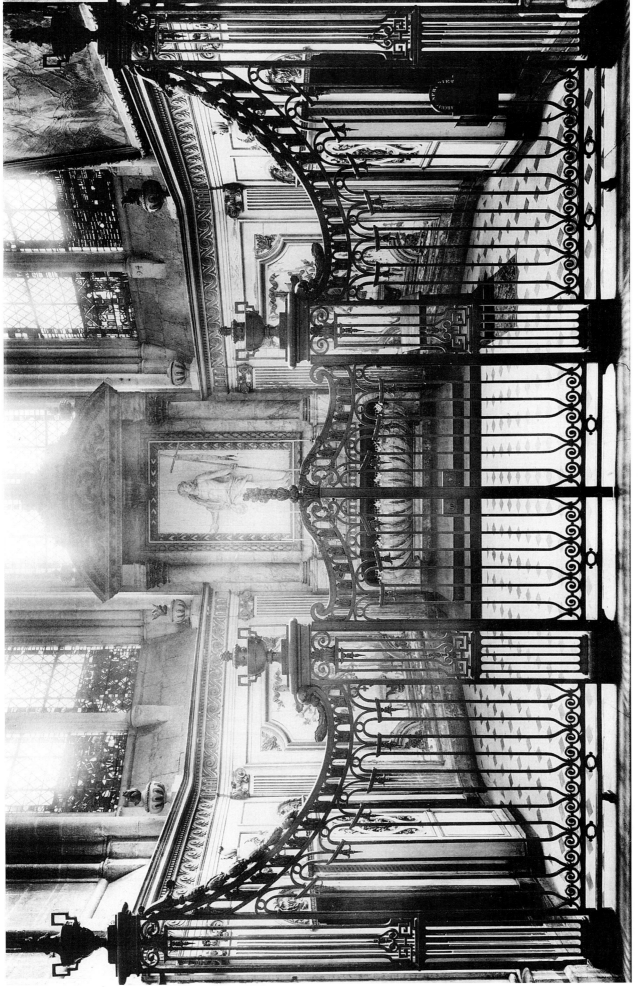

Amiens. Notre-Dame Cathedral. Grillwork of the chapel dedicated to Saint John the Baptist.

Plate 77

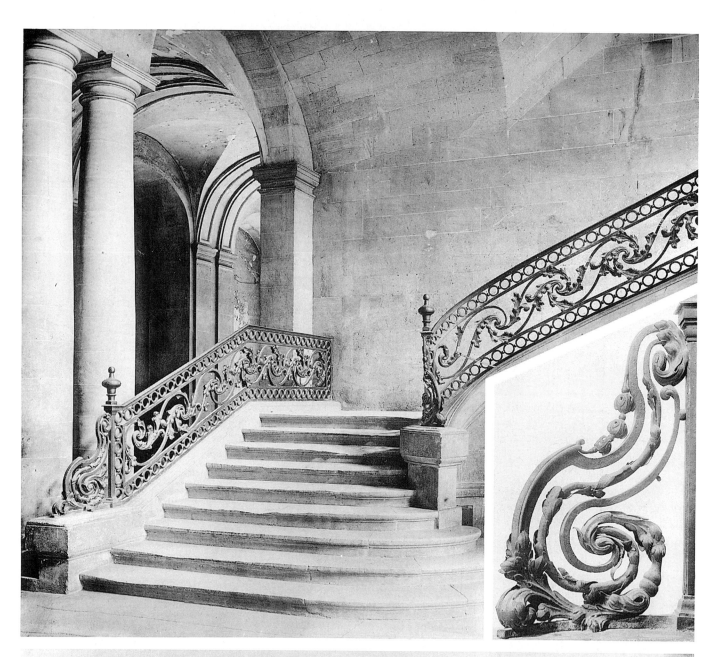

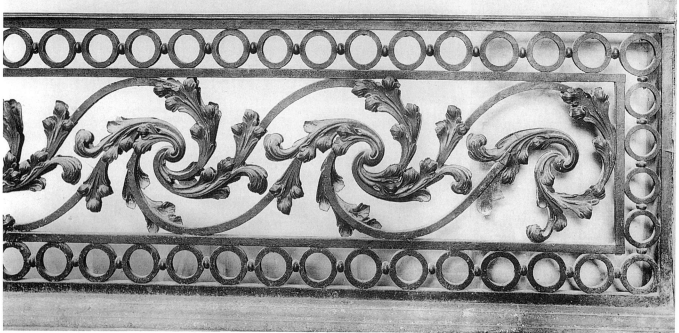

Rouen. Hôtel de Ville. Staircase in the left wing; detail of a newel post; detail of a horizontal panel.

Plate 78

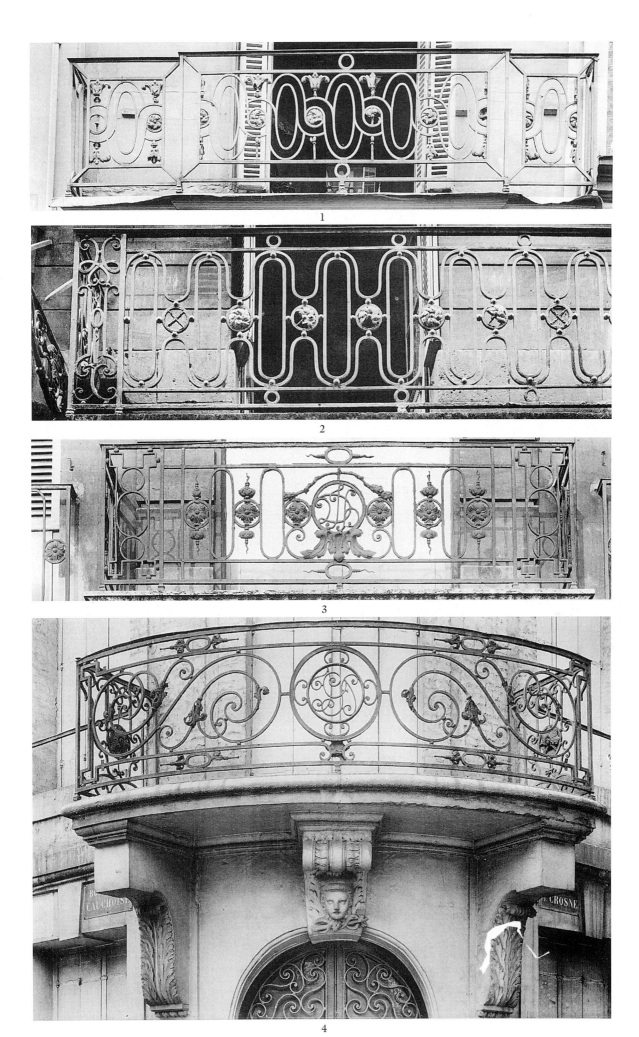

Rouen. 1. Balcony, 120 Rue de la Grosse-Horloge. **2.** Balcony, 16 Rue Jacques-le-Lieur.
3. Balcony, 8 Place de la Pucelle. **4.** Balcony, 57 Boulevard Cauchoise.

Plate 79

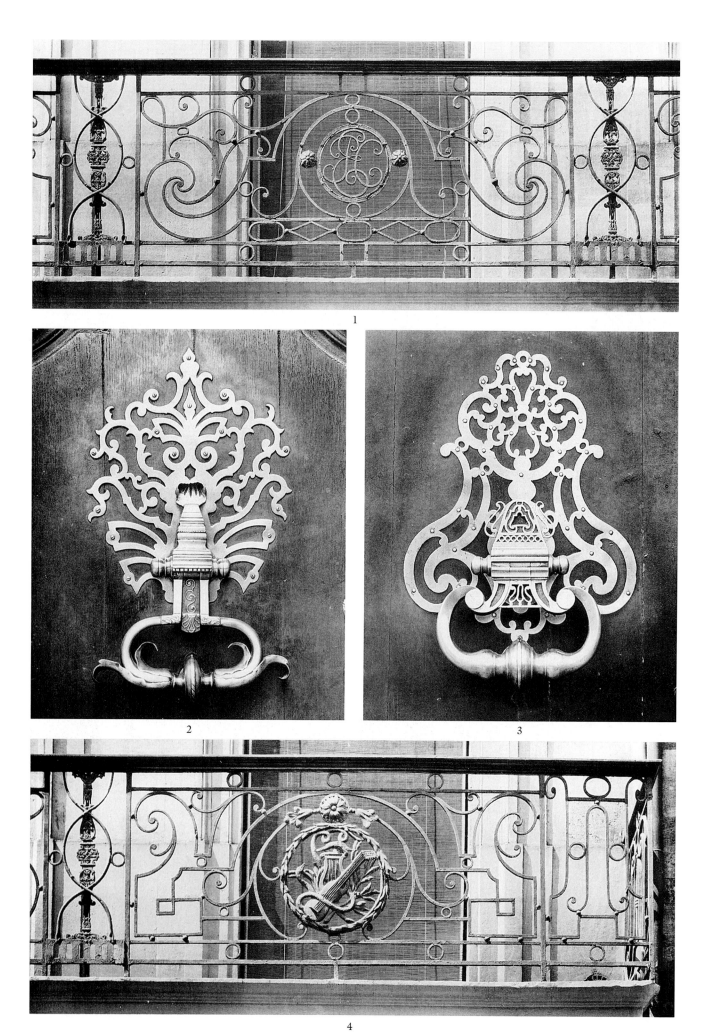

Bordeaux. **1** and **4.** Details of a three-panel balcony, 115 Cours d'Albret.
2. Door knocker, 9 Rue Poquelin Molière. **3.** Door knocker, 29 Cours d'Albret.

Plate 80

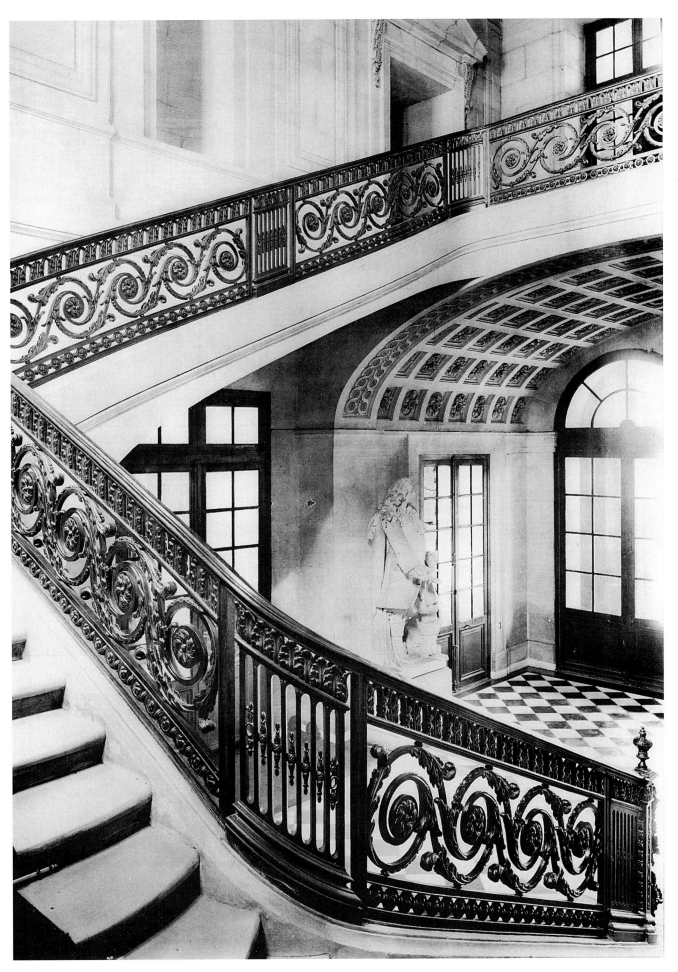

Paris. Overall view of the grand staircase of the Ecole Militaire.

Plate 81

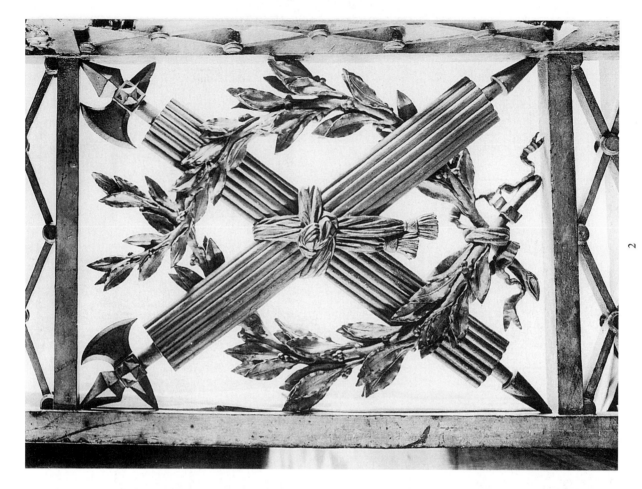

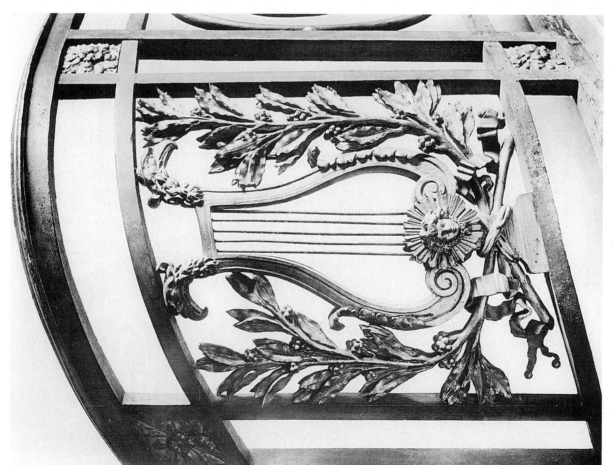

Plate 82

Compiègne. 1. Apollo staircase: banister motif. 2. Grand staircase: banister motif.

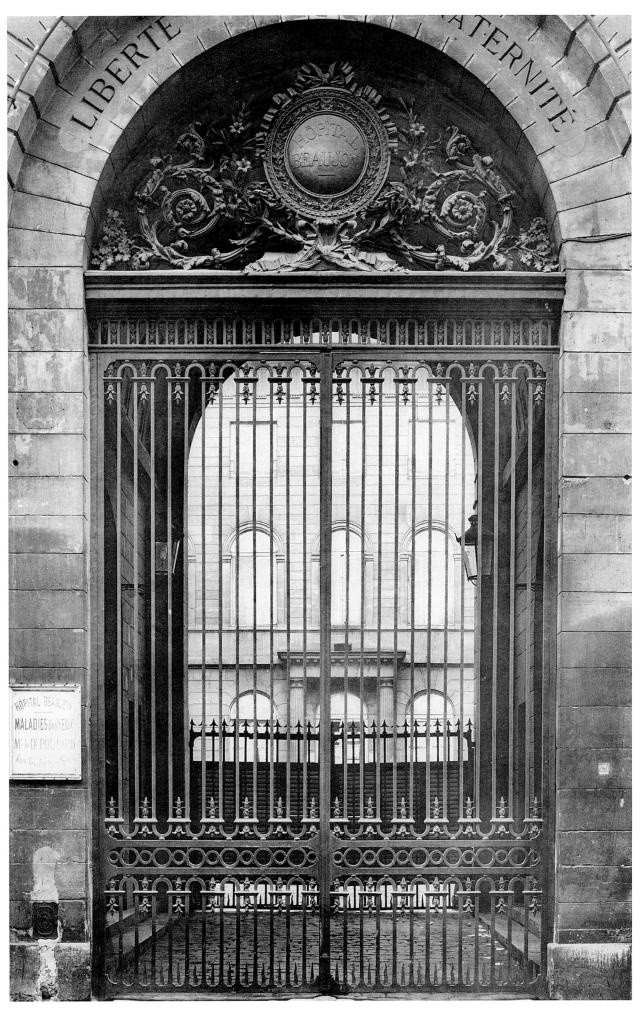

Paris. Entry gate to the Beaujon Hospital, 208 Faubourg St-Honoré,
built by Girardin around 1786.

Plate 83

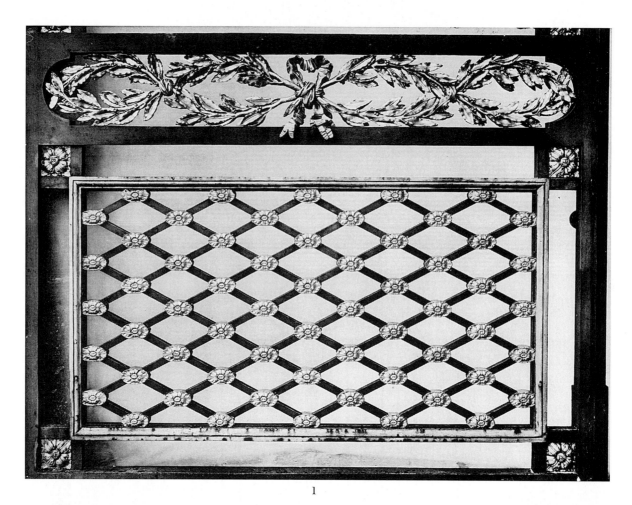

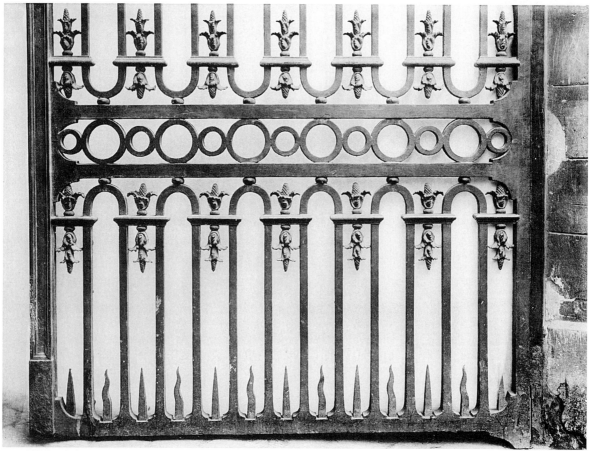

Compiègne. **1.** Detail of the bottom of the Palace's entry gate.
Paris. **2.** Detail of the bottom of the Beaujon Hospital's entry gate.

Plate 84

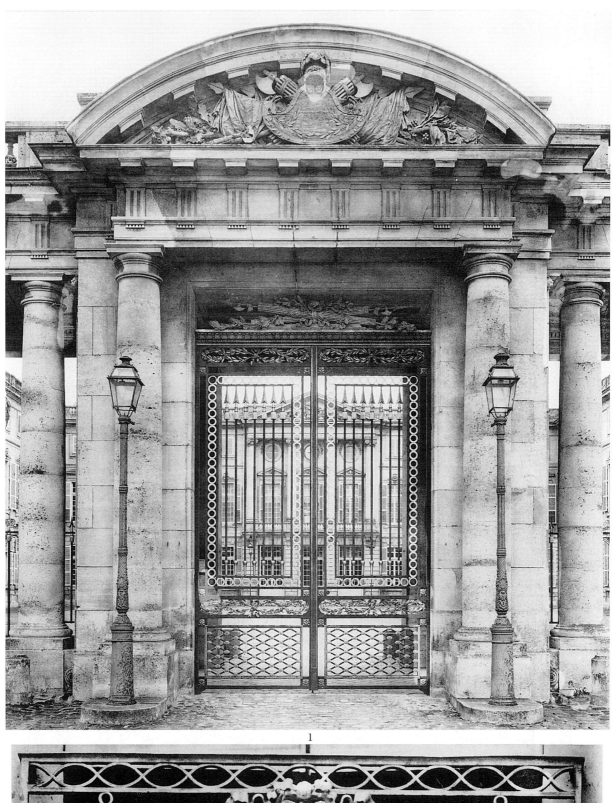

1

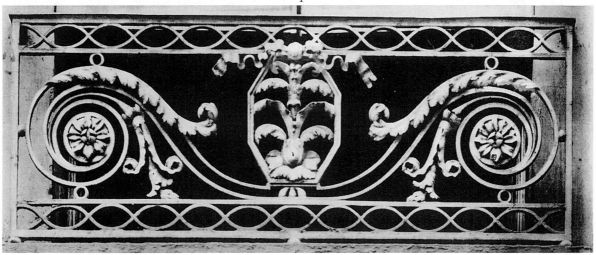

2

Compiègne. **1.** The Palace's main entry. ***Paris.*** **2.** Window rail at 52 Rue du Bac. Louis XVI style.

Plate 85

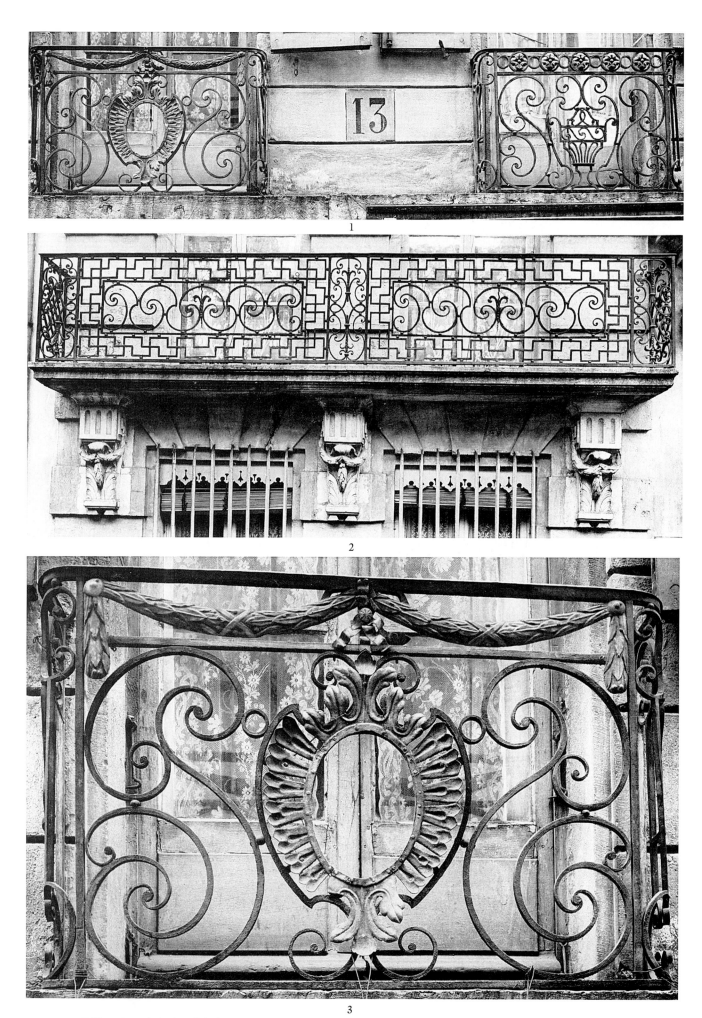

Dijon. **1** and **3.** Small balconies at 13 Rue Musette. **2.** Balcony of the former Berbisey townhouse.

Plate 86

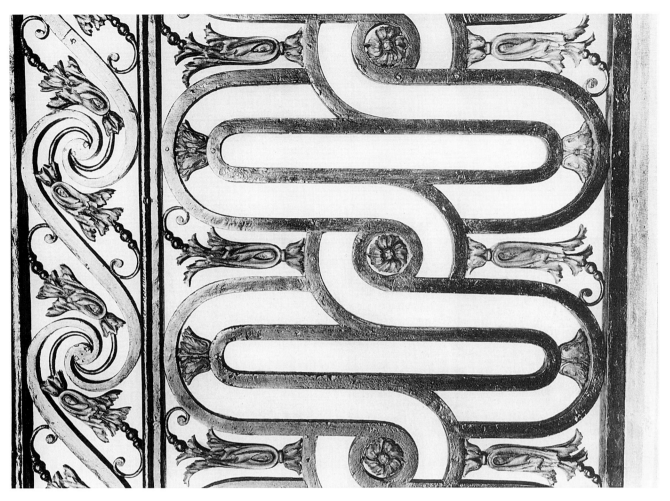

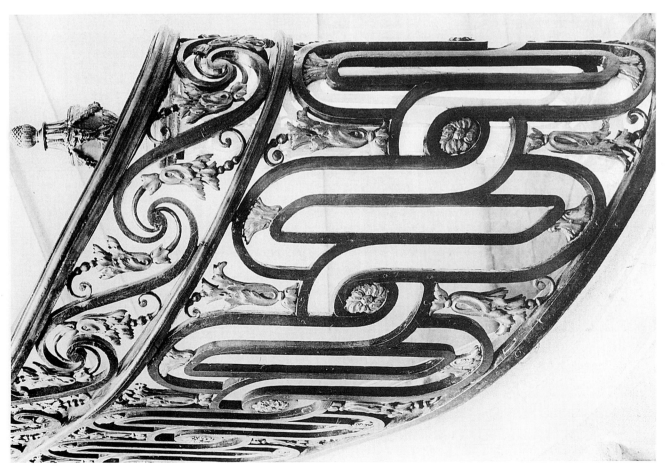

Dijon. M. Belime's townhouse, 45 Rue Jeannin. Foot of stairs and detail.

Plate 87

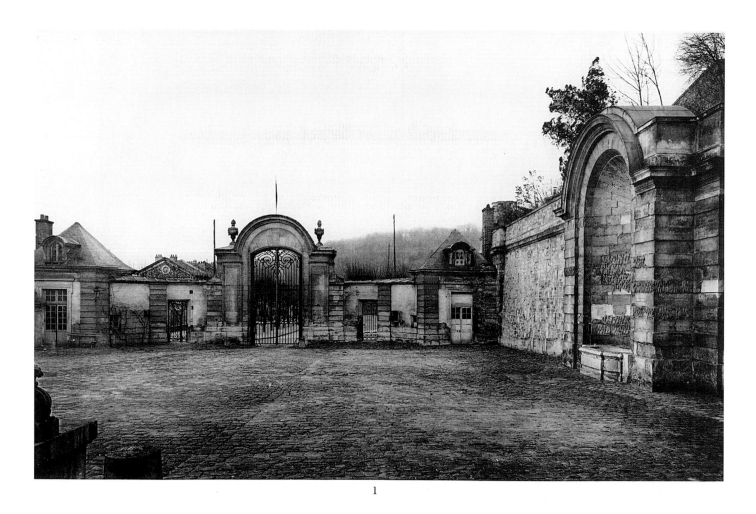

1

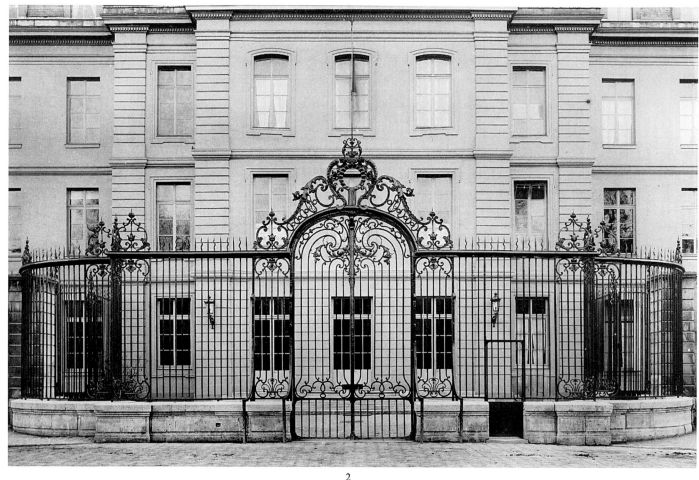

2

Sèvres. **1.** The former Sèvres Factory gate leading to the main courtyard.
2. Entry enclosure of the former Sèvres Factory, now the Ecole Normale de jeunes filles
(Young Women's Teachers' College). Total length 19.2 meters.

Plate 88

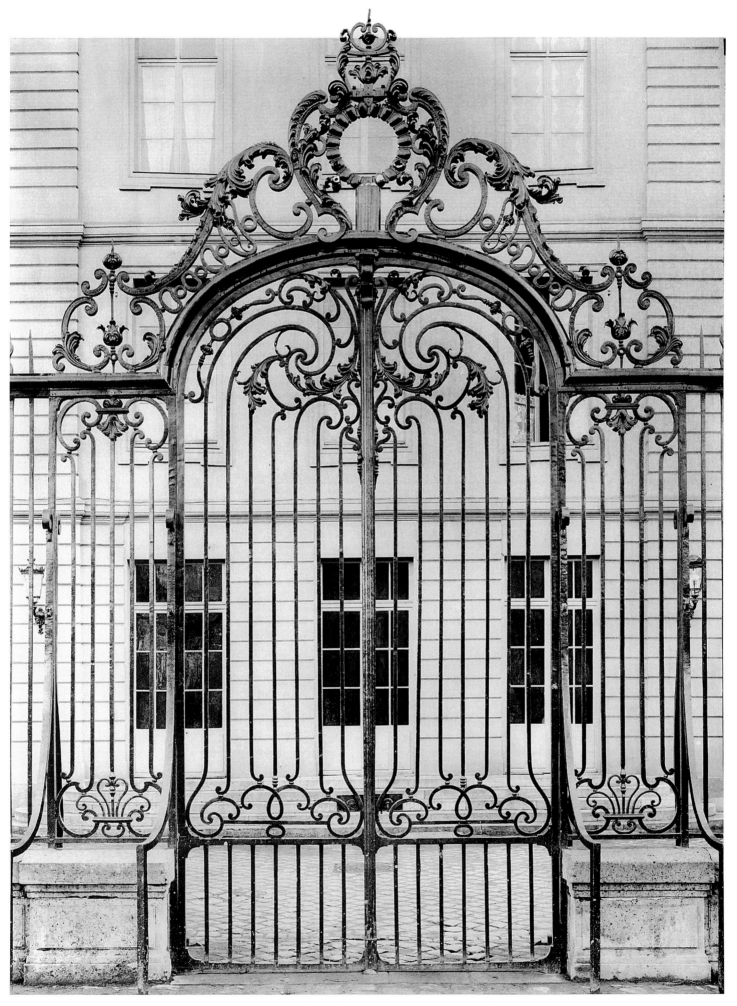

Sèvres. Main entry gate of the former Sèvres Factory. Height 7.05 meters.

Plate 89

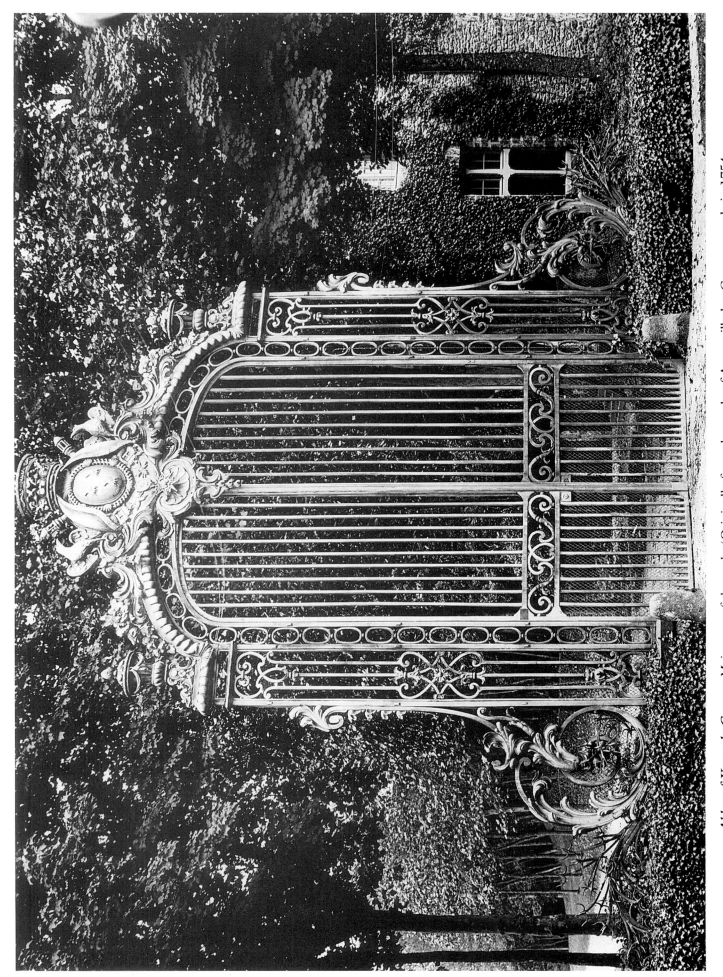

Abbey of Vaux-de-Cernay. Main gate of the park. (Originally from the castle of Arnouville-lez-Gonesse; made in 1754, following the designs of Contant d'Ivry, and brought to Vaux-de-Cernay in 1875.)

Plate 90

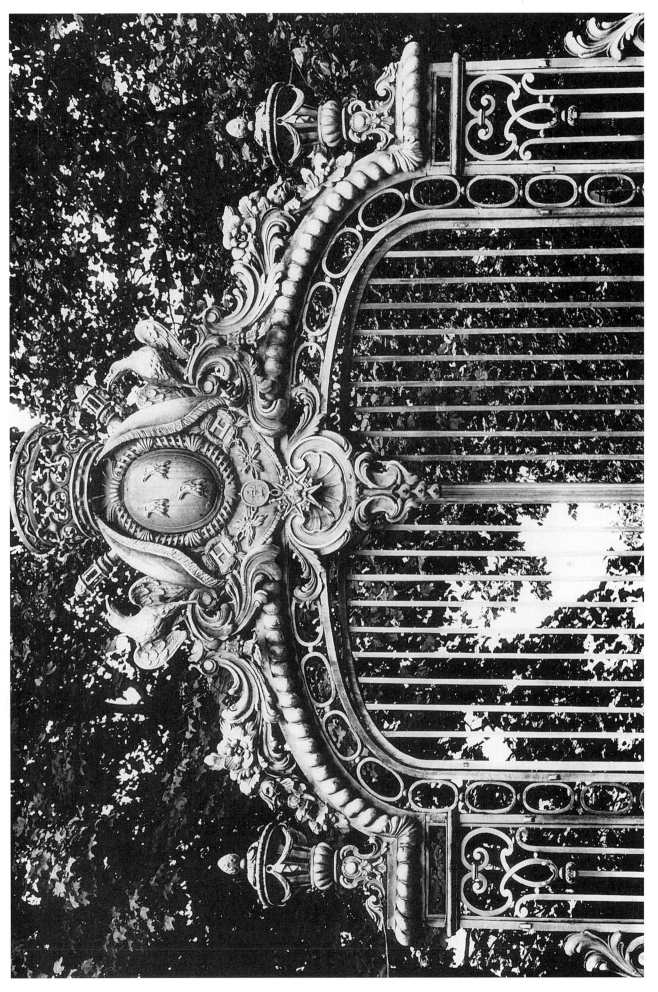

Abbey of Vaux-de-Cernay. Detail of the gate's crest.

Plate 91

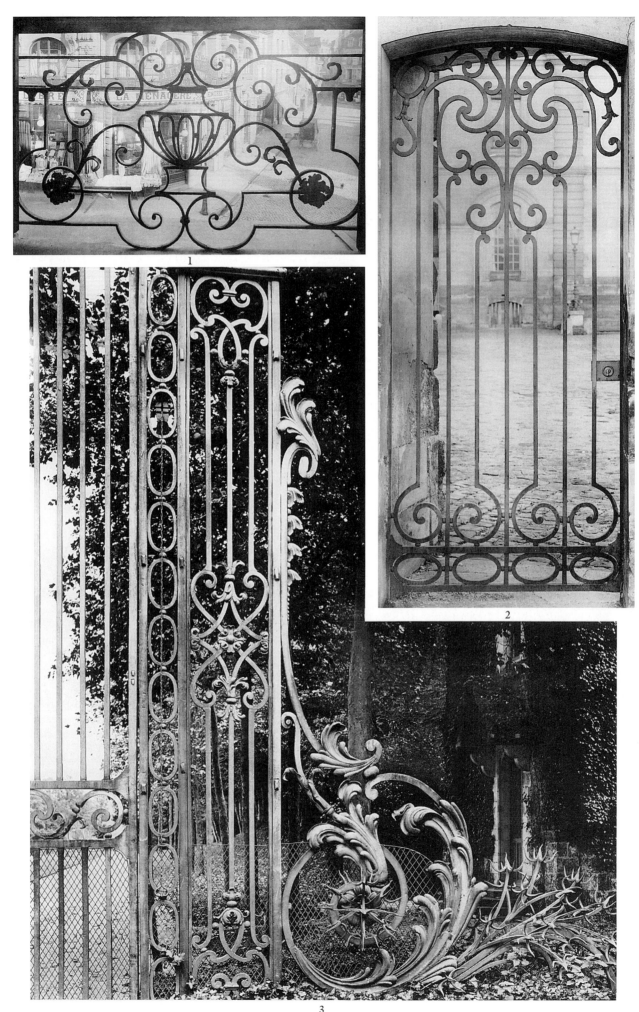

Dijon. **1.** Window rail, 68 Rue de la Liberté. *Sèvres.* **2.** Small gate of the former factory.
Vaux-de-Cernay. **3.** Detail of a pilaster and a cluster of spikes from the park's gate.

Plate 92

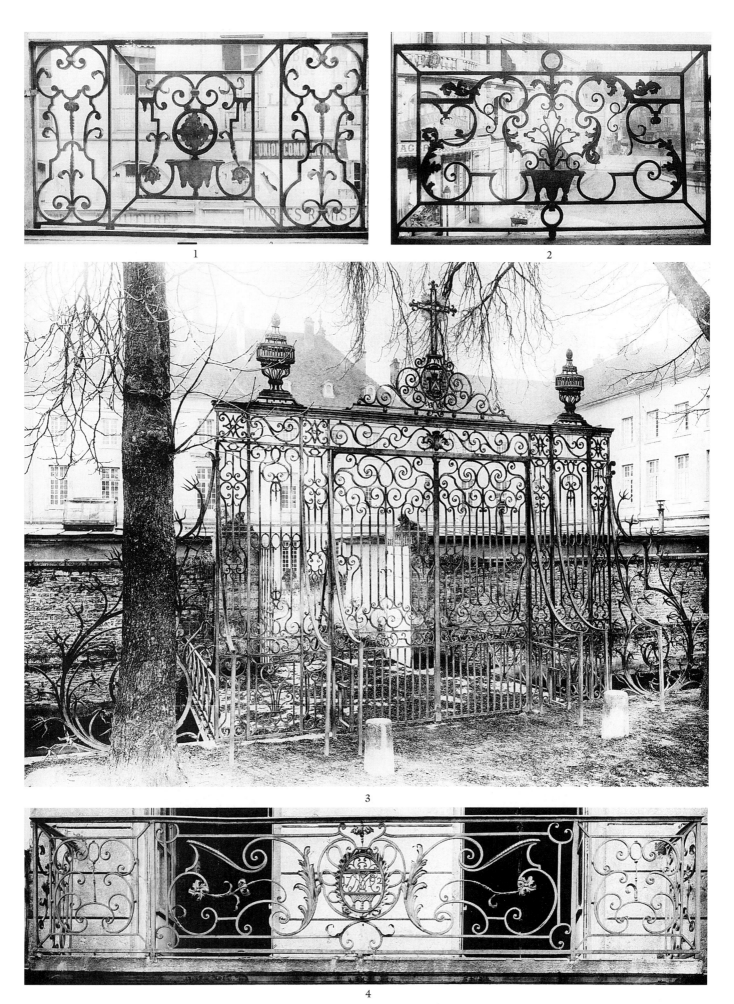

Dijon. **1** and **2.** Window rails, 78 and 68 Rue de la Liberté. **3.** Gate of the Catholic school of Plombières-lez-Dijon.
4. Balcony, Rue Notre-Dame, attributed to the senior Rude, Dijon sculptor (1792).

Plate 93

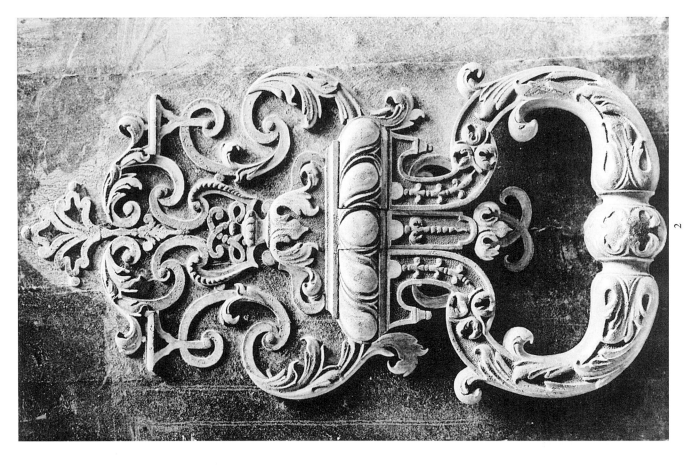

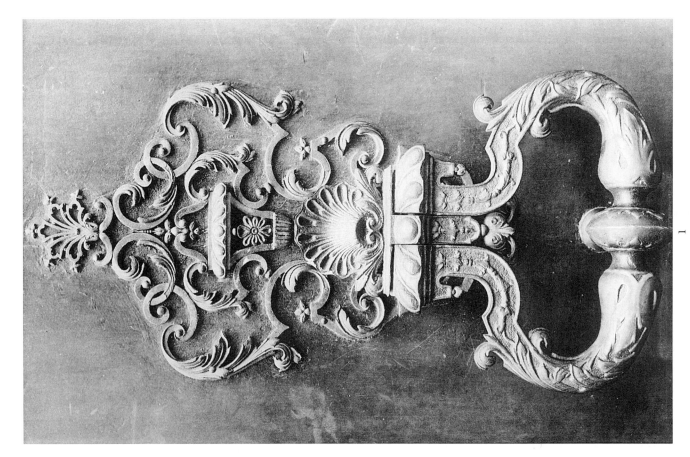

Dijon. 1. Door knocker from the townhouse of M. de Bretenières. 2. Door knocker of the Palais des Etats.

2

1

Plate 94

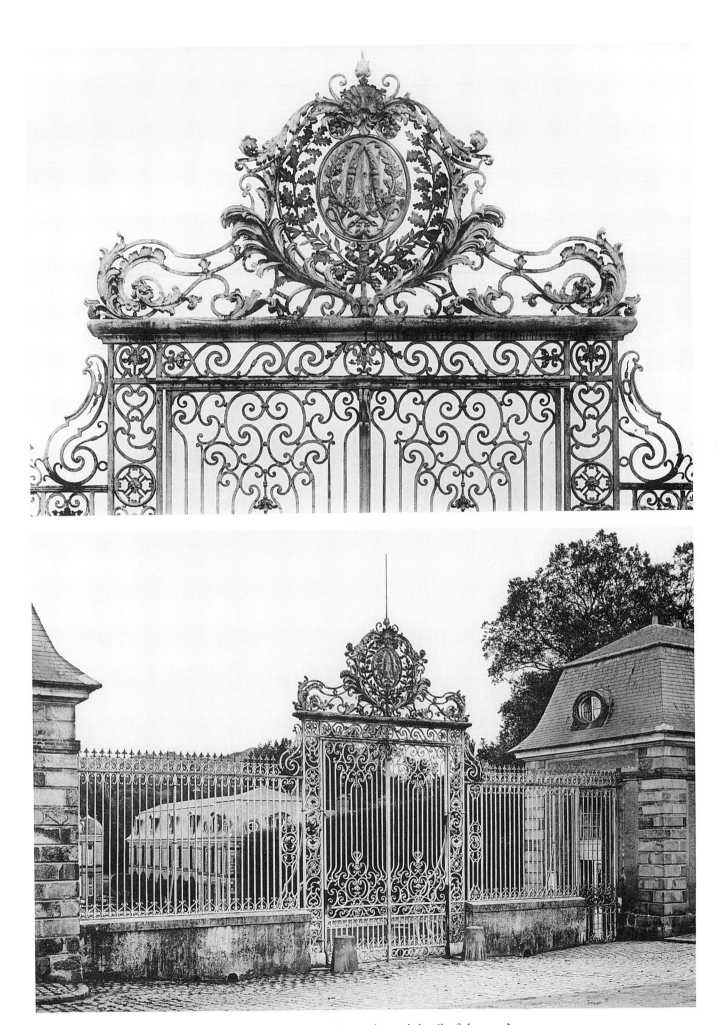

Dampierre. Entry gate to the castle, and detail of the gate's crest.

Plate 95

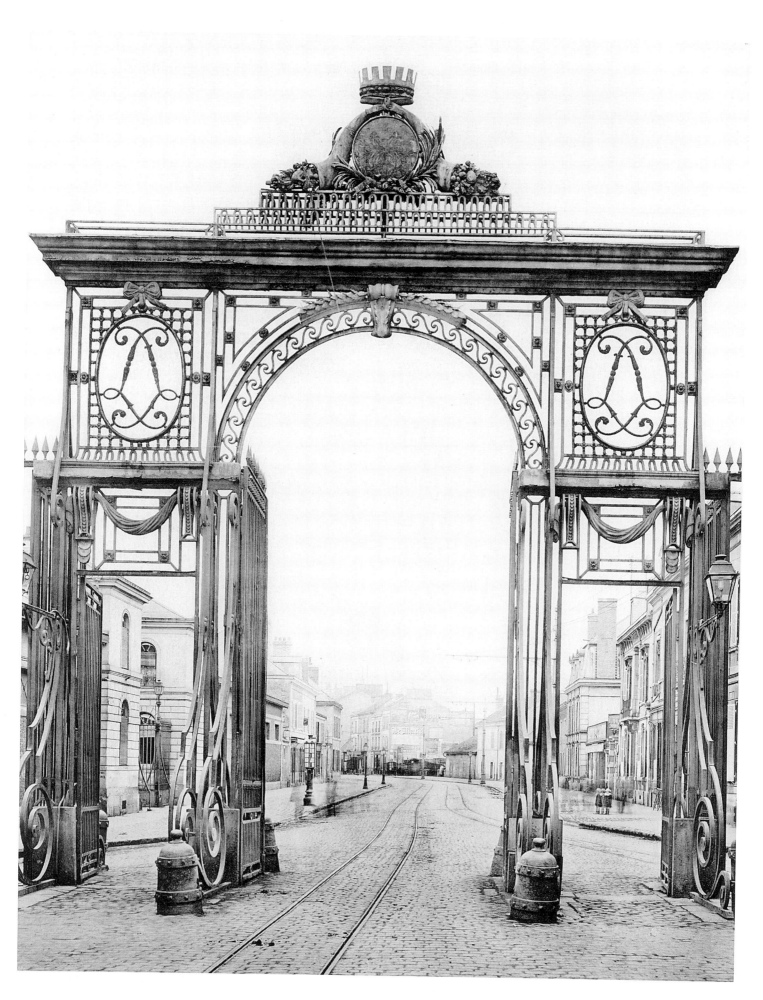

Reims. Gate of Paris, at the end of the district of that name. Executed in 1775 by Masson,
an ironworker of Reims, on the occasion of the coronation of Louis XVI.

Plate 96

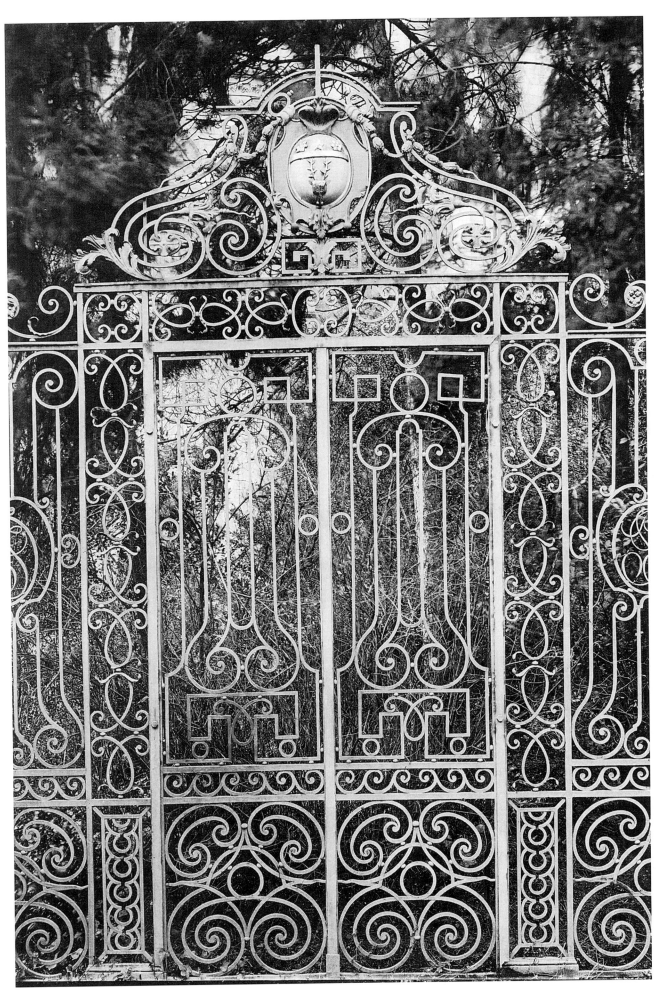

Sens. Gate of the former archbishop's palace, Louis XVI style (2.65 meters wide).

Plate 97

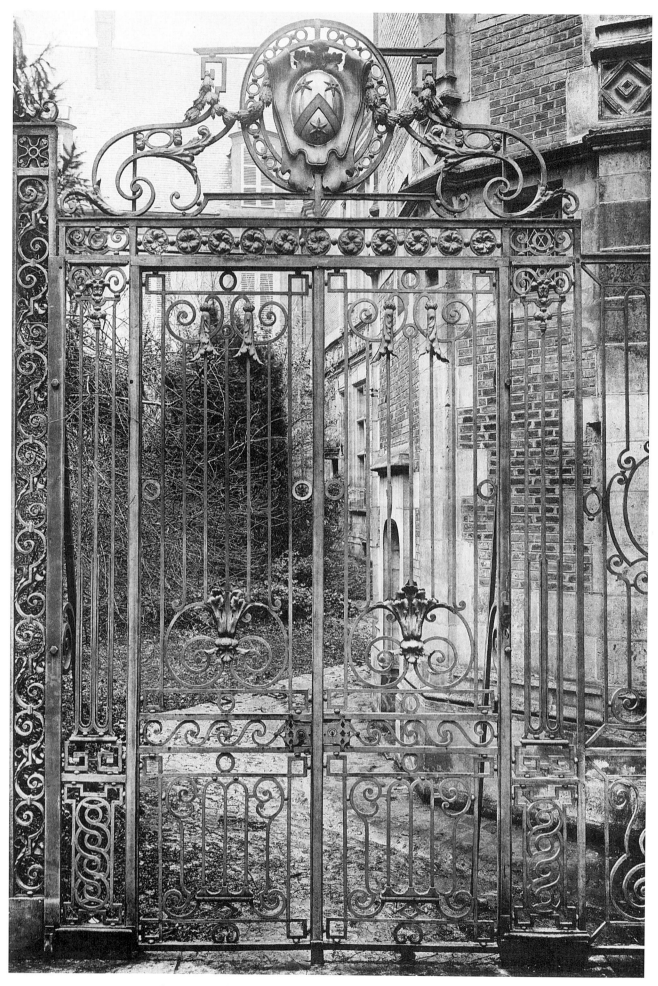

Sens. Gate of the former archbishop's palace, Louis XVI style.

Plate 98

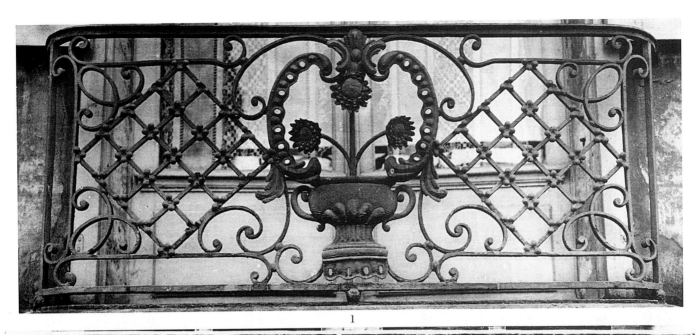

1

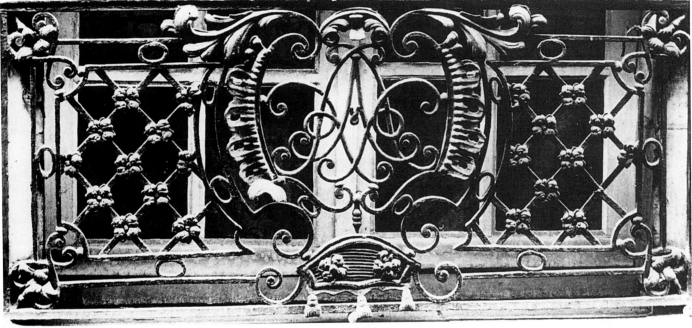

2

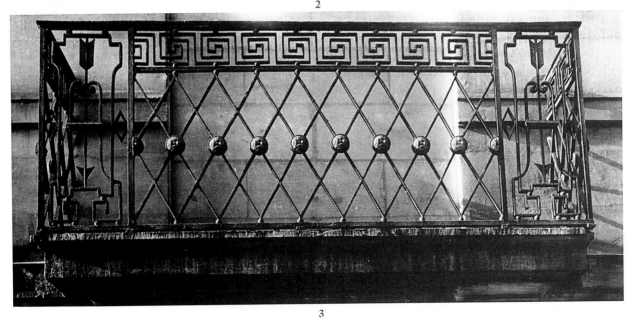

3

Tours. **1.** Window rail, 49 Rue de la Scellerie. **2.** Window rail, 47 Rue des Halles.
3. Window rail, 21 Rue de la Barre.

Plate 99

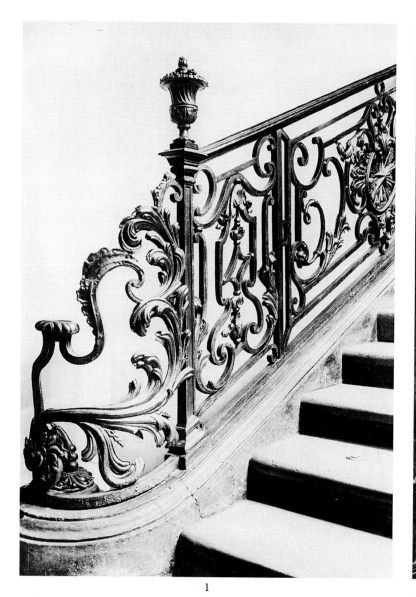

1

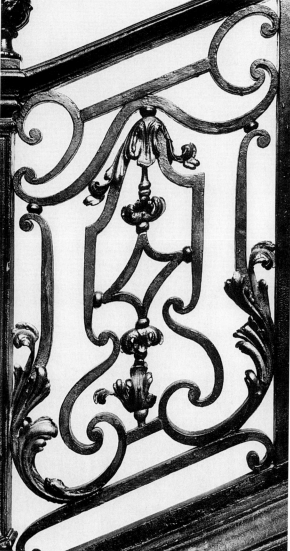

2

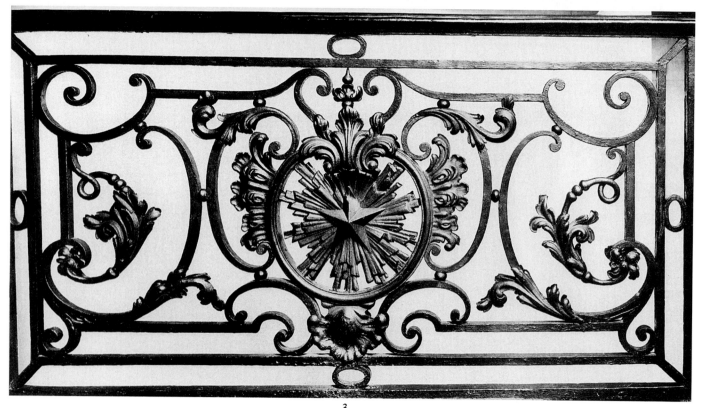

3

Paris. Townhouse of Her Ladyship Thénard, 6 Place St-Sulpice. **1.** Start of the banister of the large staircase.
2. Pilaster. **3.** Large horizontal panel (1.66 meters long).

Plate 100

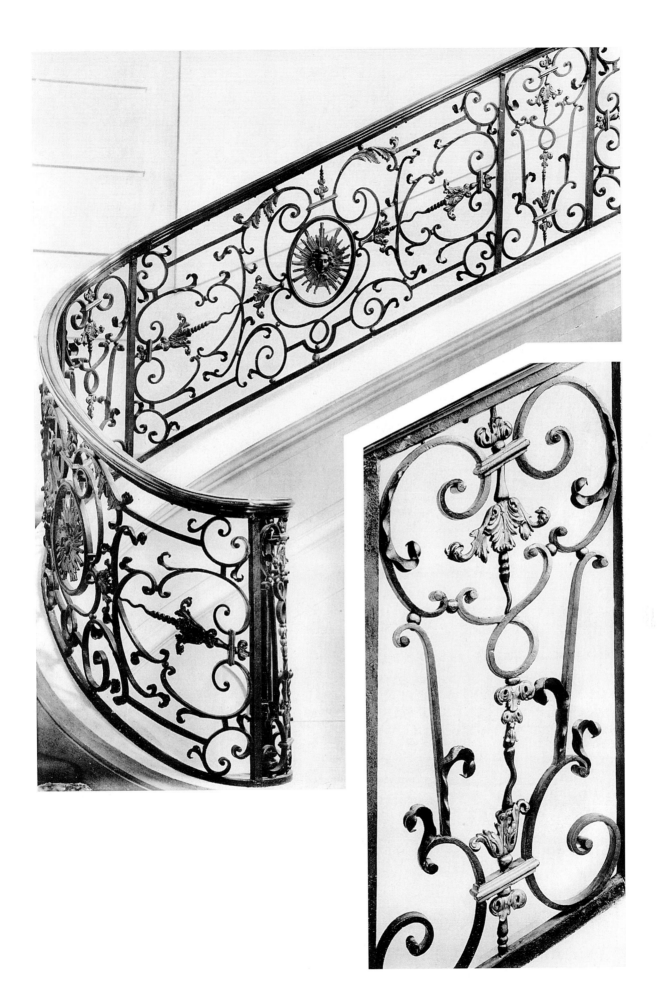

Paris. English Embassy, 39 Rue du faubourg St-Honoré (formerly the townhouse of the Duke of Charost, built in 1720; taken over by Princess Pauline Borghèse in 1810, and acquired by the English government in 1815). Banister of the grand staircase and detail of a pilaster. *Plate 101*

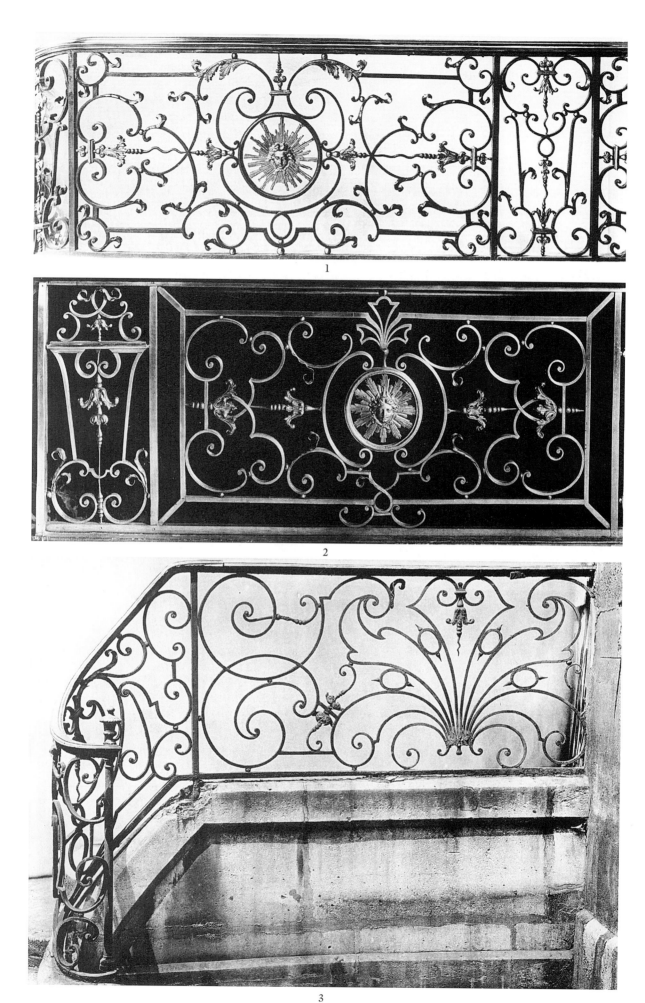

1

2

3

Paris. **1.** English Embassy. Banister panel and pilaster. **2.** Austrian Embassy. Banister panel and pilaster.
3. Stoop of the Estrées townhouse, 8 Rue Barbette.

Plate 102

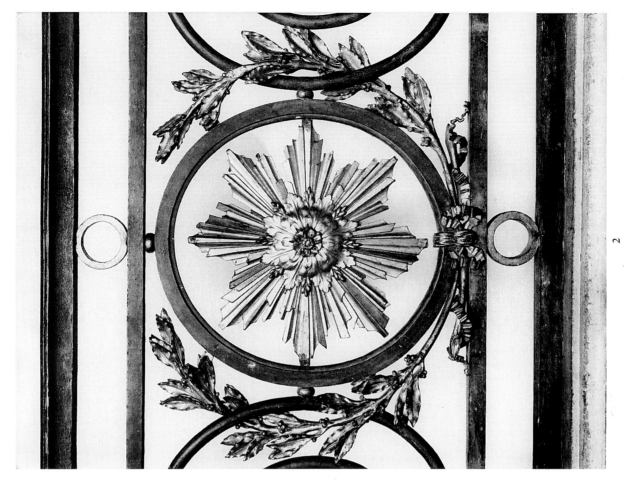

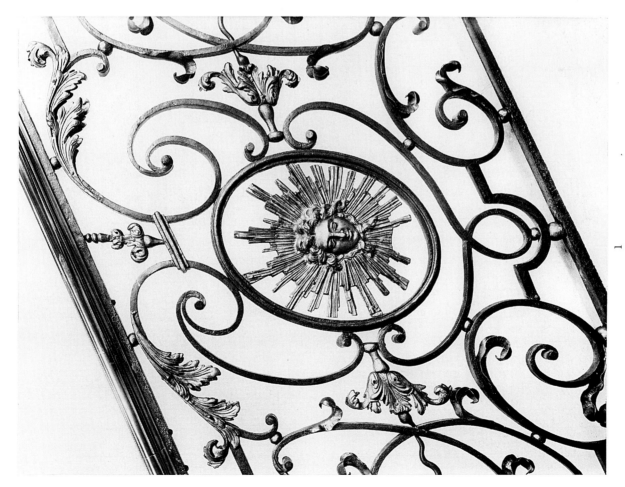

2

1

Paris. 1. English Embassy. Detail of a banister panel. *Compiègne.* 2. Banister motif from the Apollo staircase.

Plate 103

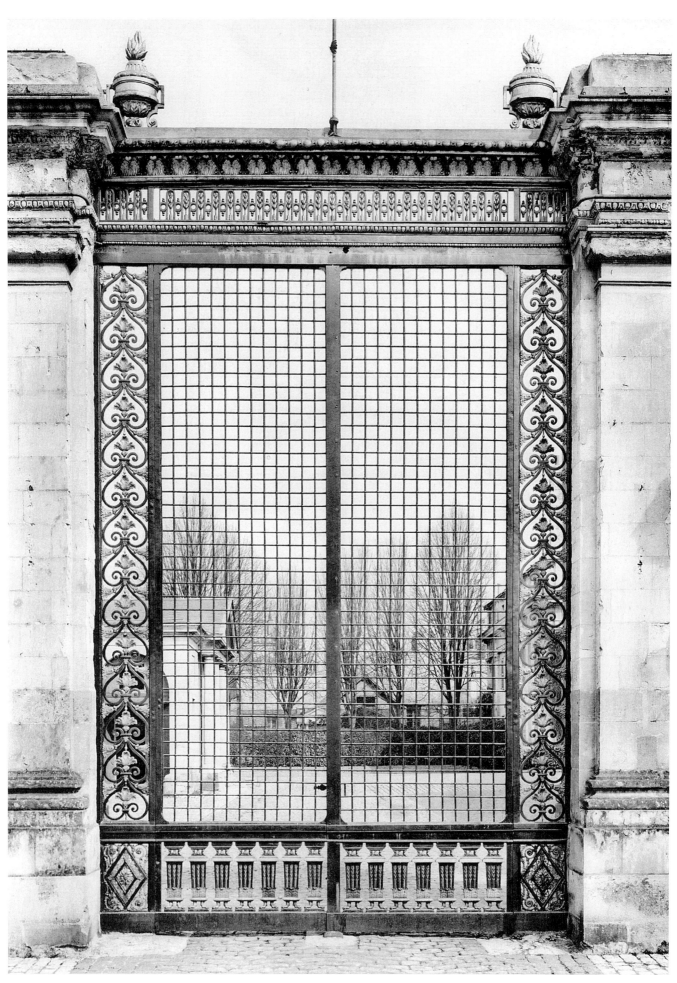

Tours. Gate of the Prefecture, originally at the abbey of Beaumont-lez-Tours.
Executed by René Nesle, master ironsmith, and set in place in 1785. Total length 4.22 meters.

Plate 104

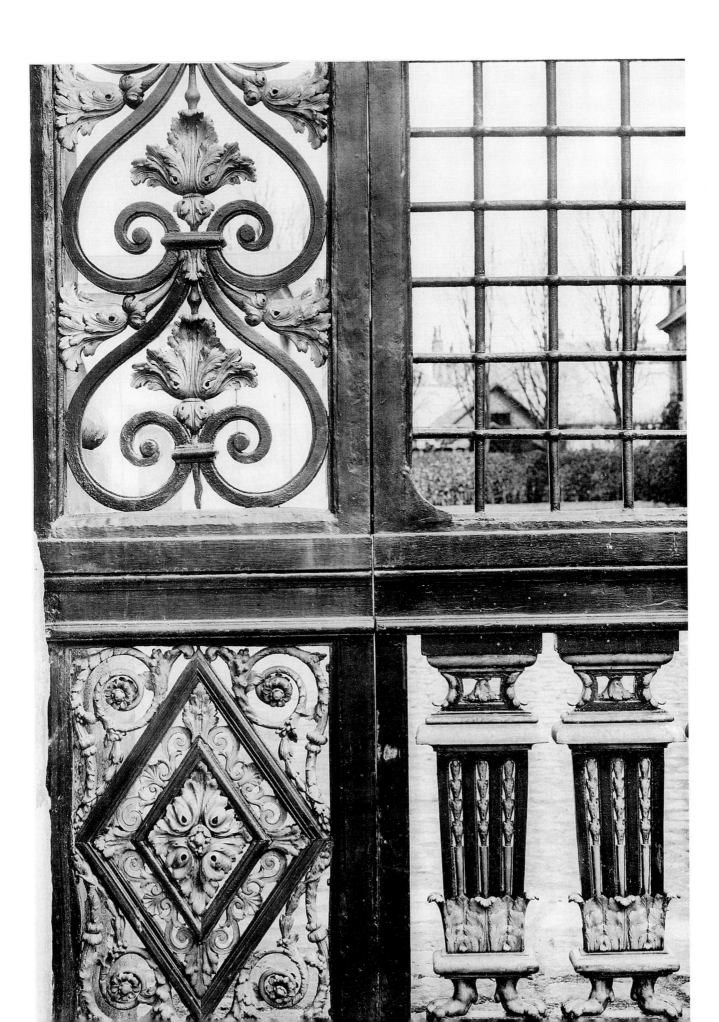

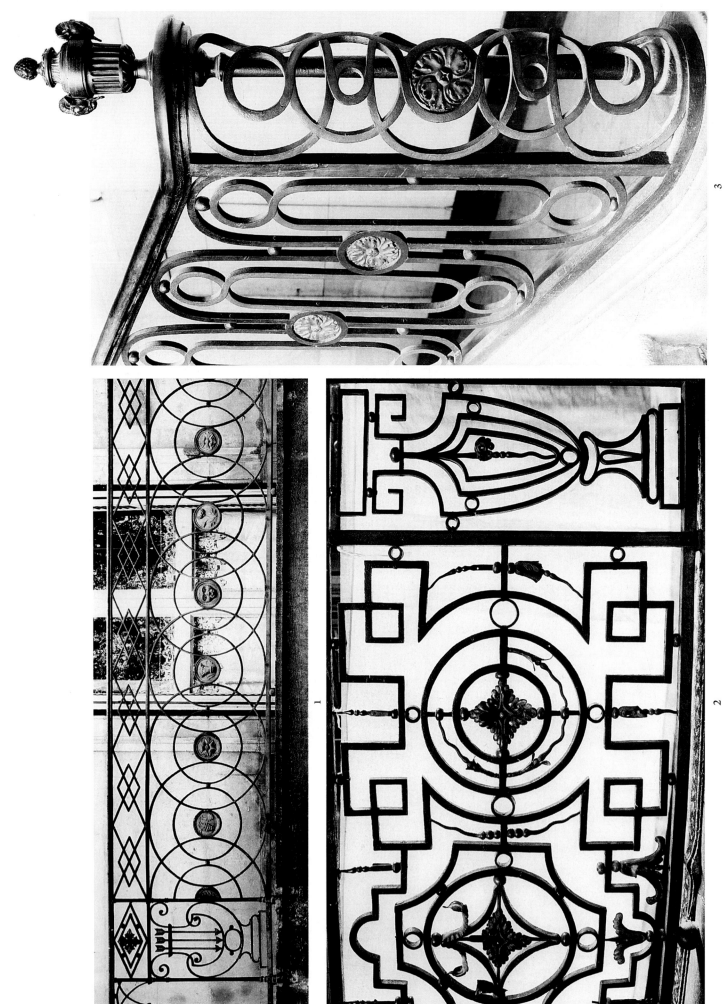

Tours. 1. Balcony, 10 Place Emile-Zola. *Dijon.* 2. Communion rail at the Church of St-Michel. 3. Start of the banister at the former bishopric.

Plate 106

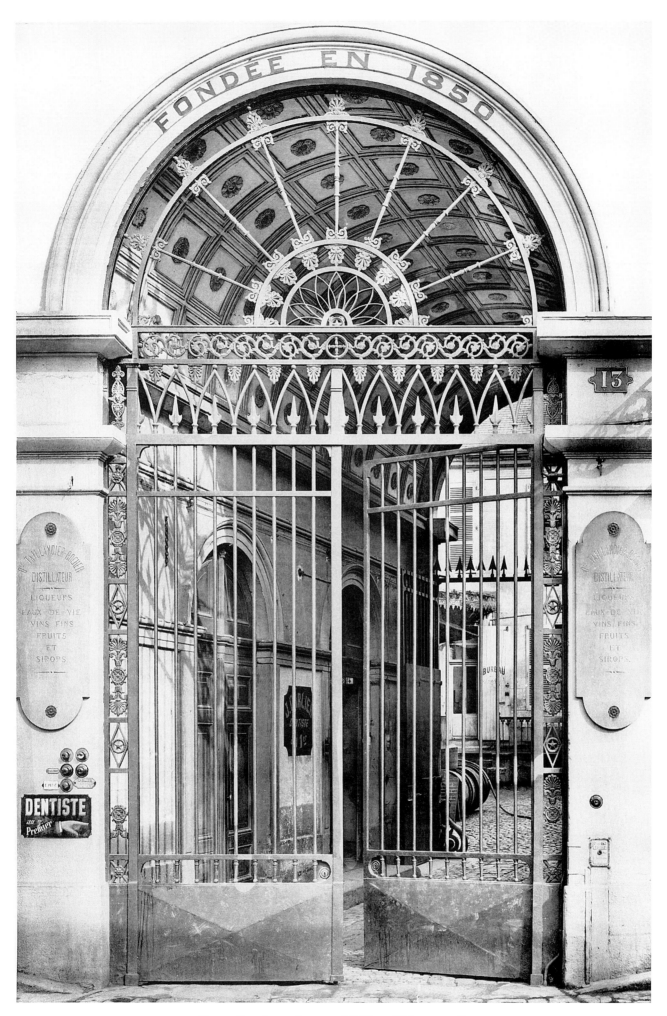

Tours. Empire-style gate, 13 Place Châteauneuf.

Plate 107

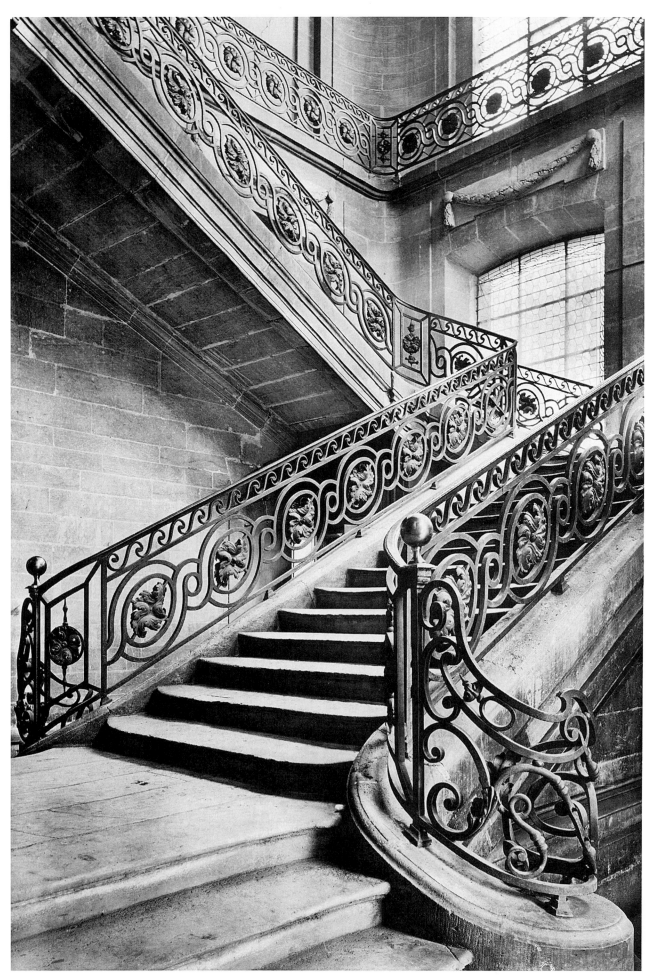

Reims. Hôtel-Dieu (formerly the Saint-Remi cloister).
Staircase of the linen room, built in 1778. View from the bottom.

Plate 108

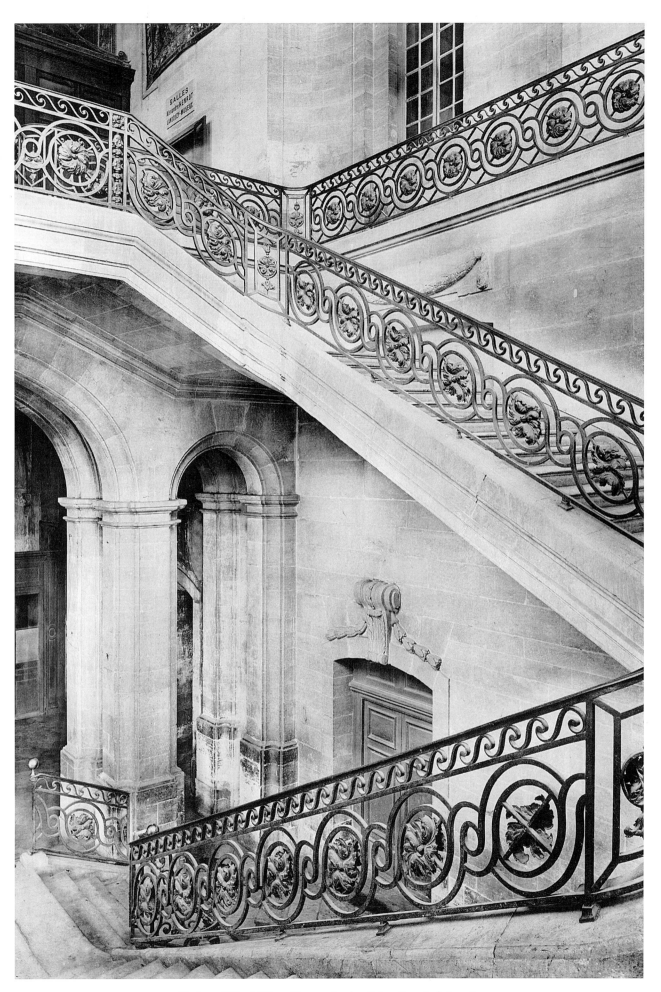

Reims. Hôtel-Dieu (formerly the Saint-Remi cloister).
Linen room staircase, built in 1778. Overall view.

Plate 109

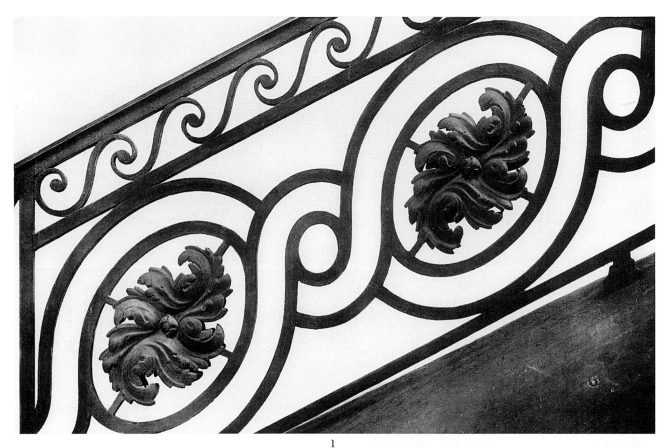

1

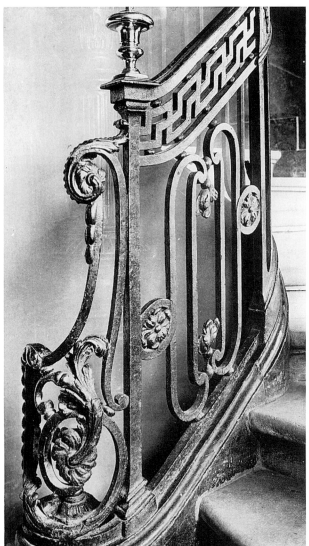

2

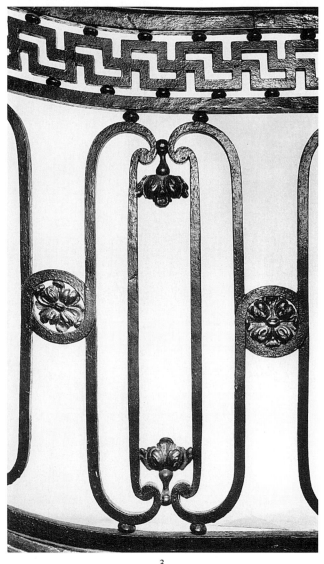

3

Reims. **1.** Hôtel-Dieu (formerly the Saint-Remi cloister). Detail of a panel
of the linen room staircase (0.81 meter high). *Paris.* **2** and **3.** Former townhouse,
9 Rue du Faubourg Poissonnière, belonging to Mrs. Meignan. Foot of stairs and banister detail.

Plate 110

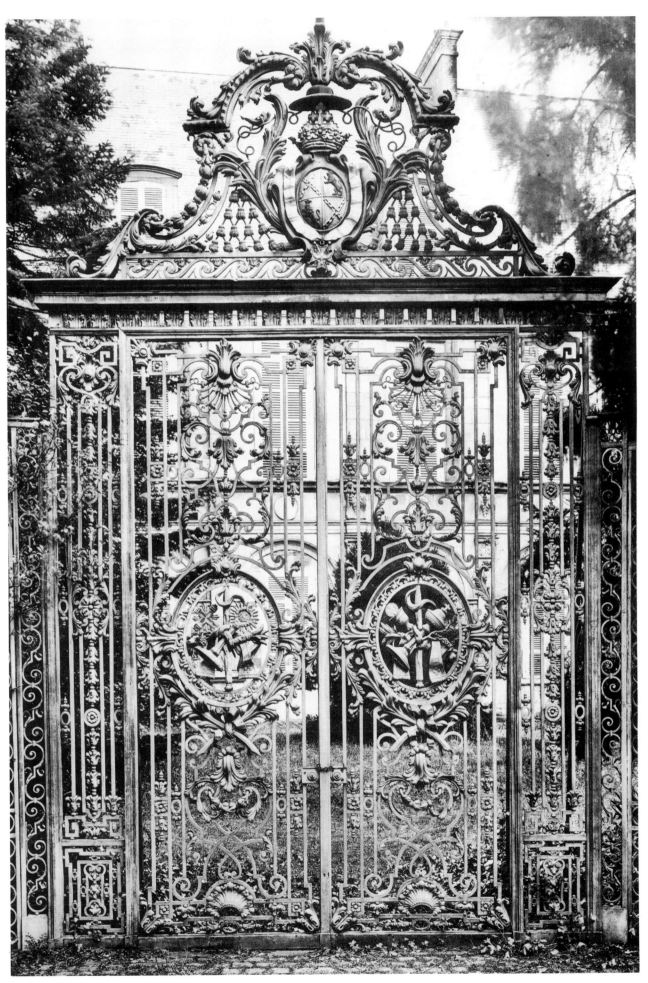

Sens. Main gate of the former archbishop's palace. Width of the gate,
including the pilasters, 4.3 meters.

Plate 111

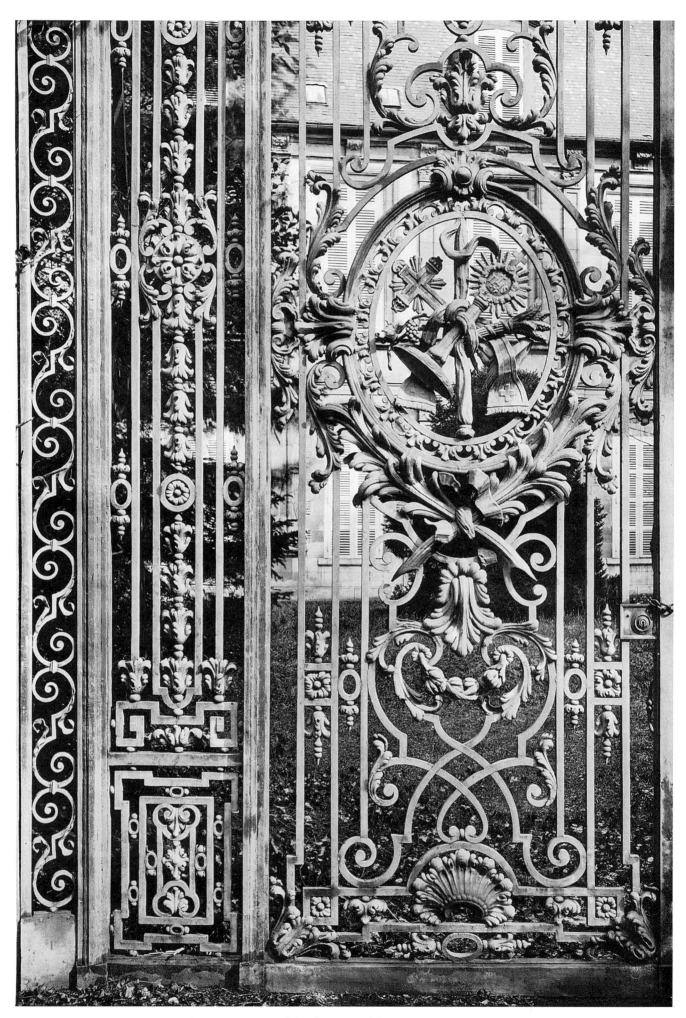

Sens. Main gate of the former archbishop's palace, detail.

Plate 112

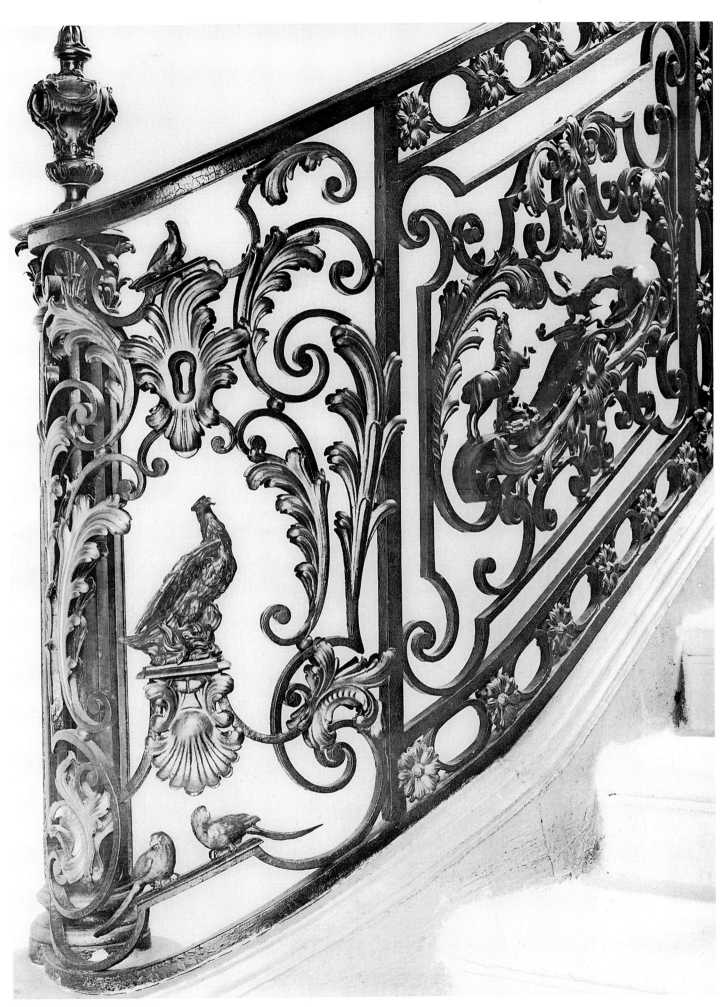

Tours. The Duke of Maillé's townhouse, Rue de l'Archevêché. Start of the banister in wrought iron, decorated with ornaments of spun copper and animals of engraved bronze.

Plate 113

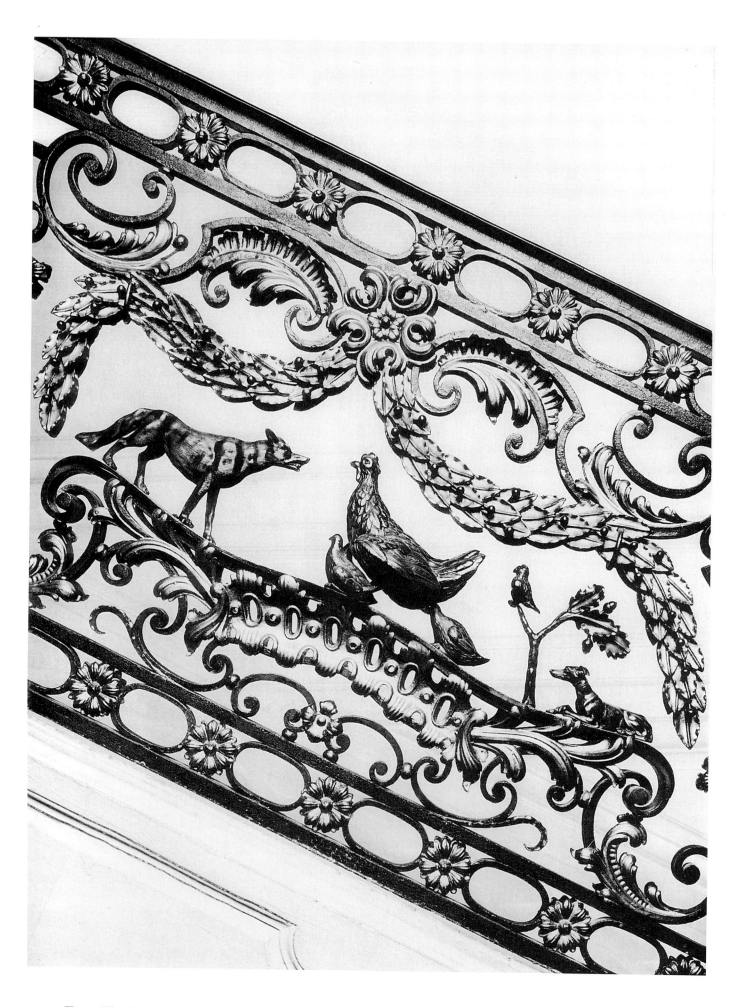

Tours. The Duke of Maillé's townhouse, Rue de l'Archevêché. Detail of a large banister panel decorated with ornaments of spun copper and animals of engraved bronze.

Plate 114

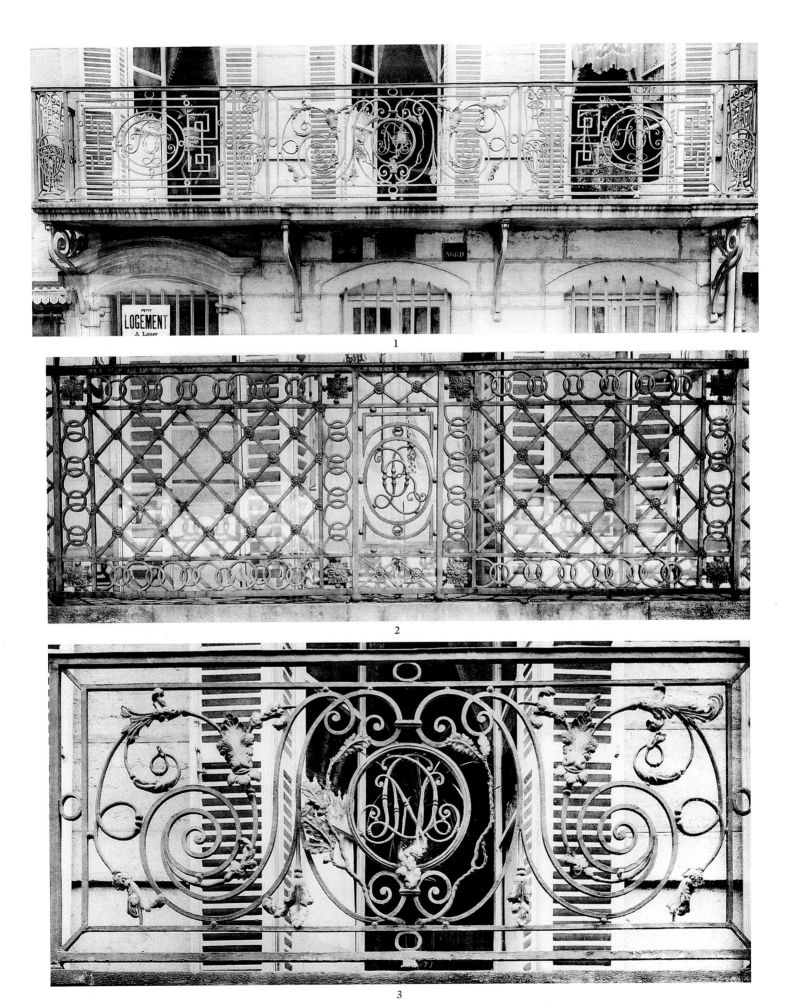

1

2

3

Dijon. **1** and **3.** Balcony of M. Gattefosse's house, 28 Rue Charrue.
2. Louis XVI–style balcony, 9 Rue Vaillant.

Plate 115

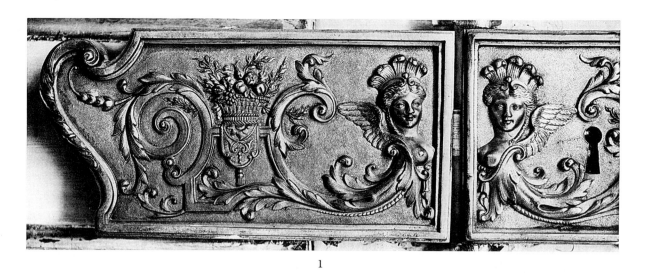

1

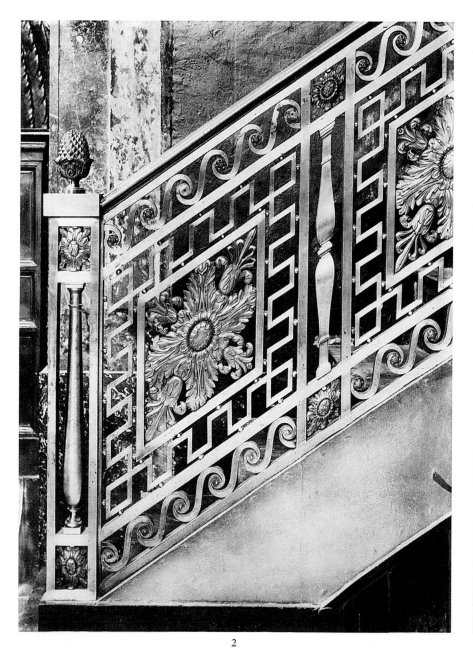

2

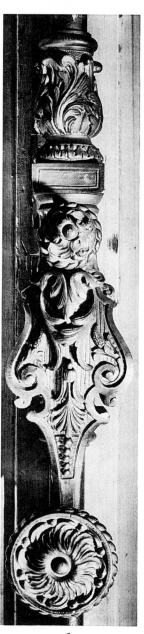

3

Paris. **1.** Lock in the style of Louis XVI. **2.** Stairs to the pulpit of St-Roch church, made during the First Empire of polished wrought iron, with ornaments of engraved and gilded bronze. **3.** Hasp of the Soubise townhouse.

Plate 116

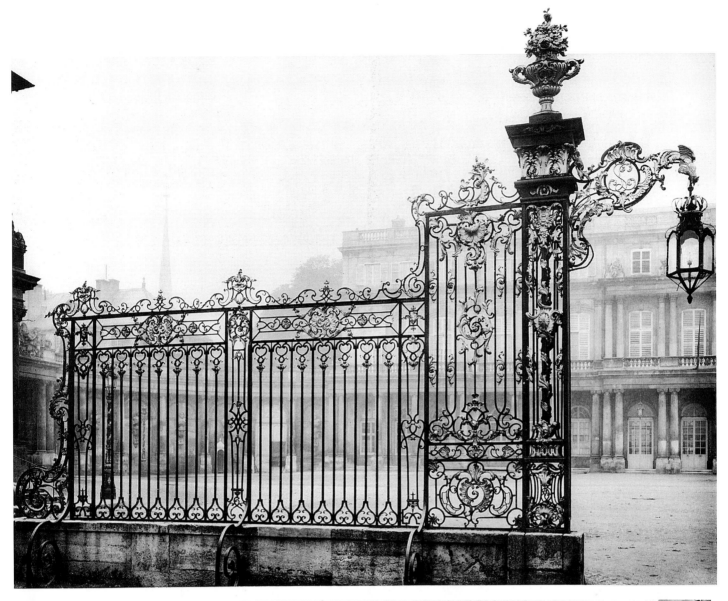

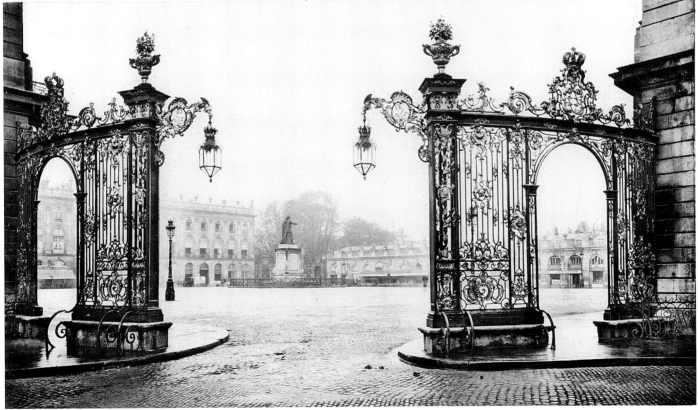

Nancy. **1.** Grillwork of the Hémicycle de la Carrière. **2.** Grillwork on Place Stanislaus.

Plate 117

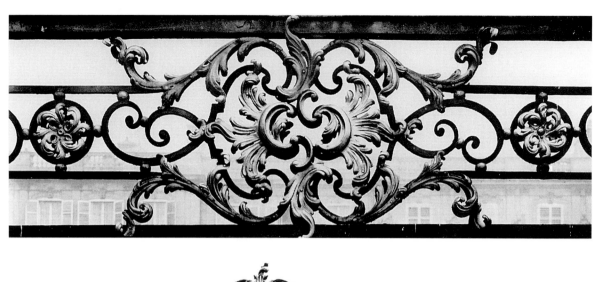

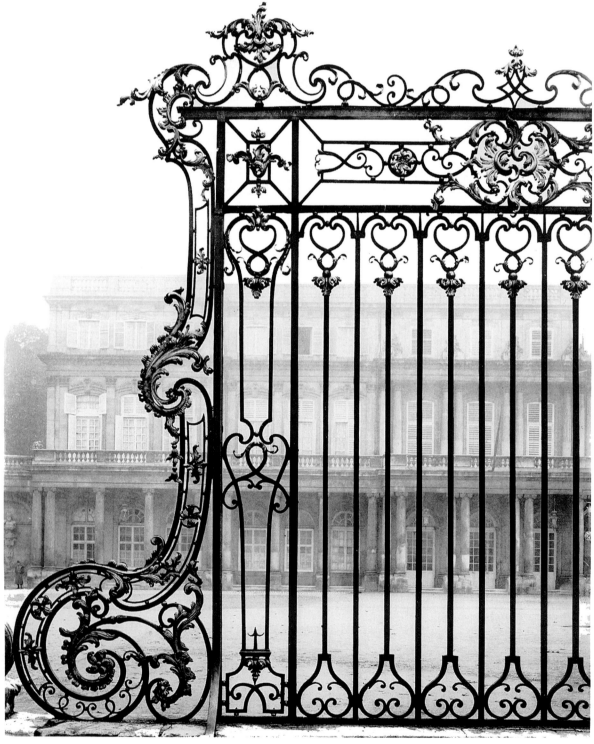

Nancy. Hémicycle de la Carrière. Details of the grillwork.

Plate 118

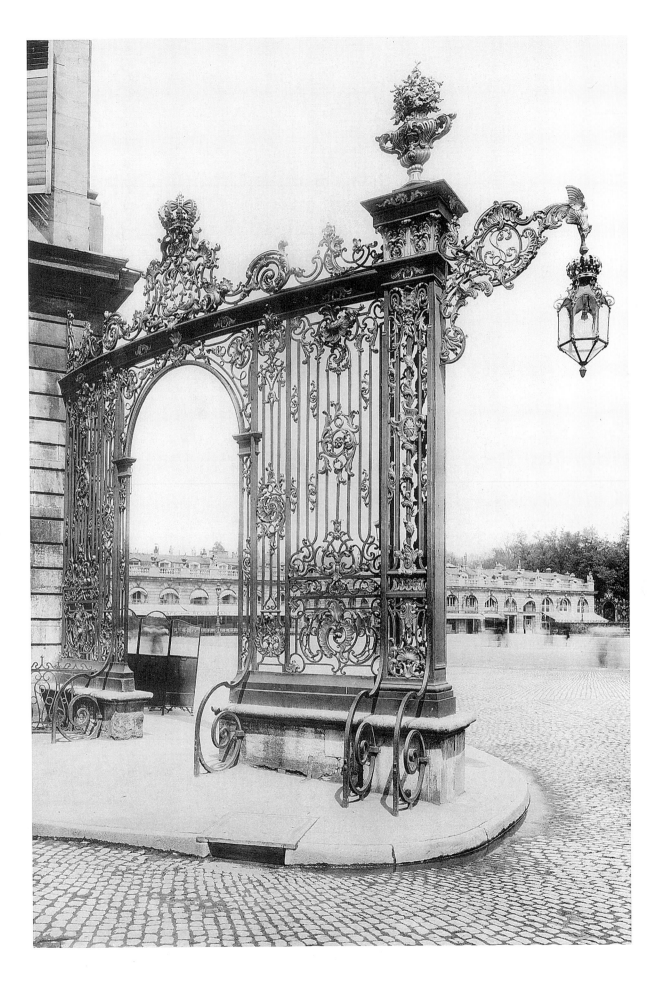

Nancy. Place Stanislaus. Grillwork of wrought iron enhanced with gold.
Executed by the celebrated ironworker Jean Lamour.

Plate 119

Nancy. Place Stanislaus. Large-scale detail of the crest of the grillwork.

Plate 120

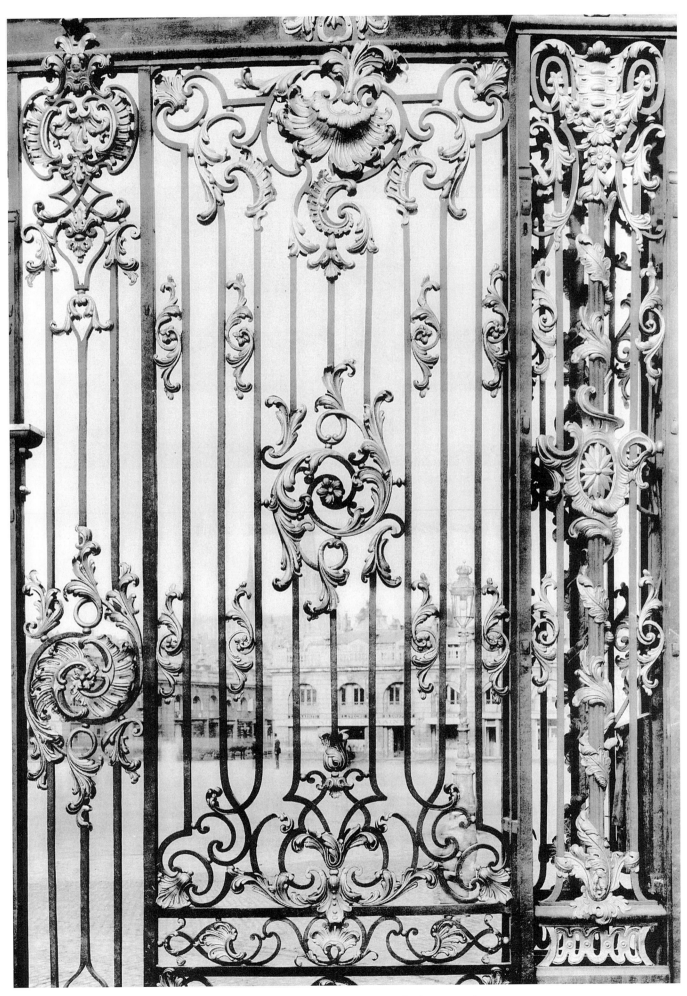

Nancy. Place Stanislaus. Details of a large panel.

Plate 121

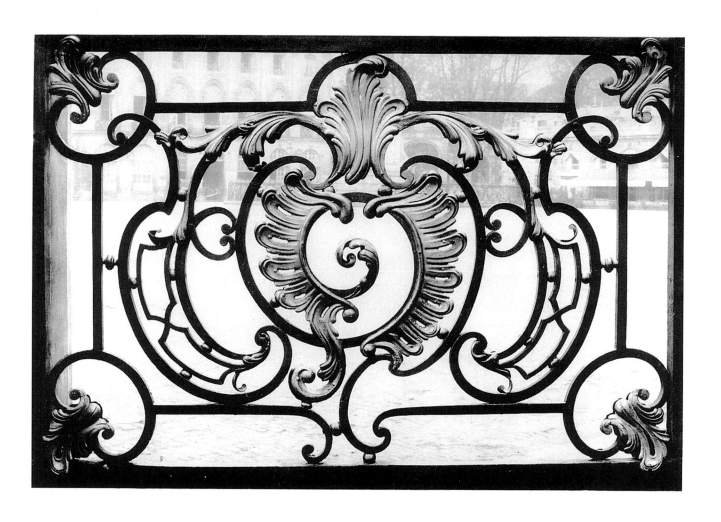

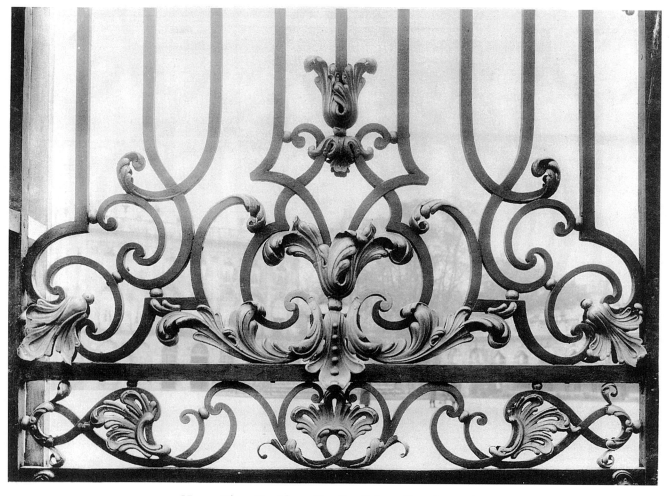

Nancy. Place Stanislaus. Details of the grillwork panels.

Plate 122

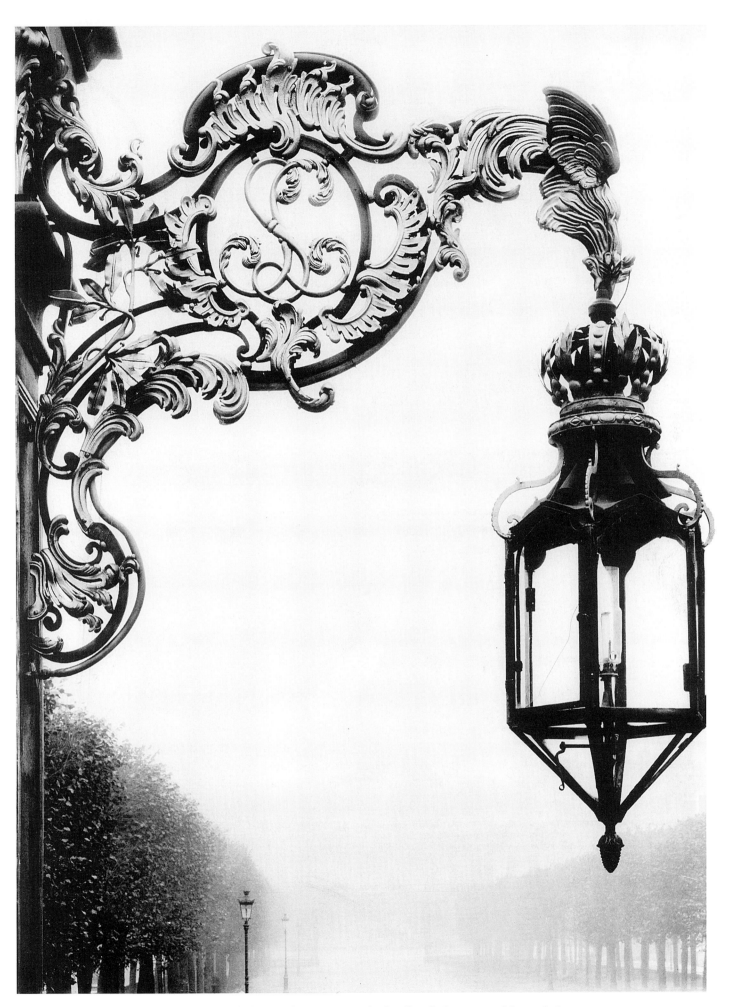

Nancy. Place de la Carrière. Large-scale details of a lantern and its corbel.

Plate 123

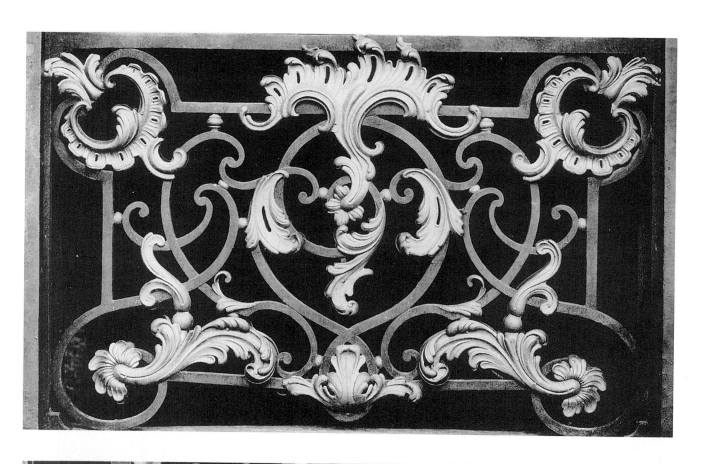

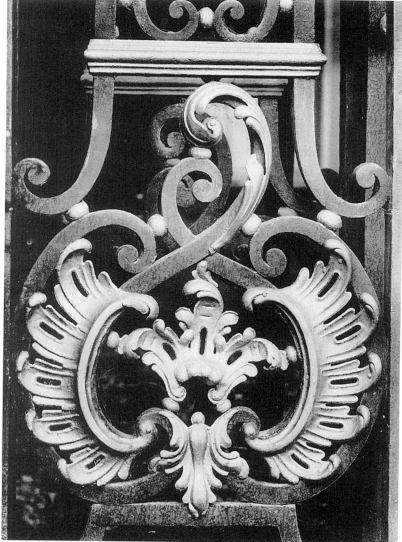

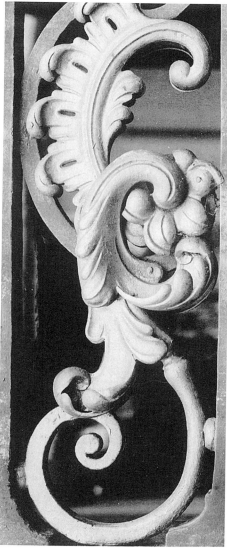

Nancy. Place Stanislaus. Large-scale details of the grillwork ornaments.

Plate 124

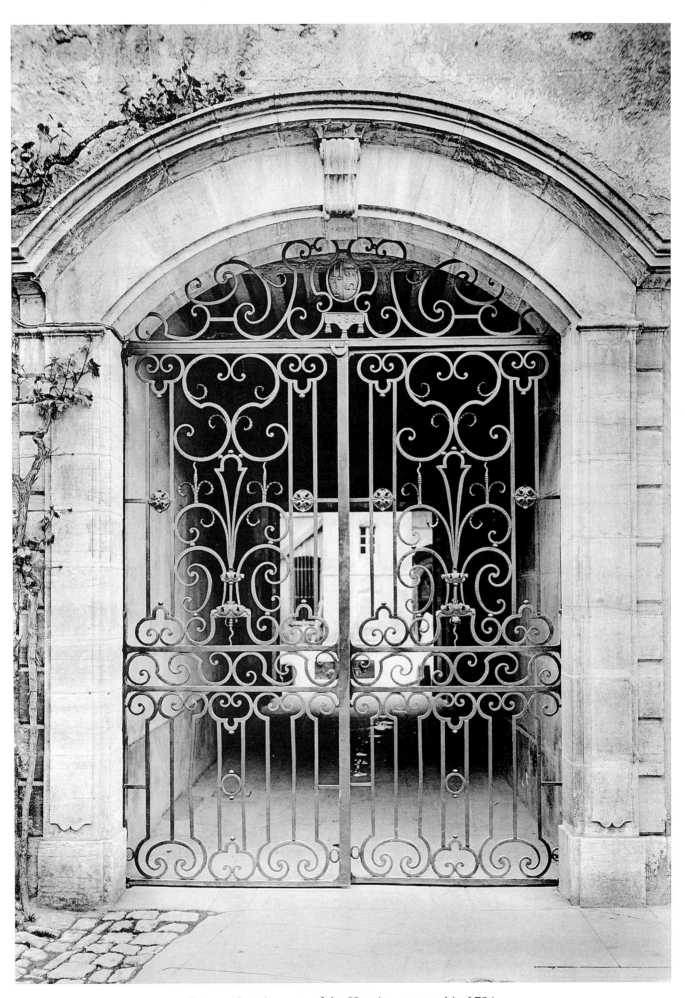

Beaune. Interior gate of the Hospice, executed in 1786.

Plate 125

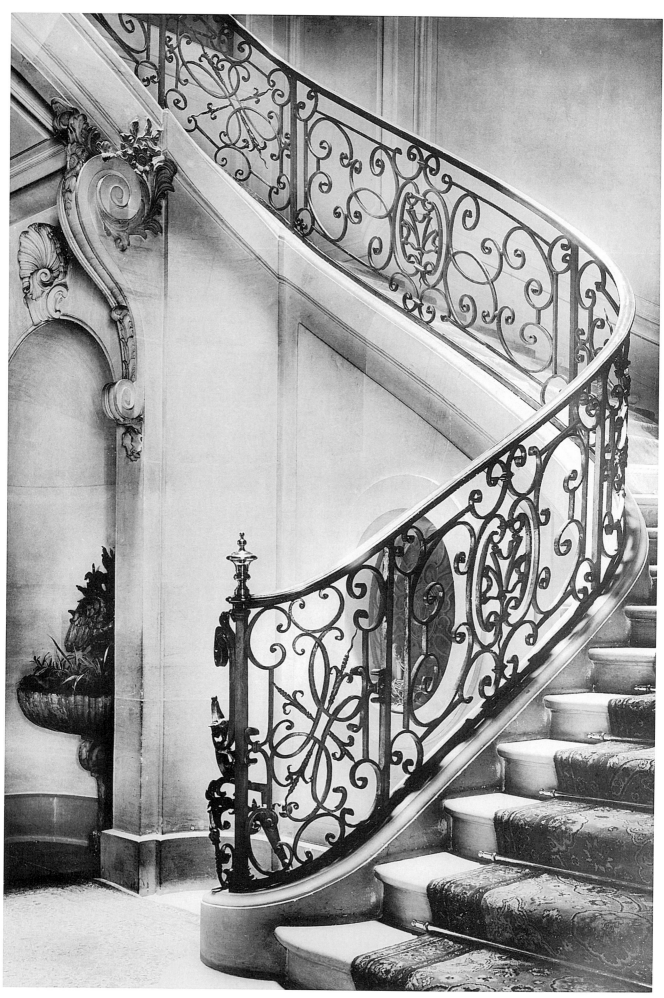

Paris. Staircase in the Hôtel Ritz, 15 Place Vendôme.

Plate 126

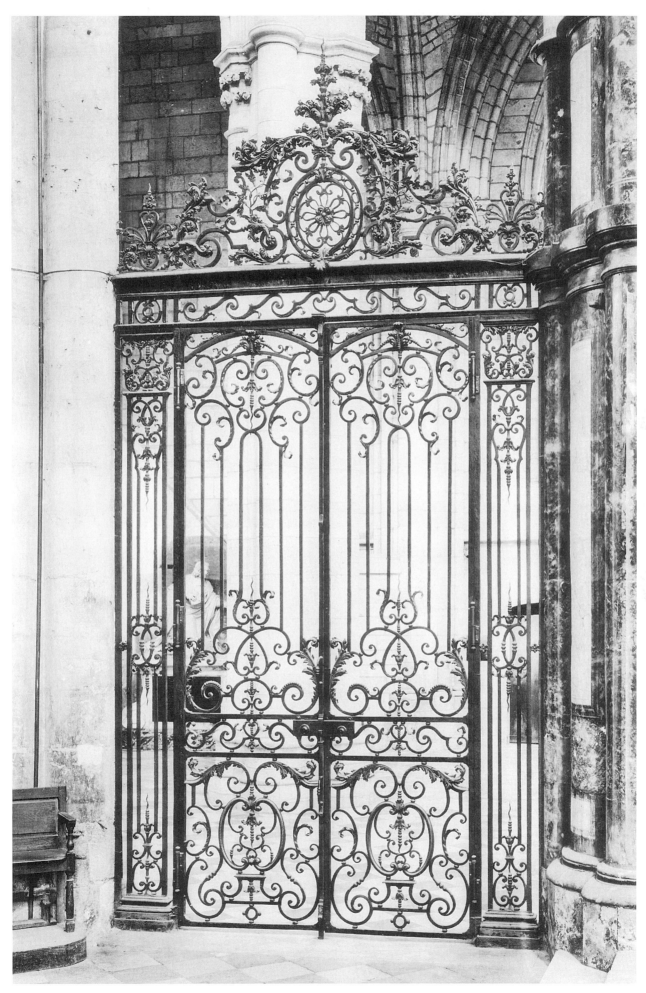

Beauvais. Gate of the choir enclosure of the Saint-Pierre Cathedral.

Plate 127

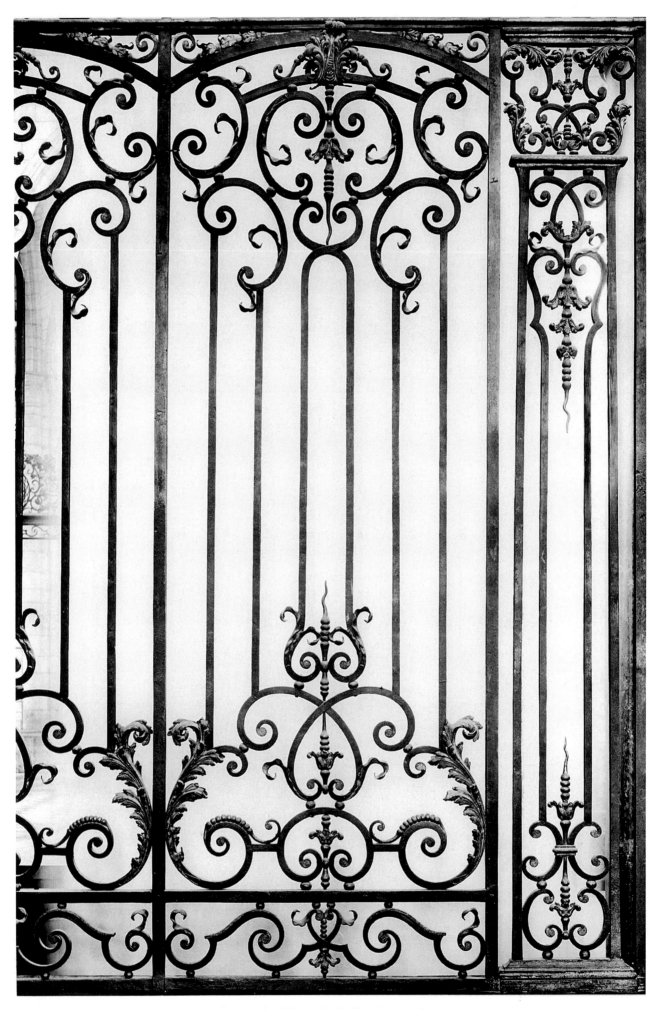

Beauvais. Detail of the cathedral's choir enclosure gate.

Plate 128

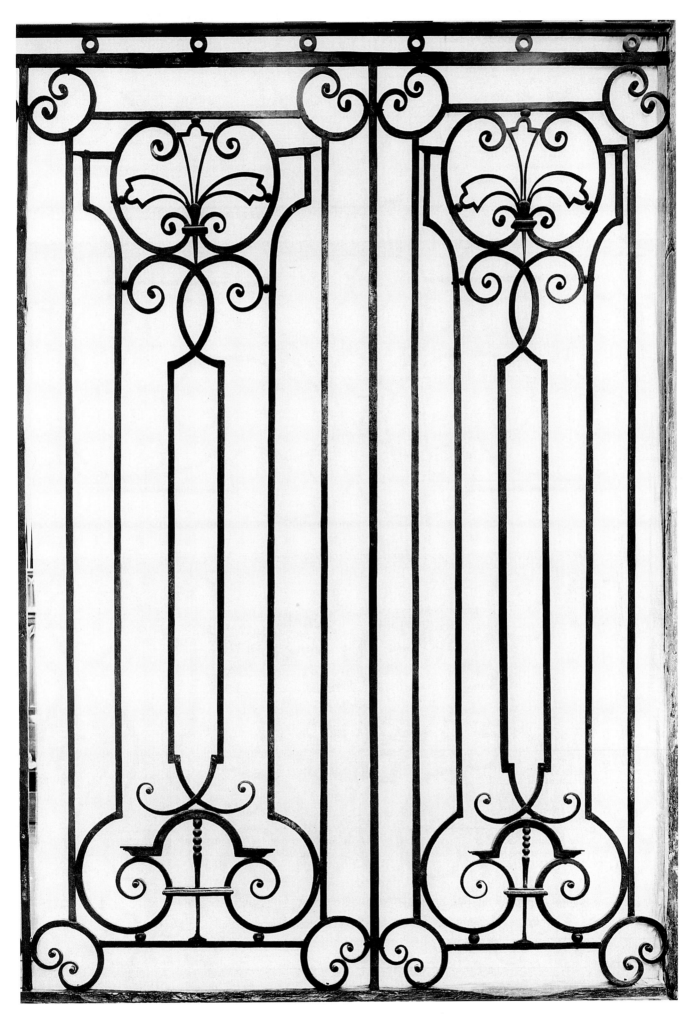

Beauvais. Detail of the cathedral's choir enclosure gate.

Plate 129

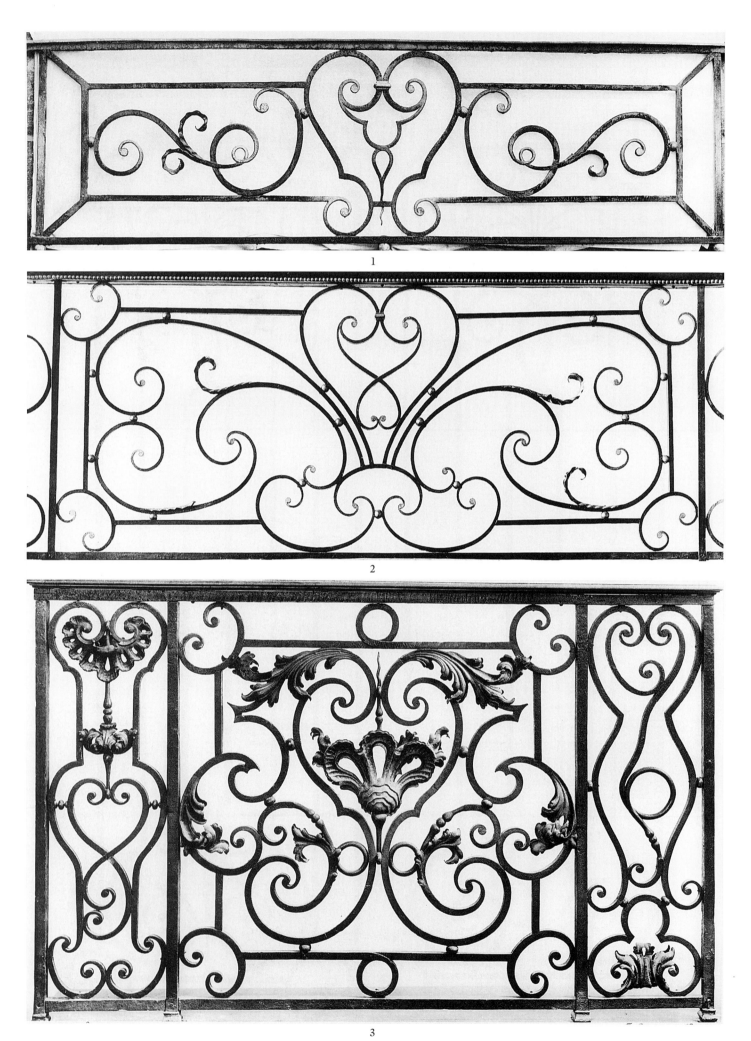

Dijon. **1** and **2.** Balcony and banister of the Prefecture.
3. Balcony of the Bishopric (now in the Museum).

Plate 130

Vaubadon. Main gate of the Château de Broglie.

Plate 131

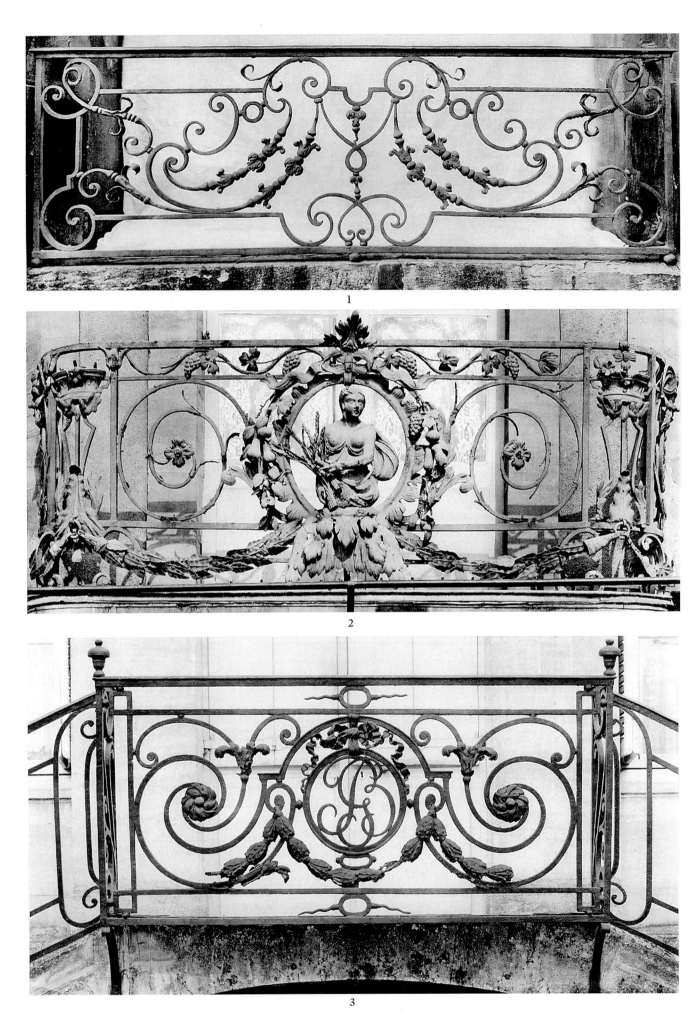

Paris. **1.** Window rail of the Hôtel Lambert. *Bayeux.* **2.** Balcony at 1 Rue Saint-Jean.
Vaubadon. **3.** Central part of the banister of a stoop at the Château de Broglie.

Plate 132

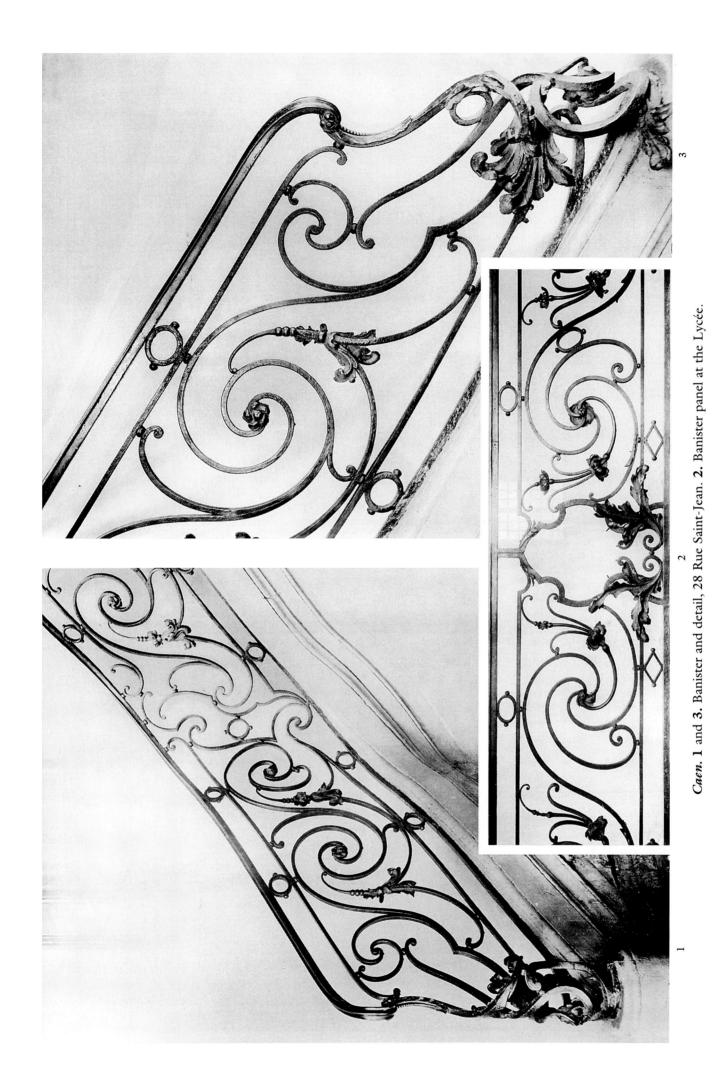

Caen. **1** and **3.** Banister and detail, 28 Rue Saint-Jean. **2.** Banister panel at the Lycée.

3

2

1

Plate 133

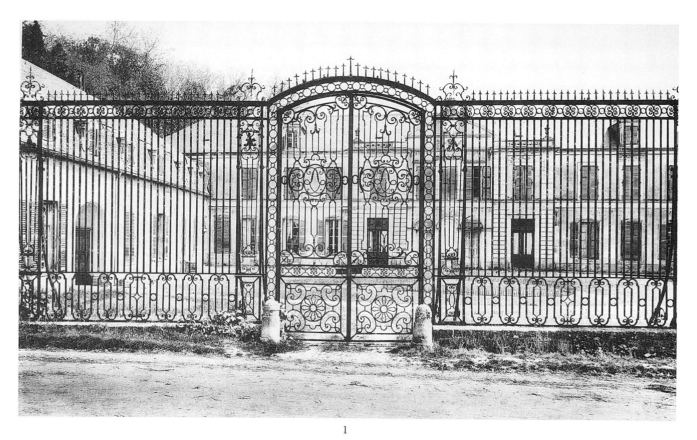

1

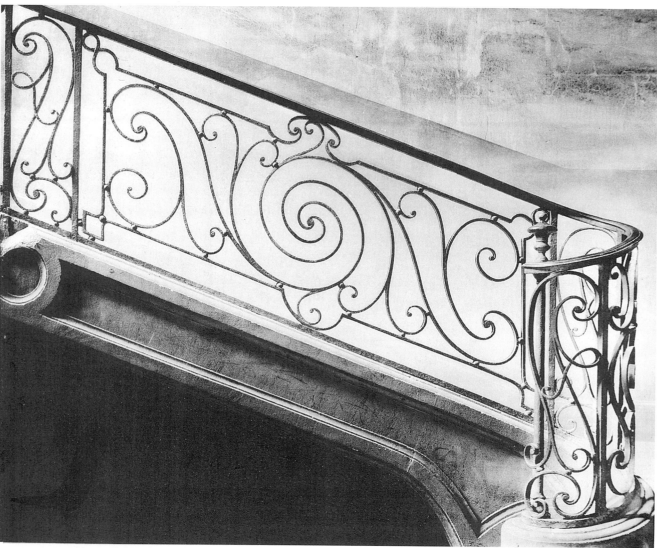

2

Oisilly. **1.** Overall view of the castle fence. *Bayeux.* **2.** Banister in the Museum.

Plate 134

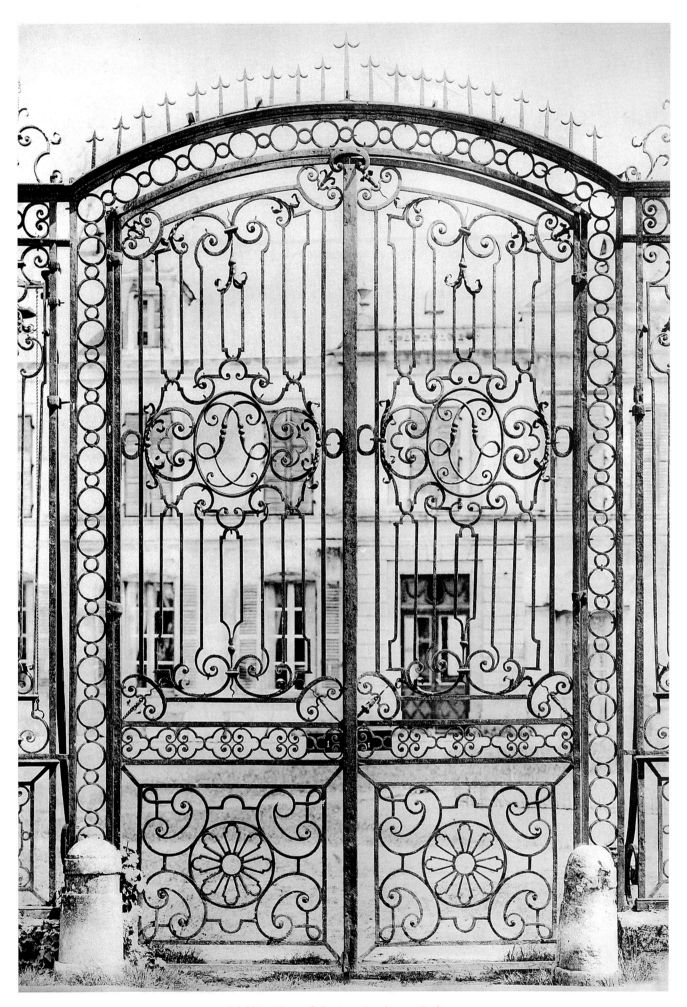

Oisilly. View of the gate in the castle fence.

Plate 135

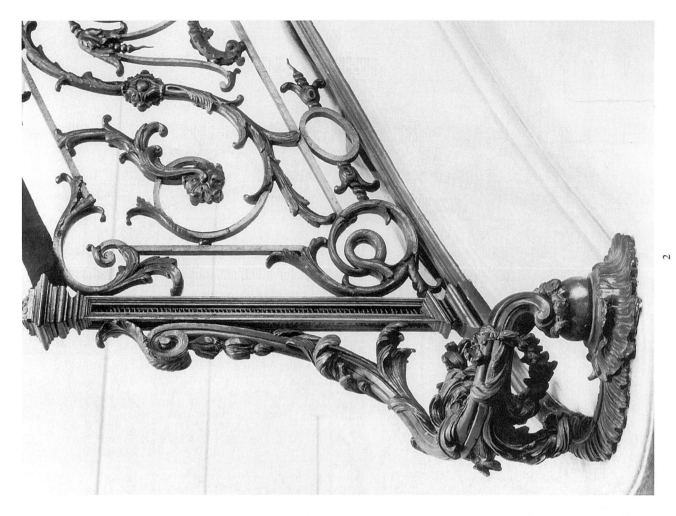

2

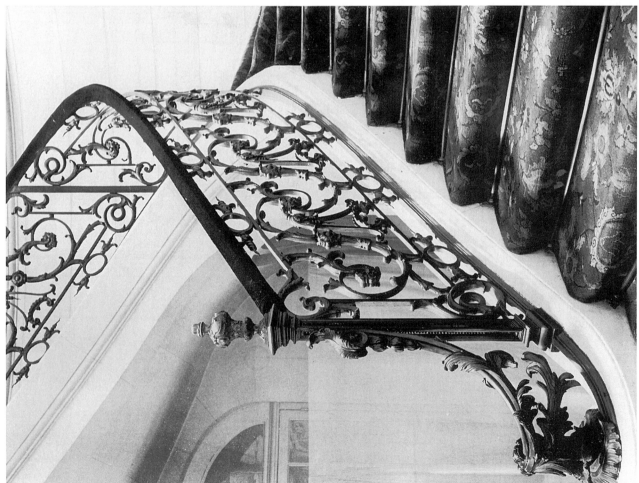

1

Paris. Hôtel d'Evreux, 19 Place Vendóme. **1.** Banister of the main staircase. **2.** Detail of the foot of the stairs.

Plate 136

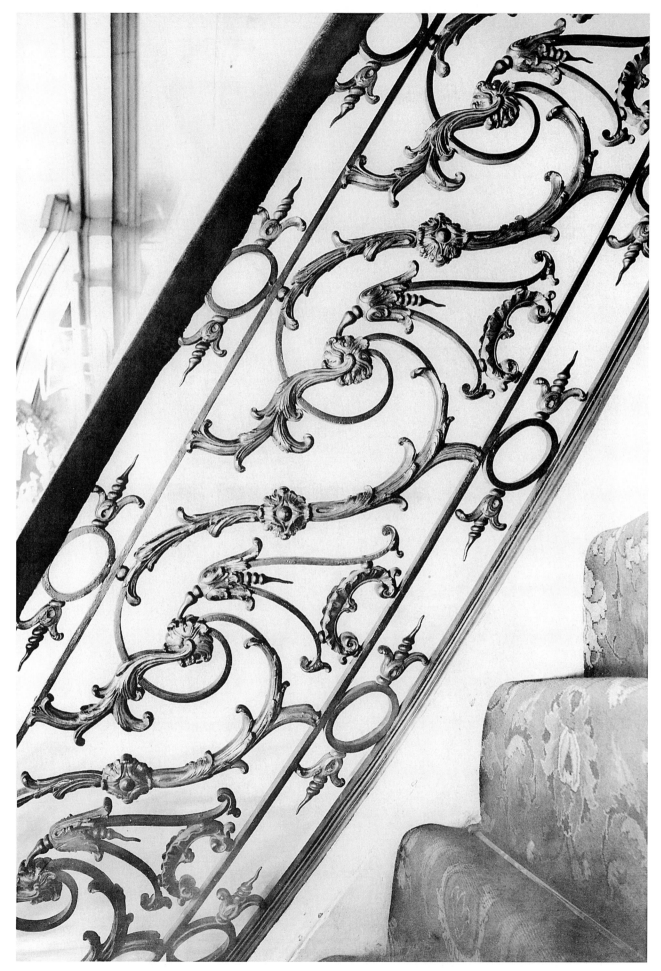

Paris. Hôtel d'Evreux, 19 Place Vendôme. Banister of the main staircase.

Plate 137

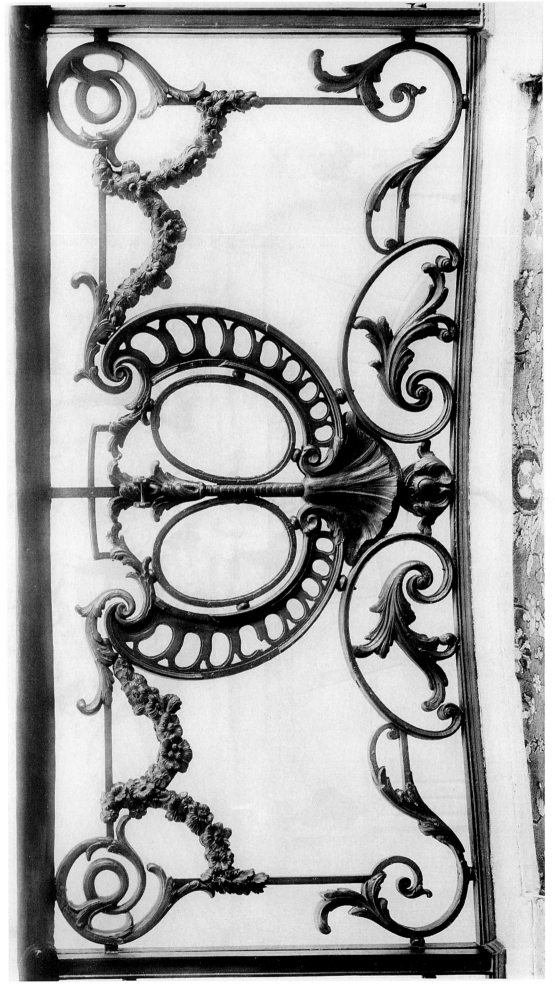

Paris. Hôtel d'Evreux, 19 Place Vendôme. Motif of the banister that forms a balcony on the second floor.

Plate 138

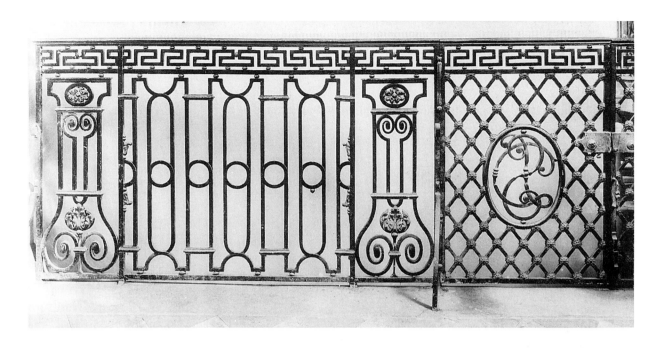

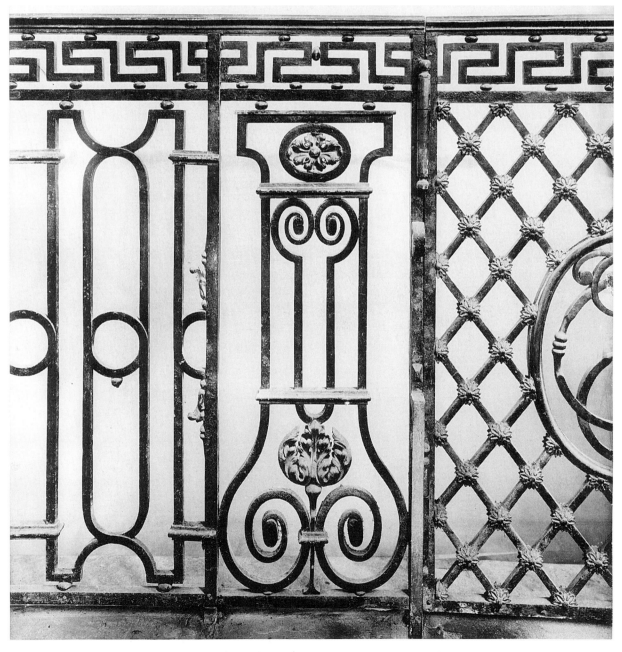

Beauvais. Cathedral communion rail and detail.

Plate 139

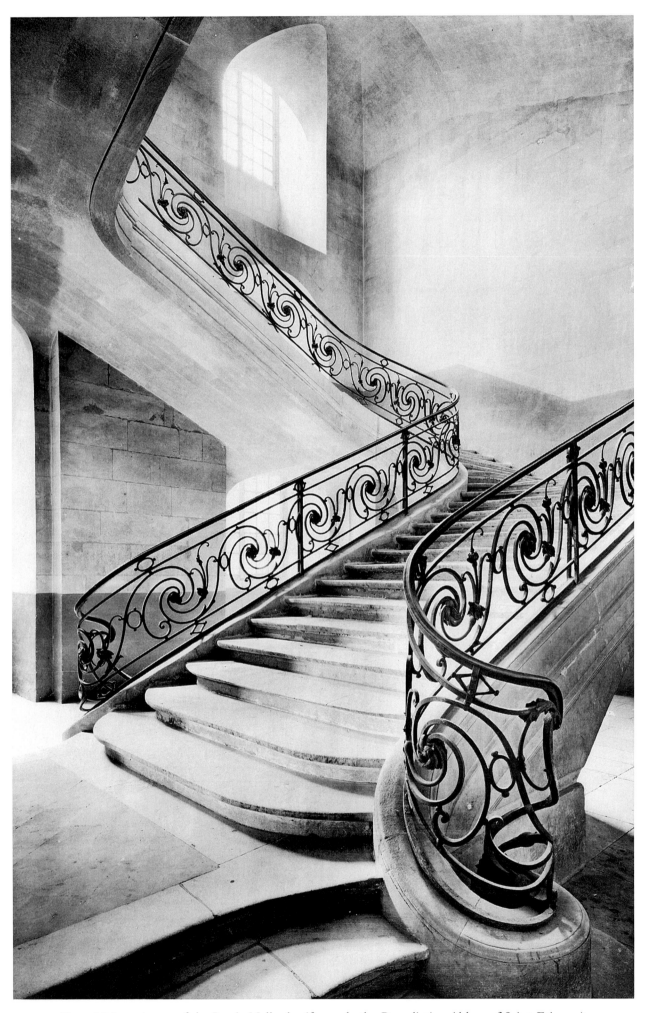

Caen. Main staircase of the Lycée Malherbe (formerly the Benedictine Abbey of Saint-Etienne).

Plate 140

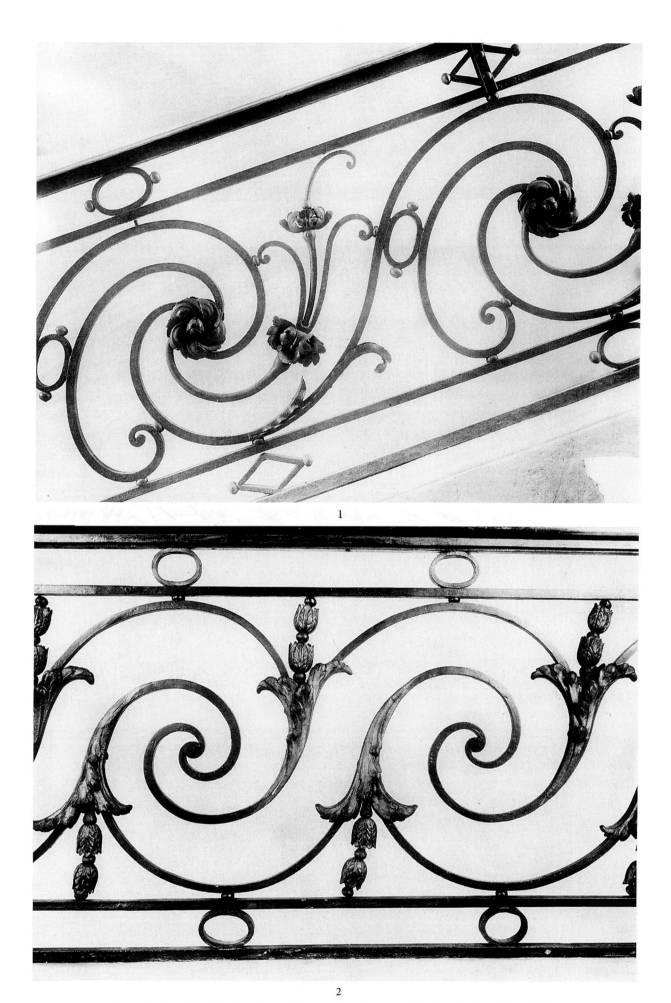

1

2

Caen. **1.** Detail of the banister of the main staircase of the Lycée (see Plate 140).
Paris. **2.** Detail of the banister at 12 Place Vendôme.

Plate 141

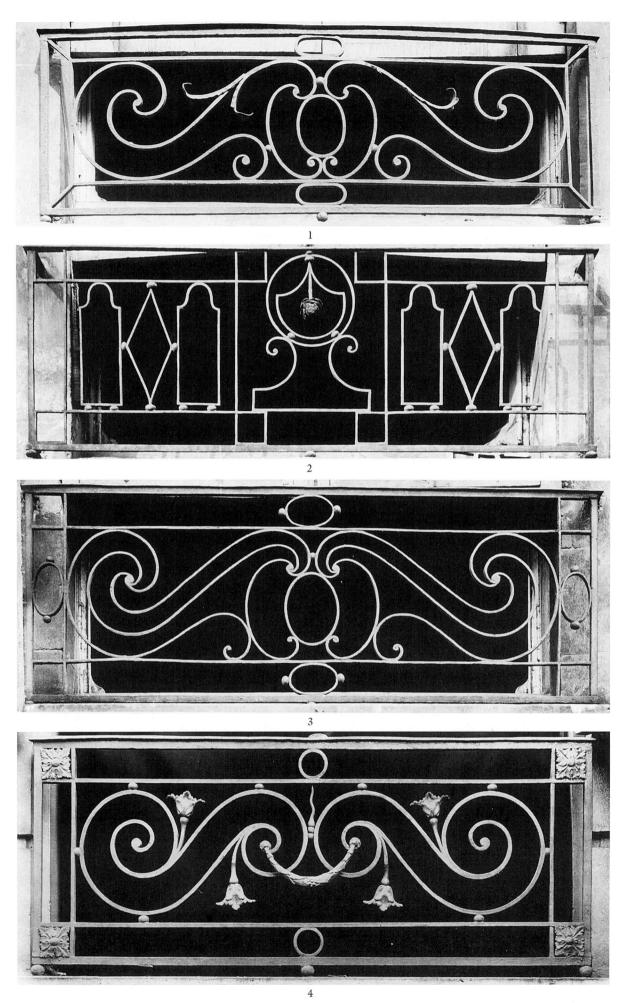

1

2

3

4

Caen. **1–3.** Window rails at 23 Rue Guilbert, 6A Rue Pémagnie, and 27 Place Saint-Sauveur.
Paris. **4.** Window rail at 15 Rue de Grenelle (Hôtel de Bérulle).

Plate 142

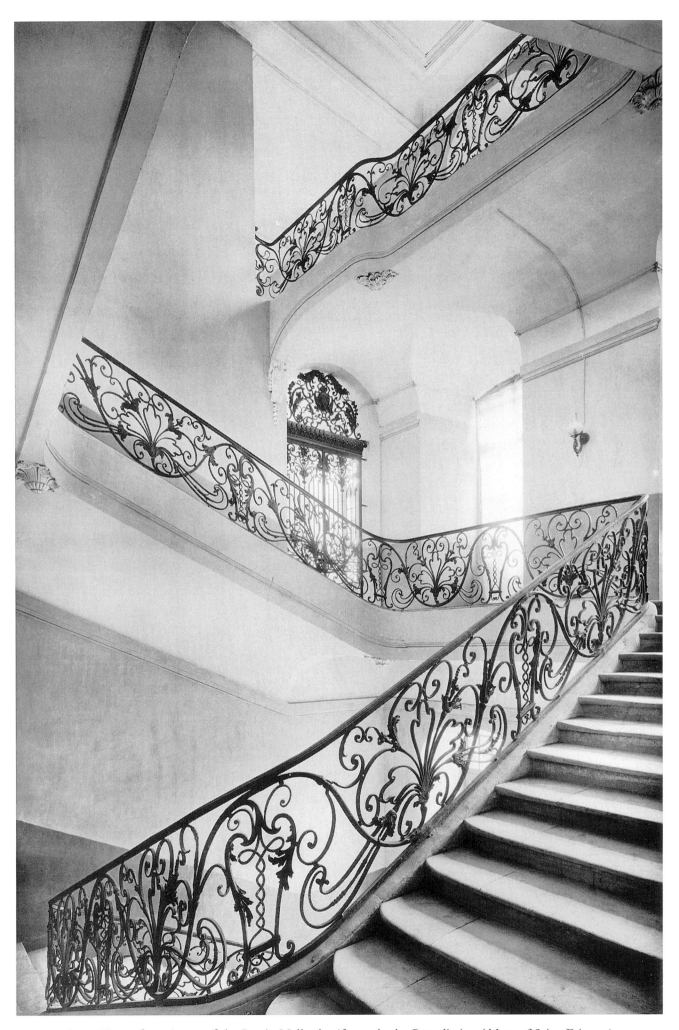

Caen. View of a staircase of the Lycée Malherbe (formerly the Benedictine Abbey of Saint-Etienne).

Plate 143

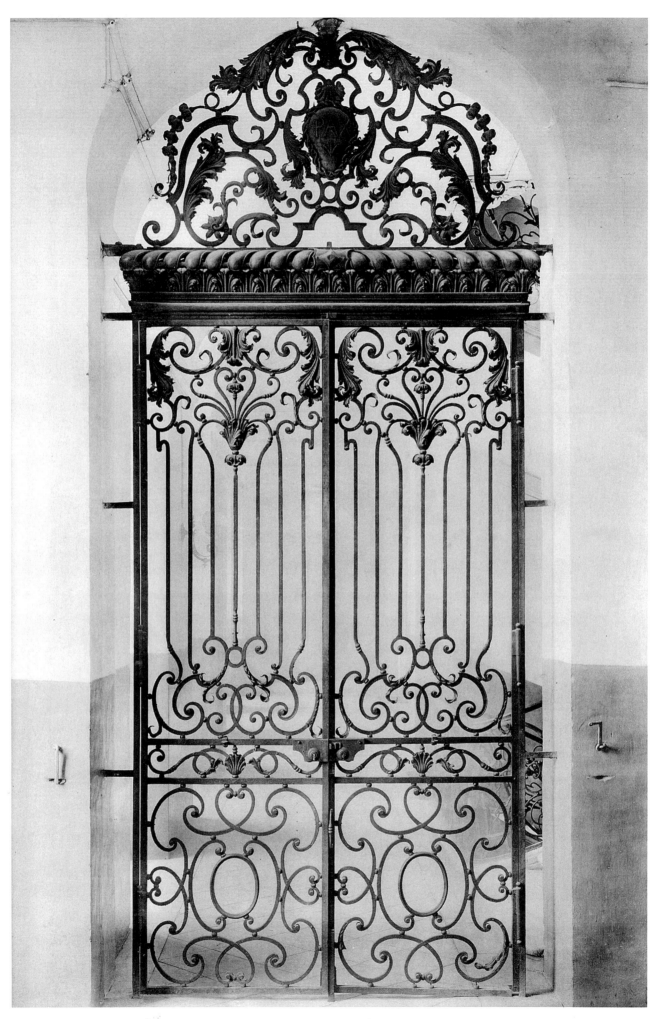

Caen. Inside gate of the Lycée Malherbe (the former Abbey of Saint-Etienne).

Plate 144

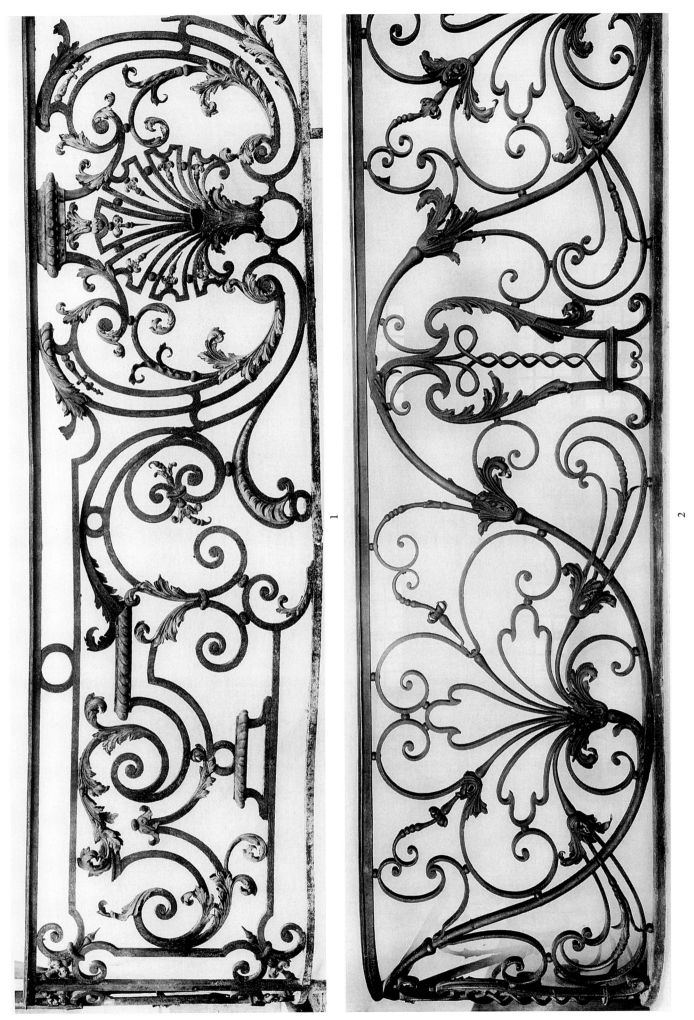

1

2

Paris. **1.** Banister in the Carnavalet Museum. *Caen.* **2.** Detail of the banister of the Lycée staircase shown in plate 143.

Plate 145

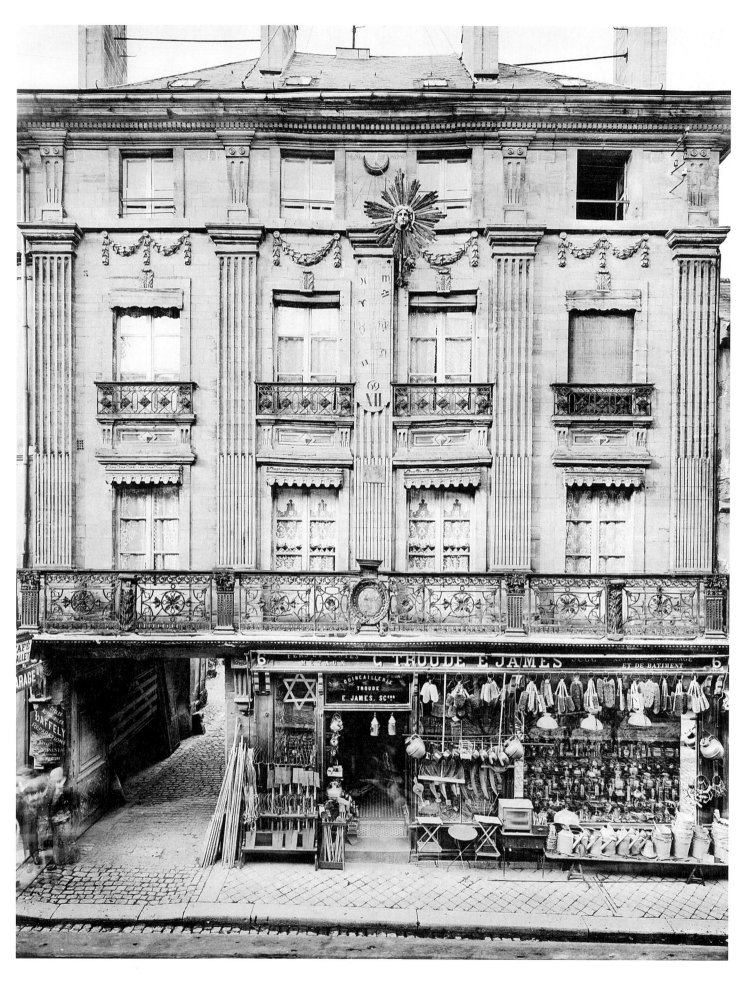

Bayeux. House known as "The Big Balcony," 6 Rue Saint-Martin.

Plate 146

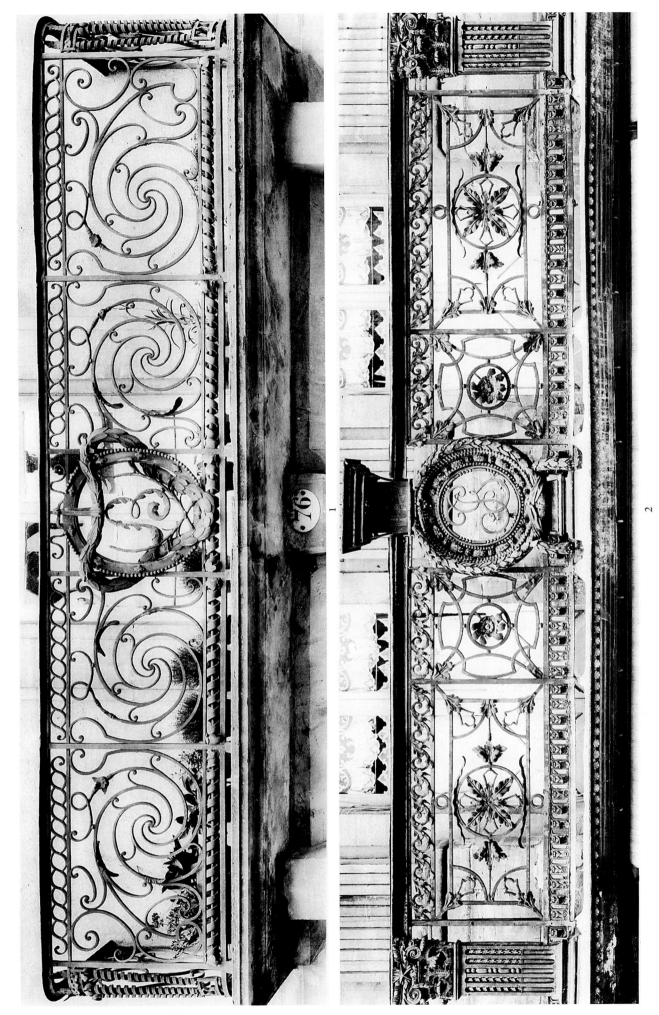

Bayeux. 1. Balcony at 76 Rue des Bouchers. 2. Balcony at 6 Rue Saint-Martin.

Plate 147

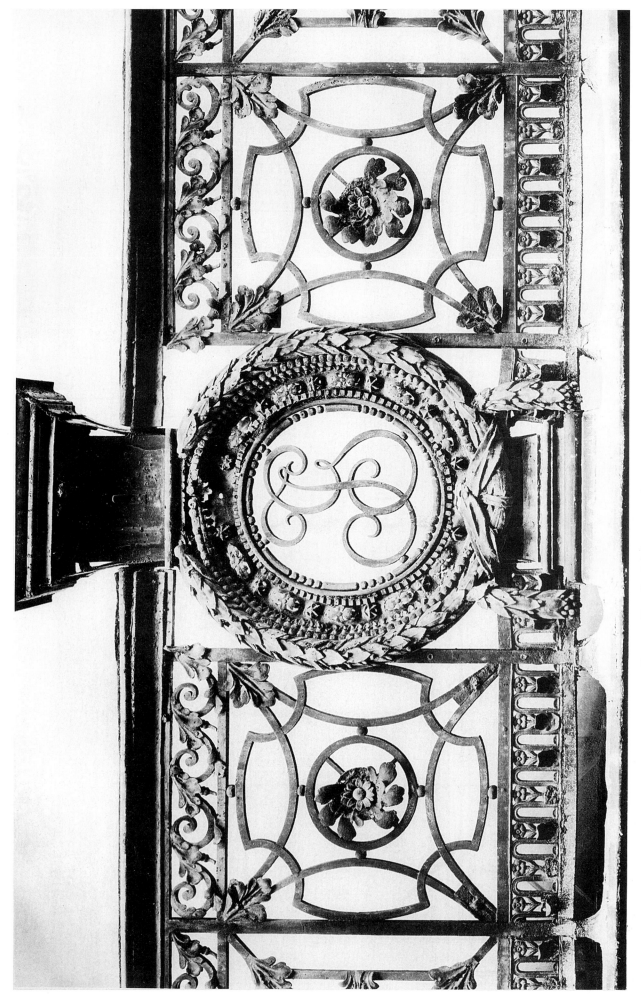

Bayeux. Detail of "The Big Balcony," 6 Rue Saint-Martin.

Plate 148

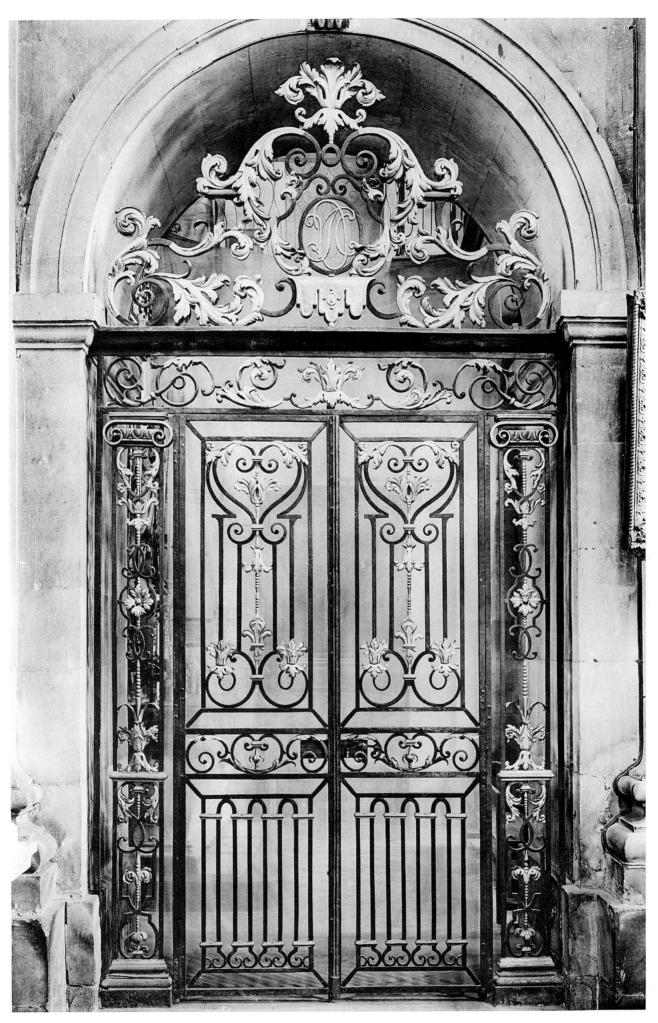

Caen. Gate of a chapel at Notre-Dame Church.

Plate 149

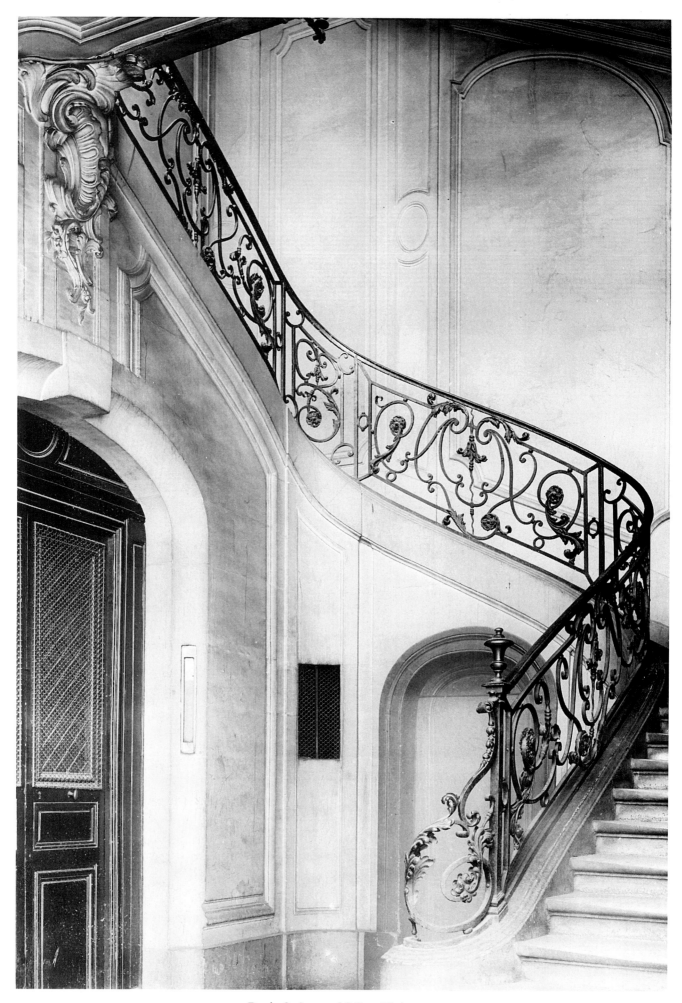

Paris. Staircase, 18 Rue Vivienne.

Plate 150

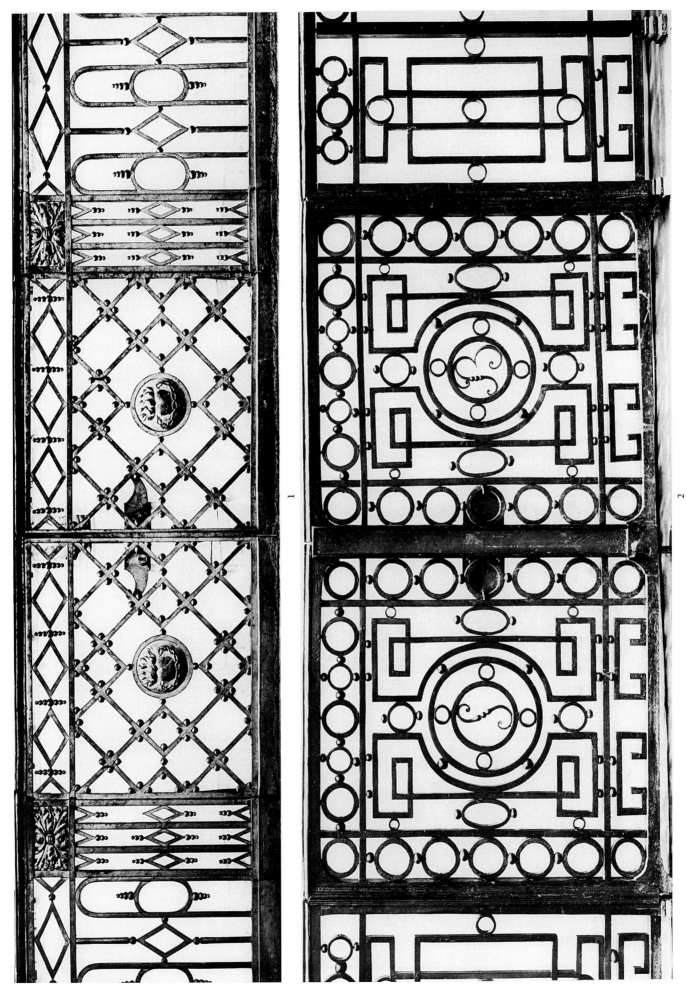

Beauvais. 1. Communion rail at Saint-Pierre Cathedral. *Dijon.* 2. Communion rail at Saint-Bénigne Cathedral.

Plate 151

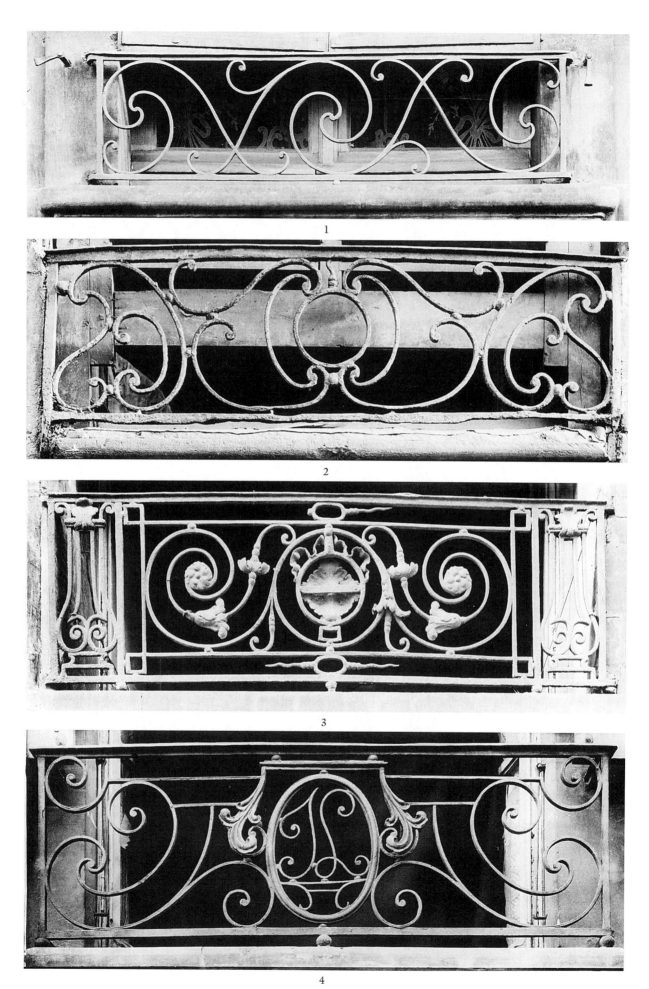

Caen. **1–4.** Window rails at 26 Place Saint-Sauveur, 3 Rue de Ham,
214 Rue Saint-Jean, and 26 Rue Guillaume-le-Conquérant.

Plate 152

Beauvais. Grille enclosing the choir at Saint-Étienne Church.

Plate 153

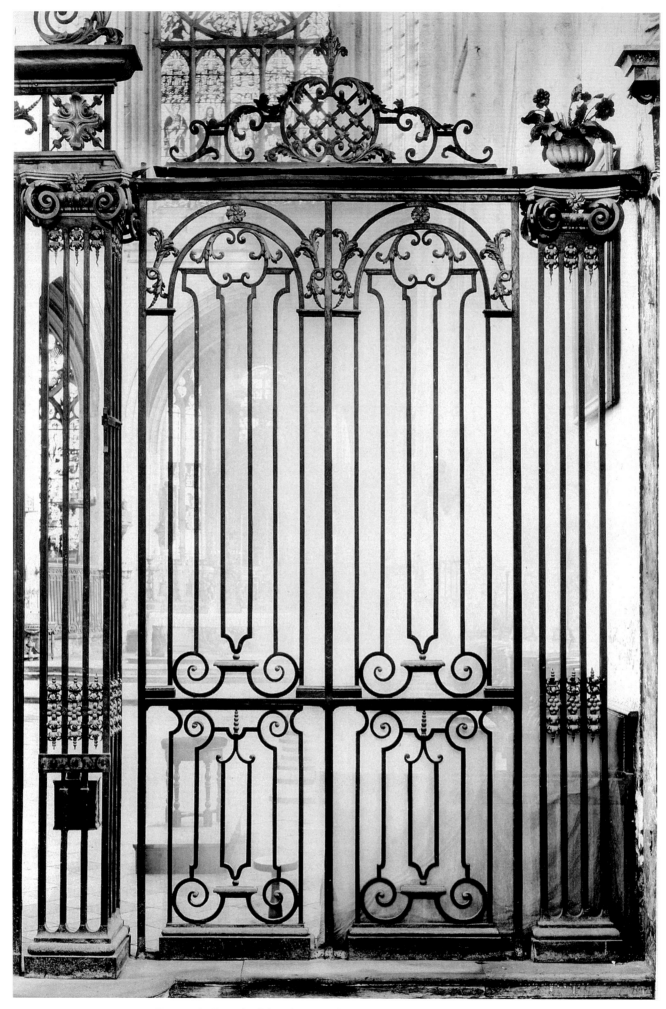

Beauvais. Detail of the choir enclosure at Saint-Etienne Church.

Plate 154

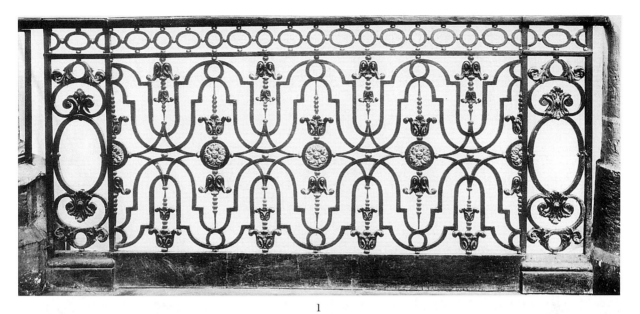

1

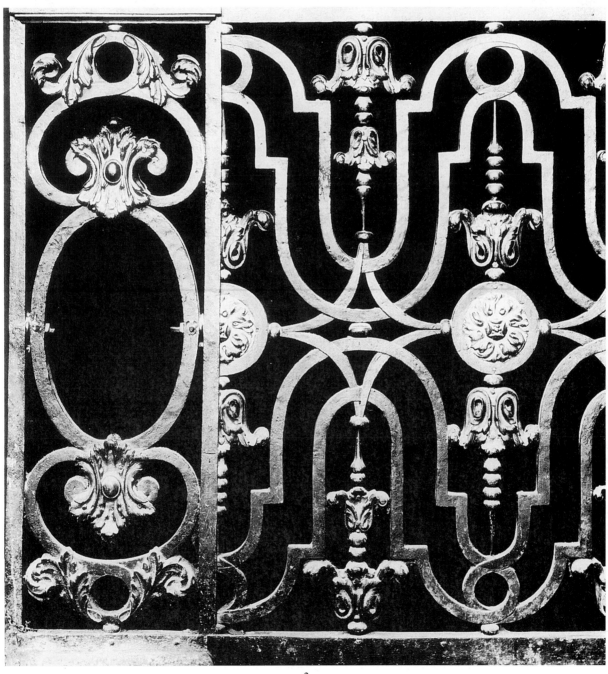

2

Beauvais. 1 and 2. Chapel enclosure at the Cathedral.

Plate 155

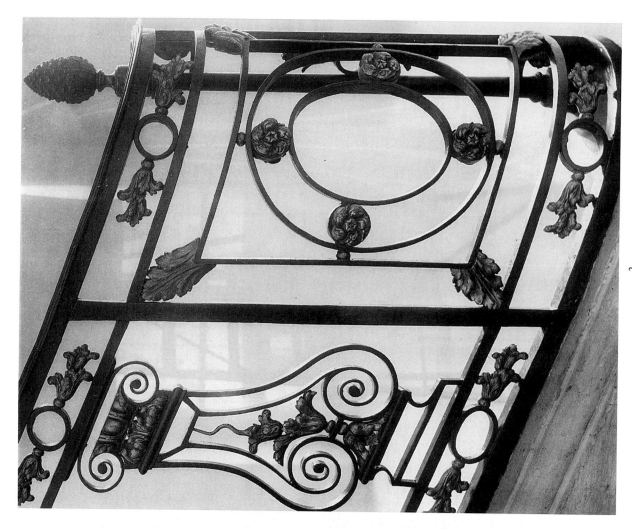

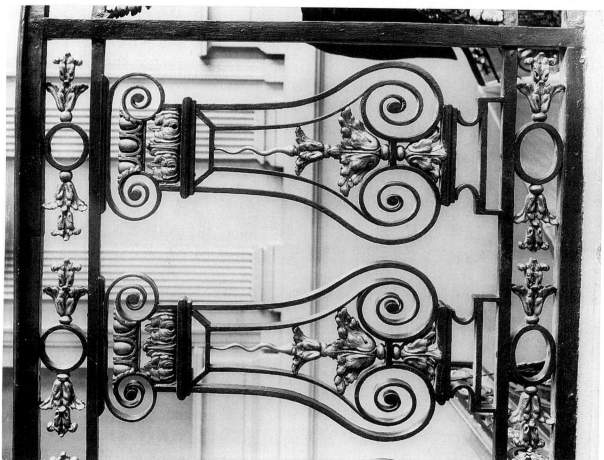

2

1

Paris. **1** and **2**. Hôtel du Châtelet, 127 Rue de Grenelle. Grand staircase banister details.

Plate 156

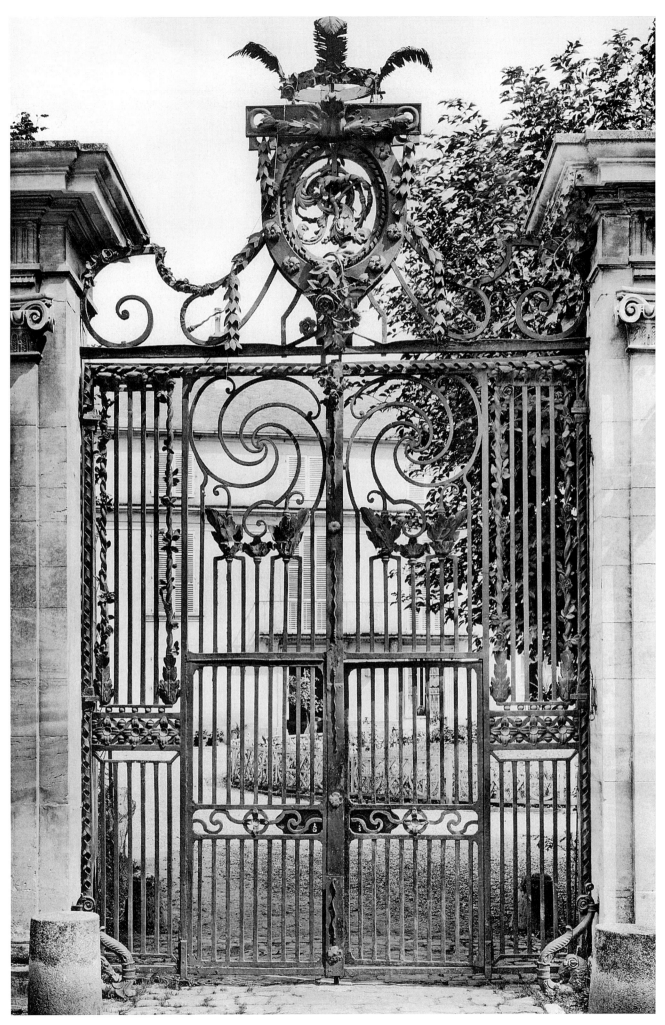

Bayeux. Entry gate, Rue d'Aprigny.

Plate 157

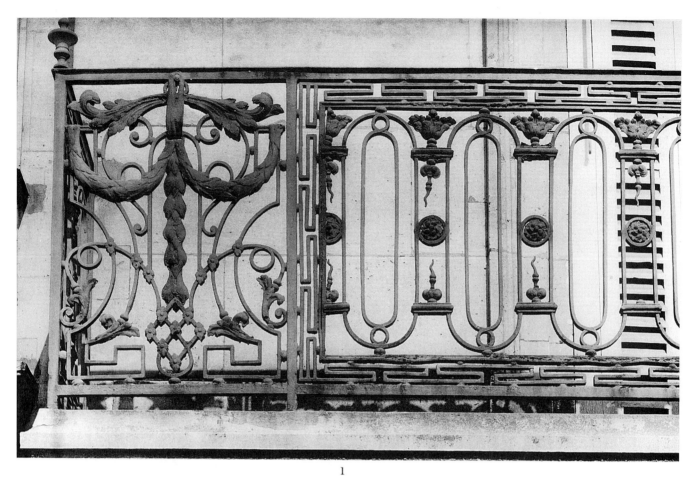

1

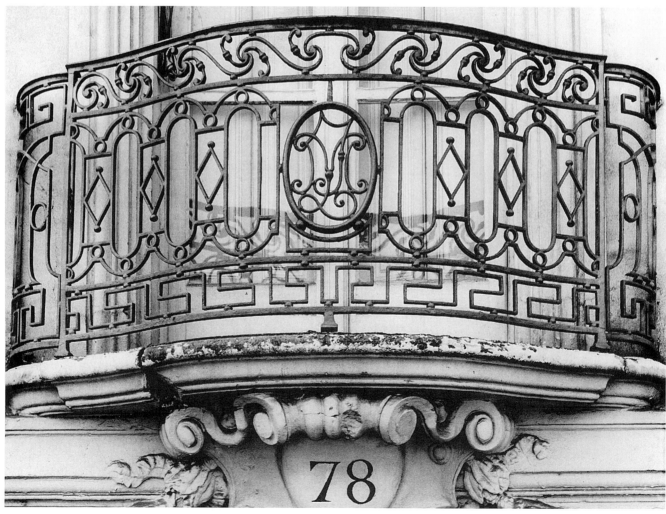

2

Versailles. **1.** Balcony detail, 85 Avenue de Saint-Cloud. **2.** Balcony, 78 Rue d'Anjou.

Plate 158

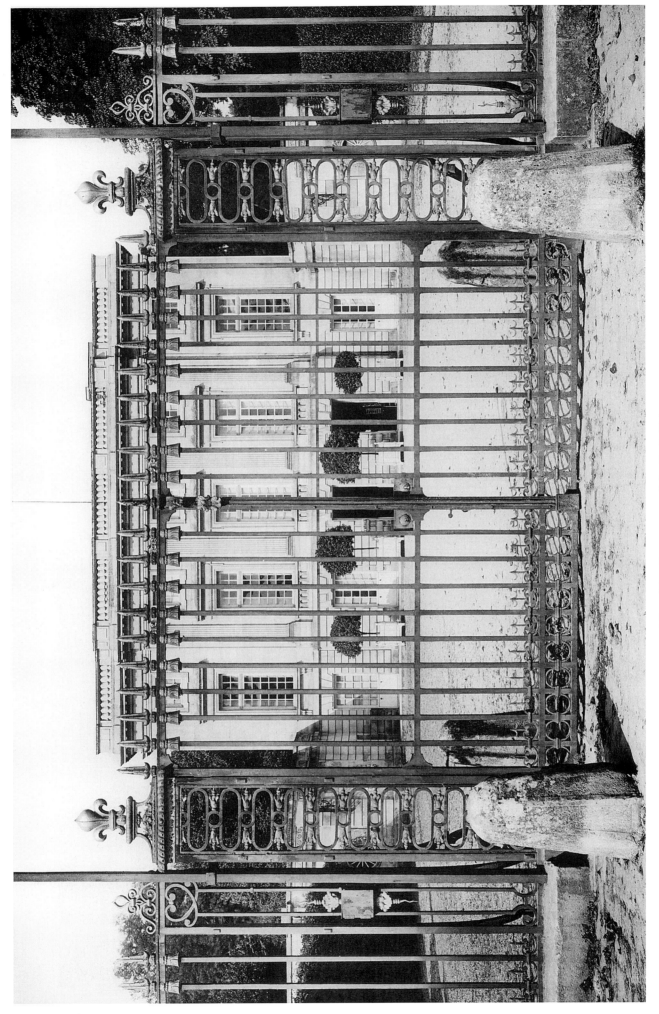

Versailles. Entry gate of the Petit-Trianon.

Plate 159

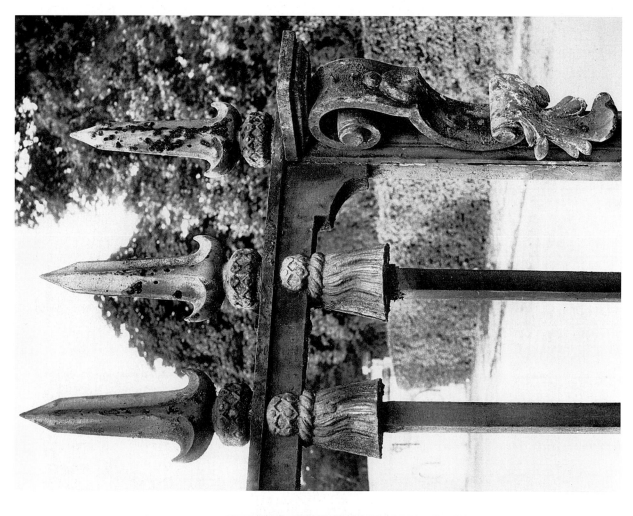

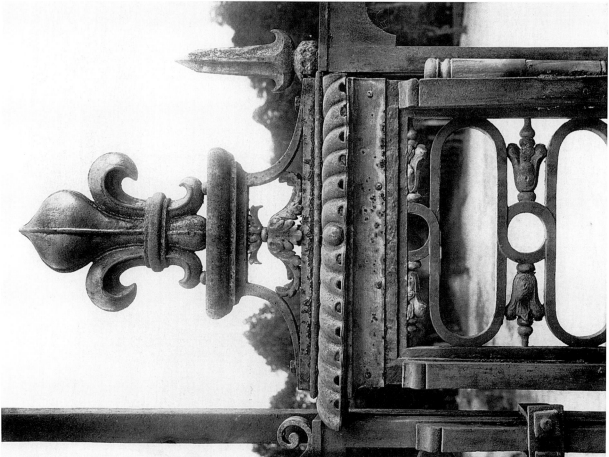

Versailles. Details of the Petit-Trianon gate.

Plate 160

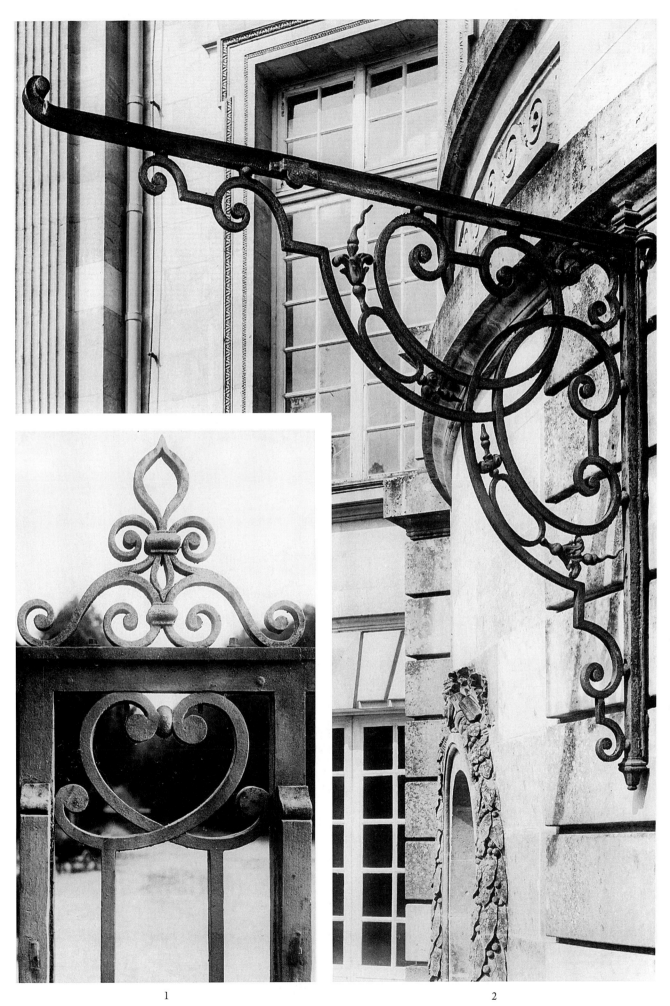

1 2

Versailles. **1.** Top of a pilaster of the Petit-Trianon gate. **2.** Petit-Trianon wall bracket.

Plate 161

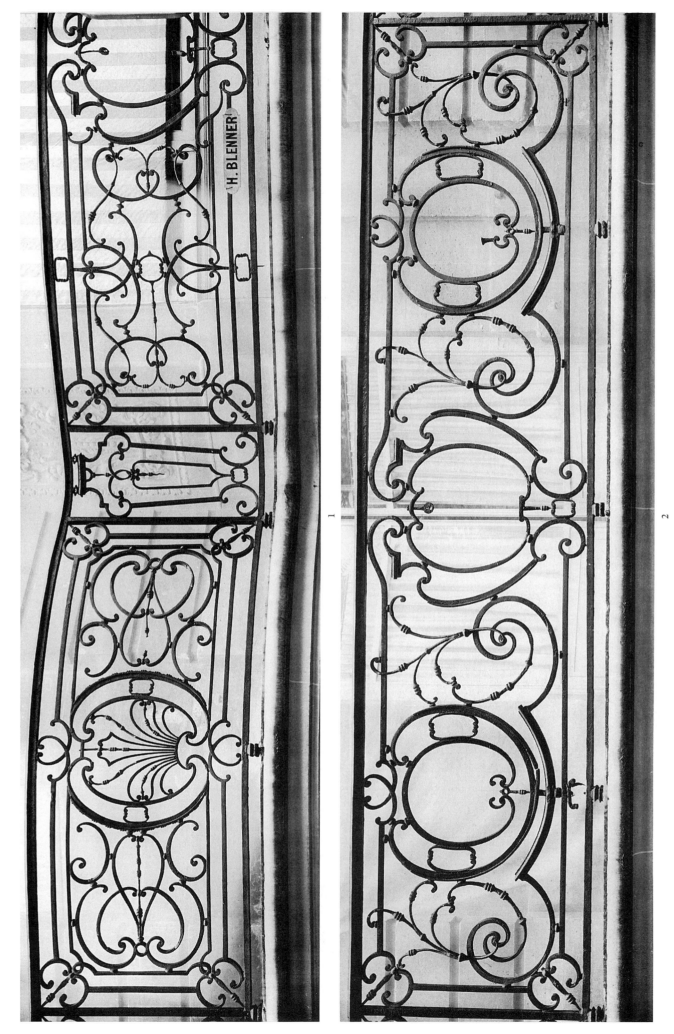

H. BLENNER

1

2

Paris. 1 and 2. Balcony details of the Pavillon de Hanovre, 33 Boulevard des Italiens.

Plate 162

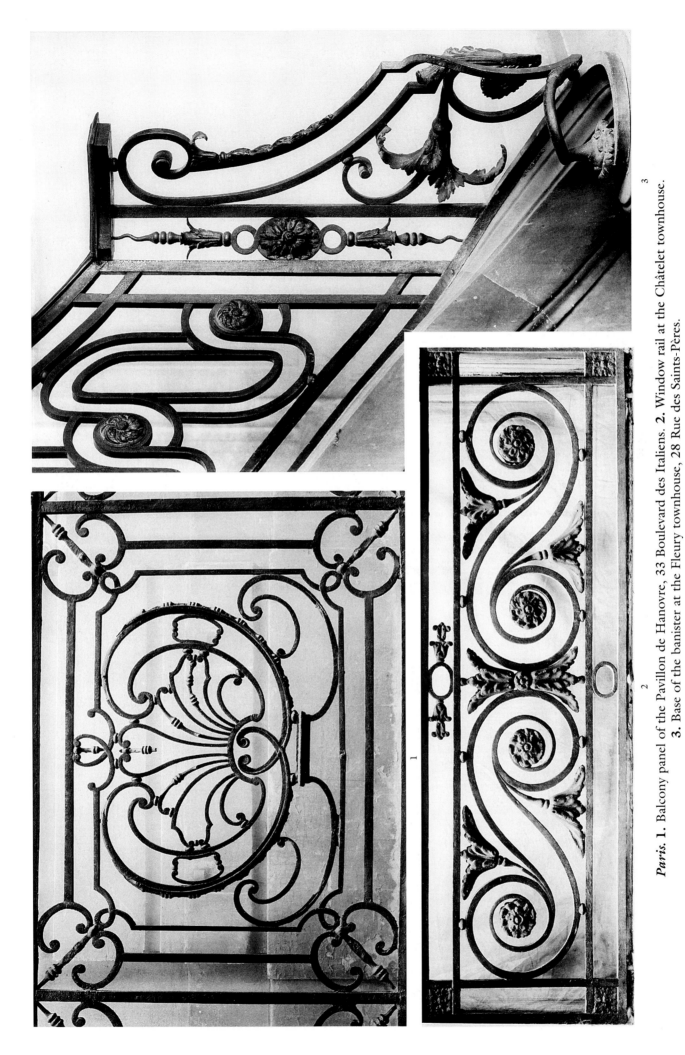

Paris. 1. Balcony panel of the Pavillon de Hanovre, 33 Boulevard des Italiens. 2. Window rail at the Châtelet townhouse. 3. Base of the banister at the Fleury townhouse, 28 Rue des Saints-Pères.

Plate 163

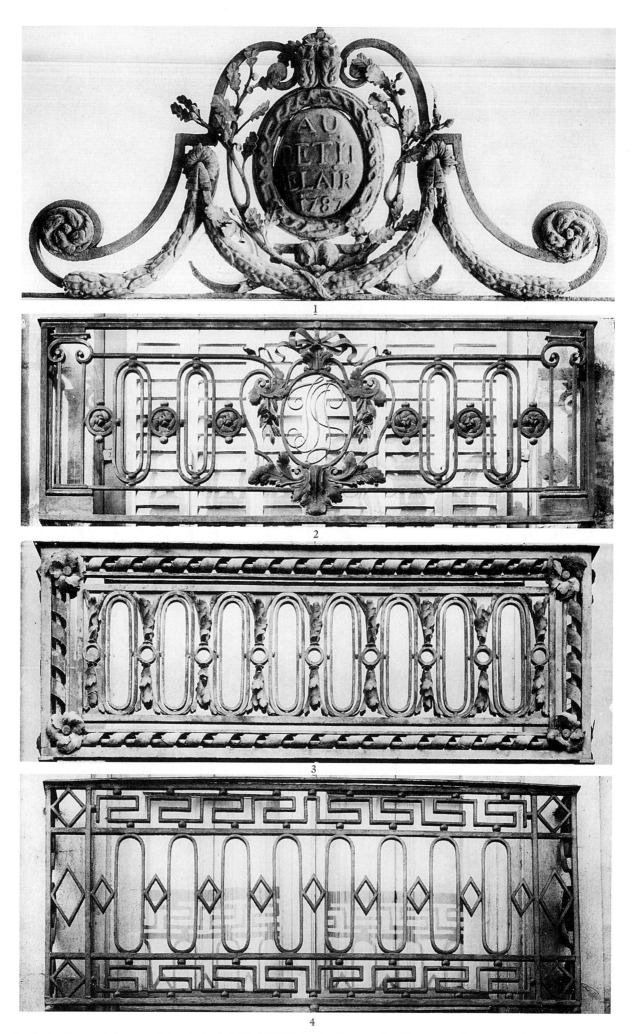

Paris. 1. Crest of the gate "Au Petit Bel-Air 1787," in the Carnavalet Museum. **Caen. 2** and **3.** Window rails, 11 and 12 Place de la Républiques. **Versailles. 4.** Window rail, 78 Rue d'Anjou.

Plate 164

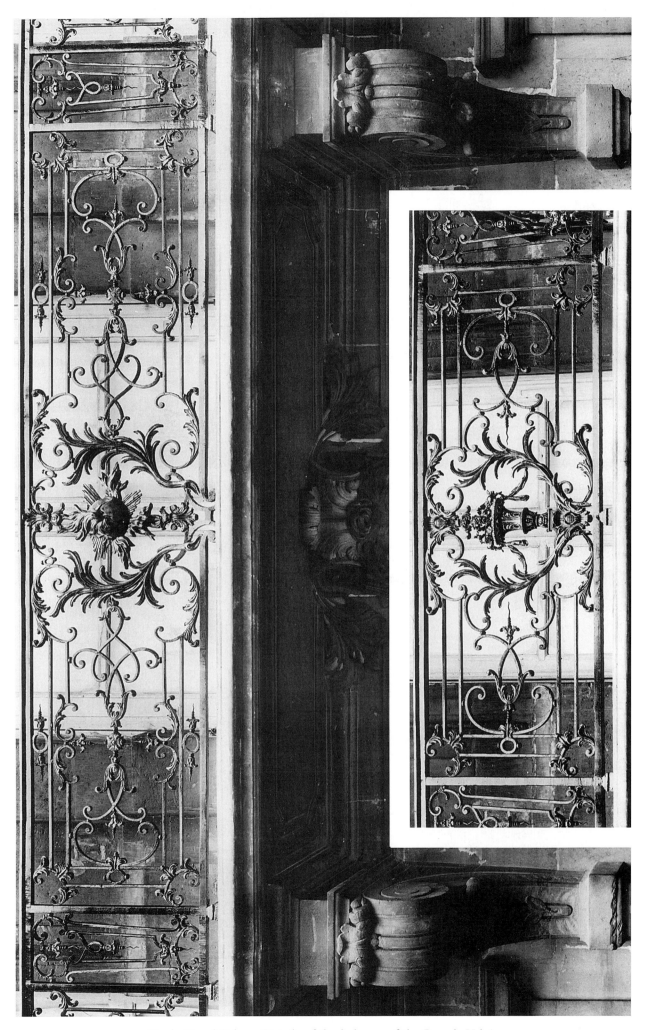

Paris. Royal Palace. Details of the balcony of the Rue de Valois.

Plate 165

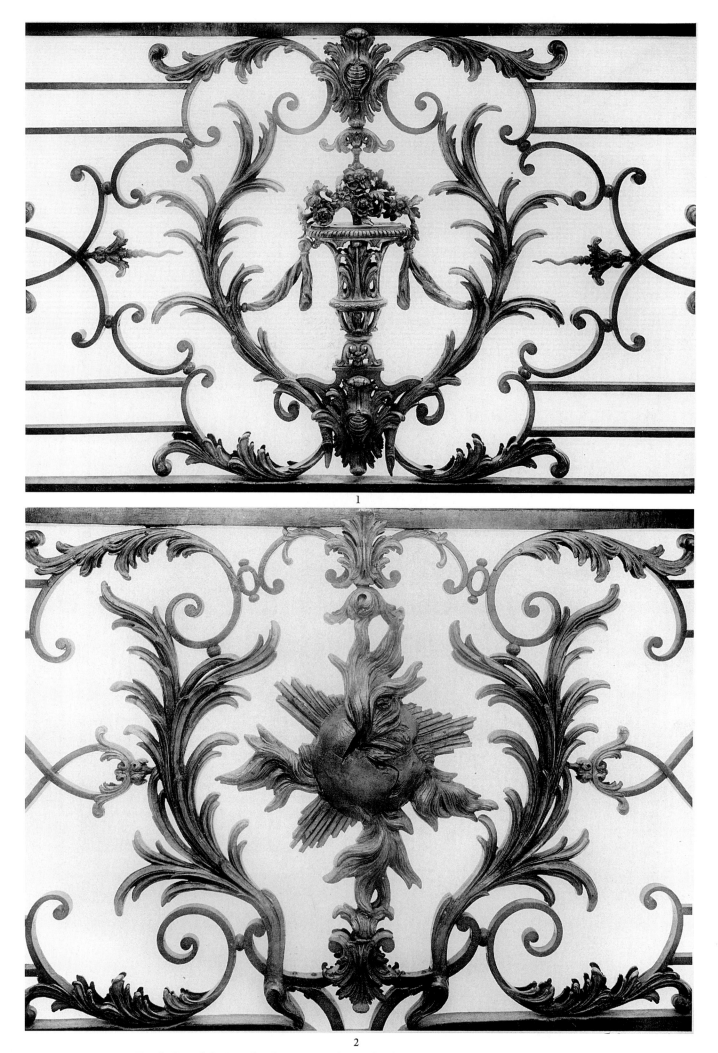

1

2

Paris. 1 and 2. Royal Palace. Central motifs of the balcony of the Rue de Valois.

Plate 166